THE MARVEL ART OF MARKO DJURDJEVIC

CREDITS:

Writer/Editor: John Rhett Thomas
Research: Jess Harrold
Transcription: Mary Kea Huckabee, Rebecca O'Dell
Senior Editor, Special Projects: Jeff Youngquist
Editors, Special Projects: Mark D. Beazley & Jennifer Grünwald
Assistant Editors: John Denning & Cory Levine
Editorial Assistant: Alex Starbuck
Senior Vice President Sales, Publishing: David Gabriel
Book Design: BLAMMO! Content & Design, Rommel Alama, Brian O'Dell
Editor in Chief: Joe Quesada
Publisher: Dan Buckley

Special thanks to Chris Allo, Jelena Kevic Djurdjevic, Joe Quesada, and Warren Simons

The views and opinions expressed in the The Marvel Art of Marko Djurdjevic are solely
those of the writers, commentators or creative talent and do not express or imply the
views or opinions of Marvel Entertainment, LLC.

THE MARVEL ART OF MARKO DJURDJEVIC. Second printing 2010. ISBN# 978-0-7851-3962-1. Published by MARVEL WORLDWIDE, INC., a subsidiary of MARVEL ENTERTAINMENT, LLC. OFFICE OF PUBLICATION: 417 5th Avenue, New York, NY 10016. Copyright © and 2009 Marvel Characters, Inc. All rights reserved. $49.00 per copy in the U.S. and $55.99 in Canada (GST #R127032852); Canadian Agreement #40668537. All characters featured in this issue and the distinctive names and likenesses thereof, and all related indicia are trademarks of Marvel Characters, Inc. No similarity between any of the names, characters, persons, and/or institutions in this magazine with those of any living or dead person or institution is intended, and any such similarity which may exist is purely coincidental. **Printed in China.** ALAN FINE, EVP - Office of the President, Marvel Worldwide, Inc. and EVP & CMO Marvel Characters B.V.; DAN BUCKLEY, Chief Executive Officer and Publisher - Print, Animation & Digital Media; JIM SOKOLOWSKI, Chief Operating Officer; DAVID GABRIEL, SVP of Publishing Sales & Circulation; DAVID BOGART, SVP of Business Affairs & Talent Management; MICHAEL PASCIULLO, VP Merchandising & Communications; JIM O'KEEFE, VP of Operations & Logistics; DAN CARR, Executive Director of Publishing Technology; JUSTIN F. GABRIE, Director of Publishing & Editorial Operations; SUSAN CRESPI, Editorial Operations Manager; ALEX MORALES, Publishing Operations Manager; STAN LEE, Chairman Emeritus. For information regarding advertising in Marvel Comics or on Marvel.com, please contact Ron Stern, VP of Business Development, at rstern@marvel.com. For Marvel subscription inquiries, please call 800-217-9158. For Marvel subscription inquiries, please call 800-217-9158. **Manufactured between 7/28/10 and 9/1/10 by R.R. DONNELLEY ASIA PRINTING SOLUTIONS, DONGGUAN, GUANGDONG, CHINA.**

10 9 8 7 6 5 4 3 2

CONTENTS

INTRODUCTION BY JASON MANLEY

• • •

THE COVERS
Commentary by Marko Djurdjevic
Additional commentary by Marvel's Chris Allo, Editorial Talent Editor, and Warren Simons, Editor

CHAPTER 1: X-MEN
X-Men First Class #1-8, X-23: Target X #1 variant,
Marvel Spotlight: X-Men Messiah CompleX,
Cable #4 variant, *Uncanny X-Men #497* variant

CHAPTER 2: BLADE
Blade #1-12

CHAPTER 3: THUNDERBOLTS
Thunderbolts #110-121, Thunderbolts: Desperate Measures,
Thunderbolts: Breaking Point, Thunderbolts: International
Incident, Thunderbolts: Reason In Madness

CHAPTER 4: DAREDEVIL
Daredevil #95-119, #500, Daredevil Annual #1,
Daredevil: Blood of the Tarantula

CHAPTER 5: MYSTIC ARCANA
Mystic Arcana: Magik, Mystic Arcana: Black Knight, Mystic
Arcana: Scarlet Witch, Mystic Arcana: Sister Grimm, Official
Handbook of the Marvel Universe: Mystic Arcana, Marvel Tarot

CHAPTER 6: WOLVERINE
Wolverine: Origins #14-20,
Wolverine: Weapon X #2 variant

CHAPTER 7: SPIDER-MAN – ONE MORE DAY
Amazing Spider-Man #544-545 variant, *Sensational Spider-Man*
#41 variant, *Friendly Neighborhood Spider-Man #24* variant

CHAPTER 8: GHOST RIDER
Ghost Rider #1.5 (Germany), *Ghost Rider #20-27, 29*

CHAPTER 9: THOR
Thor #7-8, Thor #7 variant, *Thor: Ages of Thunder,*
Thor: Reign of Blood, Thor: Man of War, Thor: God-Sized
Special #1, Thor #600-602, Thor #601 variant,
Secret Invasion Aftermath: Beta Ray Bill – The Green of Eden #1

CHAPTER 10: AVENGERS
Captain America #25 (UK + German variants), *New Avengers #38,*
Invincible Iron Man #1 variant, *Dark Reign* Promotional Art,
Wolverine #75, Mighty Avengers #12-20, 26,
Mighty Avengers #19 variant, *Dark Avengers #1* variant

CHAPTER 11: HULK
Wizard Magazine #189, World War Hulk: Gamma Files, Hulk #2 variant,
Hulk vs. Hercules: When Titans Collide, Hulk Family #1

CHAPTER 12: MAGNETO
X-Men: Magneto – Testament #1-5

CHAPTER 13: MARVEL'S 70TH ANNIVERSARY VARIANTS
70th Anniversary Variant Cover Art Featuring Human Torch, Sub-Mariner,
Thing, Marvel Girl, Wolverine, Iron Fist, Captain America, Thor,
Spider-Man, Hulk, Ms. Marvel, Iron Man

CHAPTER 14: VARIOUS ARTISTRY
Spider-Man test painting, Baron Zemo test painting, *What If:*
X-Men – Age of Apocalypse, Sub-Mariner #4, Super-Villain Team-Up:
MODOK'S 11 #2-5, Comic Box #50, What If: Civil War, Ultimate Fantastic
Four #50, Incredible Hercules #115 variant, *Howard the Duck Omnibus* hardcover,
Eternals #1 variant, *Amazing Spider-Man #573* variant, *What If: House of M,*
What If: Spider-Man – Back in Black, What If: Secret Wars,
Dark Reign: Hood #1-2, Man in the Iron Mask #1-6

• • •

CHARACTER CONCEPTS
Quasar, Wraith, Warlock, Star-Lord, Penance, Spider-Man Noir, X-Men

CLOSING THE BOOK

Marko Djurdjevic

■ FOREWORD

Marko Djurdjevic is an art chainsaw of skull-ripping, bone-shredding, self-taught talent. He is an enigma who carved his life and his work as he dreamed it to be. Over the past ten years, Marko has sharpened his skills through hard fought personal battles, countless hours at the grindstone, and has overcome severe adversity to become one of the top entertainment illustrators and designers on the planet.

Marko is a visual storyteller capable of building rich worlds for his clients and inspiring millions of artists and art lovers alike with his works. He is a man who believes in self-improvement, learning, and sharing with others. Marko is more than just an artist. He is a good man, a family man, and is a worldly soul full of experience and emotional depth. When I see his works, I see greatness. When I am fortunate to spend time with him, I see a true friend.

Over the past six years, Marko has contributed to many of the biggest entertainment projects around. He has worked on comics, films, games, toys, and new media with a fervor. He has become an esteemed teacher who gives back all the information he fought so hard to learn during his life, sharing his theories with artists all over the world. His work has progressed from primarily pencil work to the mastery of digital and a variety of traditional medias.

Some artists have it easy. Marko did not. No one handed him an art education. No one handed him his career. Marko earned it all – from sheer desire, perseverance, deep passion, and countless hours of practice.

As you turn the pages of this incredible body of work, it may not be obvious that Marko is really only just beginning his journey as an artist. After years of struggle and both creative and personal victories, his skill set is complete. Through the next decade there will be much more to come, without a doubt. The impact he has had on the world of entertainment art is inspirational. The waves he will create over the coming years will be immense. Rest assured, this will not be the last art book that comes from this man's soul and deft fingers.

Marko's works are powerful, virtuosic, and rich in imagination. If you look deep enough into these pages, you will see the same thing I see – an artist of immeasurable heart, perseverance, humor, intense work ethic, wisdom, integrity, and deep creativity. If you truly listen, works of art say more than just a narrative message, they speak directly to the soul of the artist. Within this book I think you will find, as I did when I first discovered his art years ago, that his art speaks for itself. Work like this reveals more than just a beautiful story or design. I think you will enjoy what you find, as there is a lot more here than just beautiful images from the mind of Marko Djurdjevic.

Sincerely,

Jason Manley

President
www.massiveblack.com

Founding Director
www.conceptart.org

■ THE COVERS

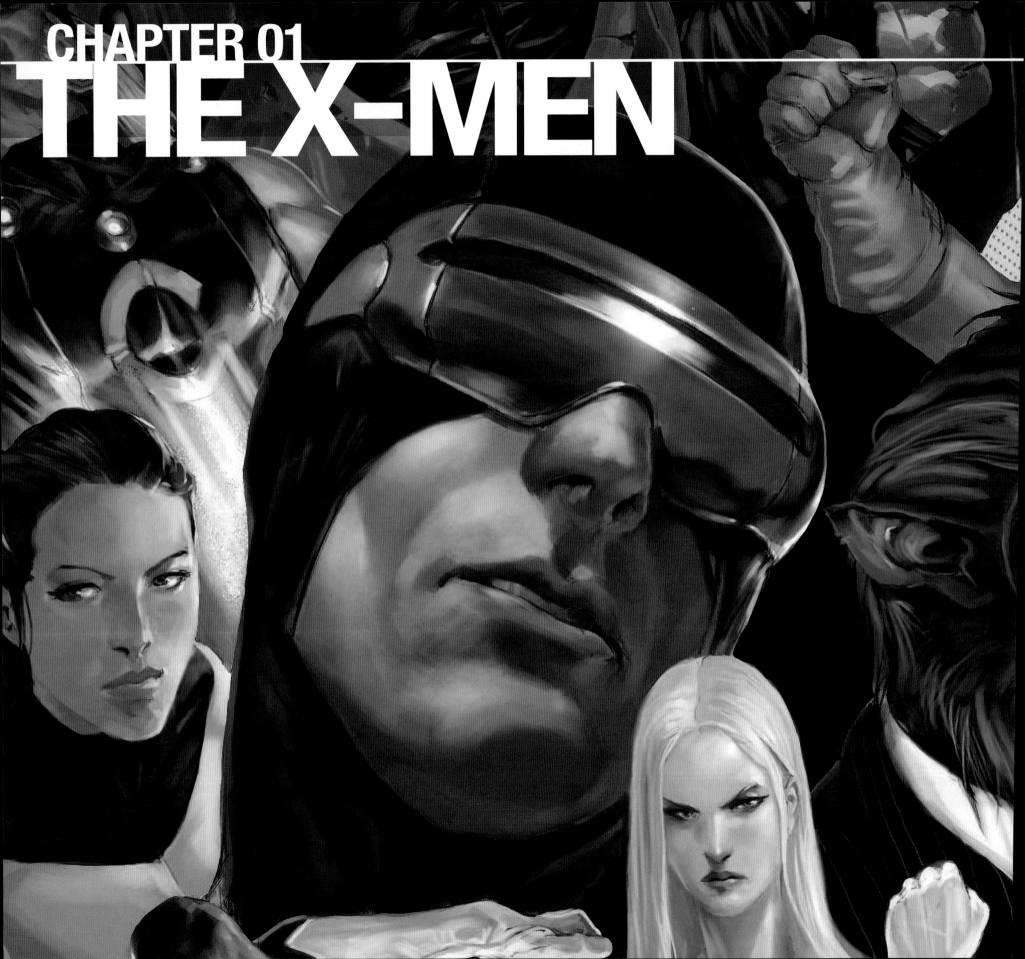

THE X-MEN

The X-Men. Drawing these timeless characters was how Marko first gained notice from Marvel after posting images on a popular arts exchange message board forum. Funny thing was, at the same time some hardcore X-fans were assailing the unassuming Serbian's irreverent character designs, Marvel's top brass were looking at the same images and coming away certain they'd uncovered a top talent. Marko was passing an audition he didn't even know he had signed up for. Or to put it another way: Like the X-Men – who were starring in the first title for which he'd be assigned to drawing covers – he was taking his "first class"…and acing it!

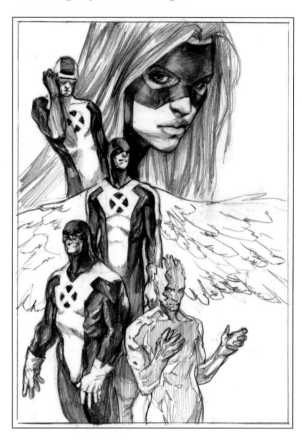

MARKO: "This was the first step in my career at Marvel. There's definitely a sense of nostalgia when I look back at *X-Men First Class* and think about how much I have evolved from there. These were the first paintings that I'd ever done. I wasn't really that much of a painter before I started at Marvel; I had only done a handful of paintings by then. But they hired me as a cover painter and I so I made it my job to figure it out. There were so many things to learn at that point and I didn't have any routine at all. So when I see these, I see myself working my way through the process intuitively, figuring out what works and what doesn't. Some of the covers were simply cheating, where I elected to go an easier route and not force myself to paint something out of my competency and thus make it look bad."

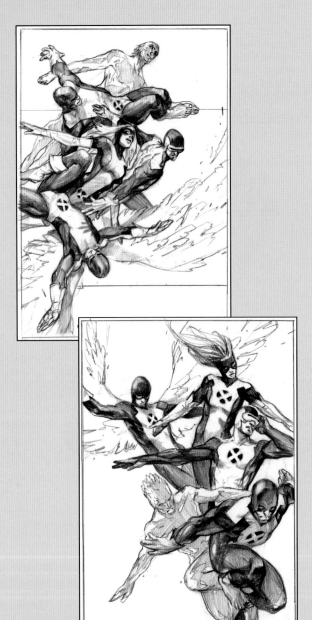

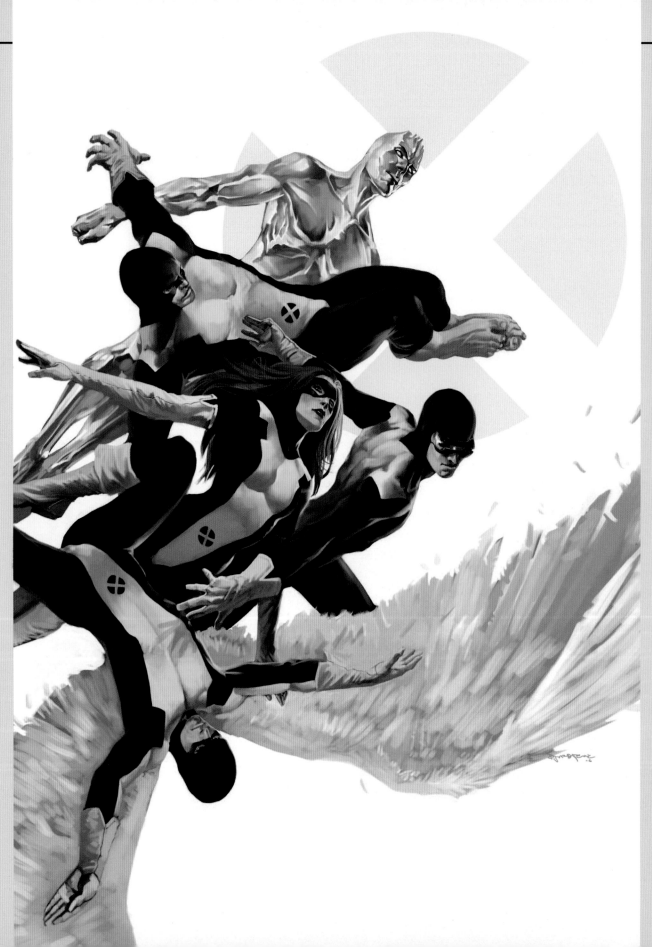

"I took *X-Men First Class* right after Marvel hired me – just before *Blade* – and I was really stoked to get an X-Men gig. I had so many high expectations when I got the assignment, but what I didn't know at that point was that *First Class* was essentially a retelling of the first years the team of five were together. I was really feeling bummed out when I heard I was going to have to do those old costumes, but at least they gave me the freedom to go ahead and redesign them and make them a bit more modern.

"I was far more excited to work on *Blade* than *X-Men First Class* because it meant confining myself to the restrictions of an all ages book to work on the X-Men. But even so, I really wanted to do a good job with it, so I tried my best to come up with different solutions that were simple and beautiful to look at."

everglades

"I look for opportunities to push the story on a two-dimensional, almost pictographic, level, and describe what's going to happen by using symbols. I think it's a valid form of expressing myself – to take some visual elements out of the literal. In this instance, I put a map of North America in the background and highlighted Florida, as that was the story where the X-Men were going to vacation and have a run-in with the Lizard. Coming up with design concepts like that is really interesting for me and really adds to the fun."

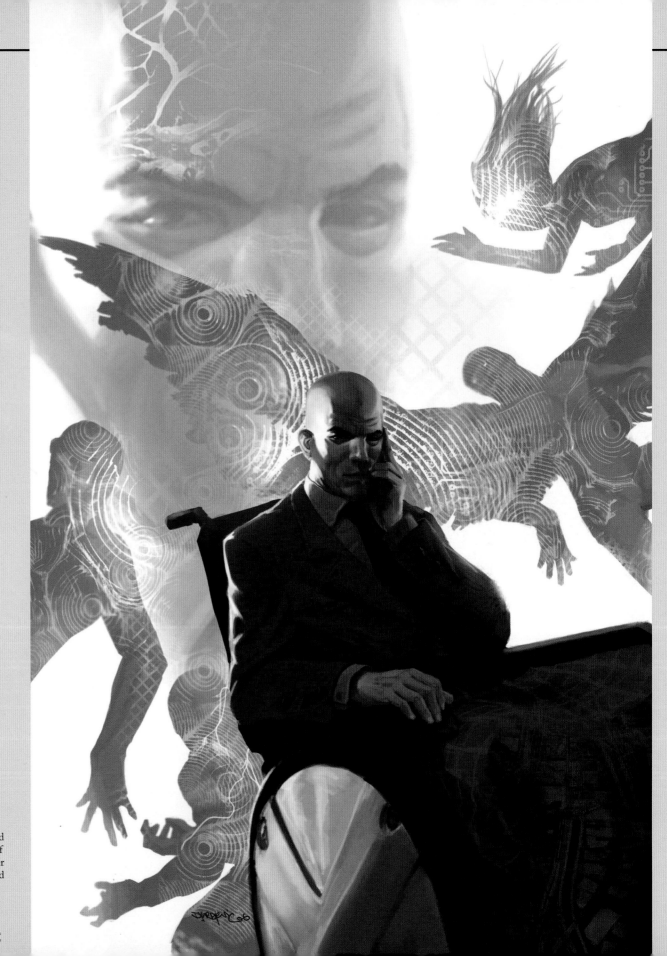

"To push the storytelling, I placed Professor X in the foreground and gave the background a kind of Hitchcockian atmosphere of suspense. All those vertical circles that were part of the character forms really helped to emphasize that the X-Men are all trapped inside his head."

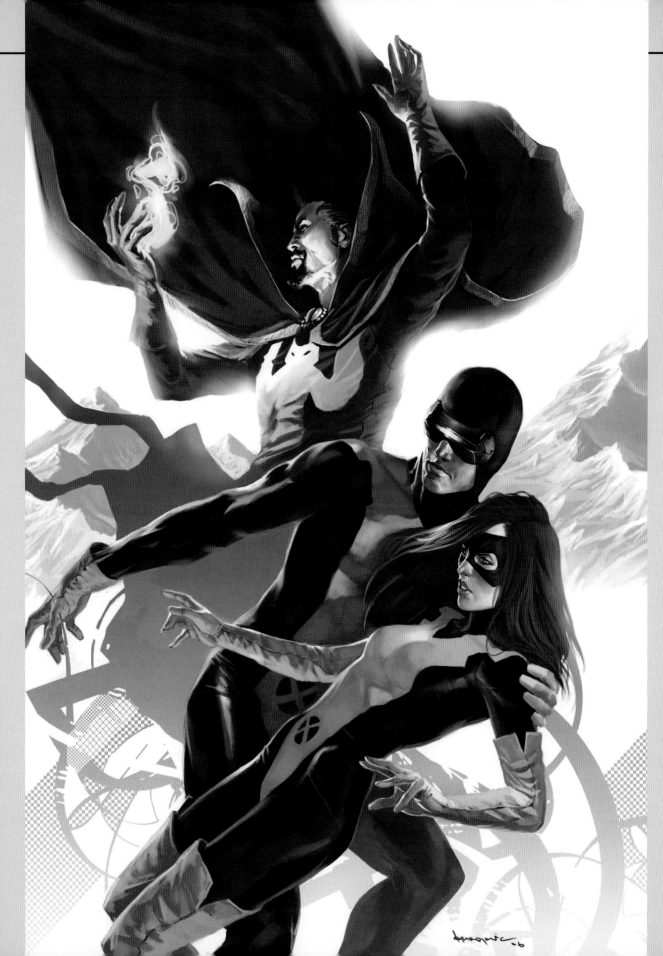

"My entire approach throughout this series was to use the old school nature of it as a base and then push the modernism as far as possible, to make those characters work as individuals even though they're all wearing the same uniform and there's only rudimentary differences between them."

"Joe Quesada had either seen his work online – or somebody had sent a link to Joe – where Marko had redesigned some of the He-Man characters. That is what caught Joe's eye. And then on further investigation we saw that he did some redesigns on X-Men characters. Joe said, 'Find this guy.' I just kept digging and digging until I found him through Massive Black. I reached out to him and said, 'Hey, Joe Quesada saw your art and wanted to know if you would be interested in doing some art for Marvel.' Marko was very excited about that because I think he was getting frustrated at doing design work for video games and never having his work be seen by the public." – **Chris Allo**

"I believe abstraction and modernism is one of the most simple but effective art forms; there are so many ties into graphic design. Whichever cover you take, you can zoom into a certain spot and it becomes more abstract the more you zoom into it. What I'm trying to do is just take this abstraction that happens in the microcosm and exploit it on the macrocosm. In using it for my backgrounds, I am able to create atmosphere, depth, shape, and meaning. The abstract graphic design shapes help to make the cover more alive, more fresh, and more centered around what is possible."

"After I reached out to Marko, I got more samples of his stuff. I showed it around, and all the reactions were very positive and encouraging. But when it gets down to it, most editors are hesitant to try new people. It took a little while to get him a gig, but I kept pushing, and pushing, and pushing, and finally Mark Paniccia bit on him and gave him the X-Men First Class covers."
– Chris Allo

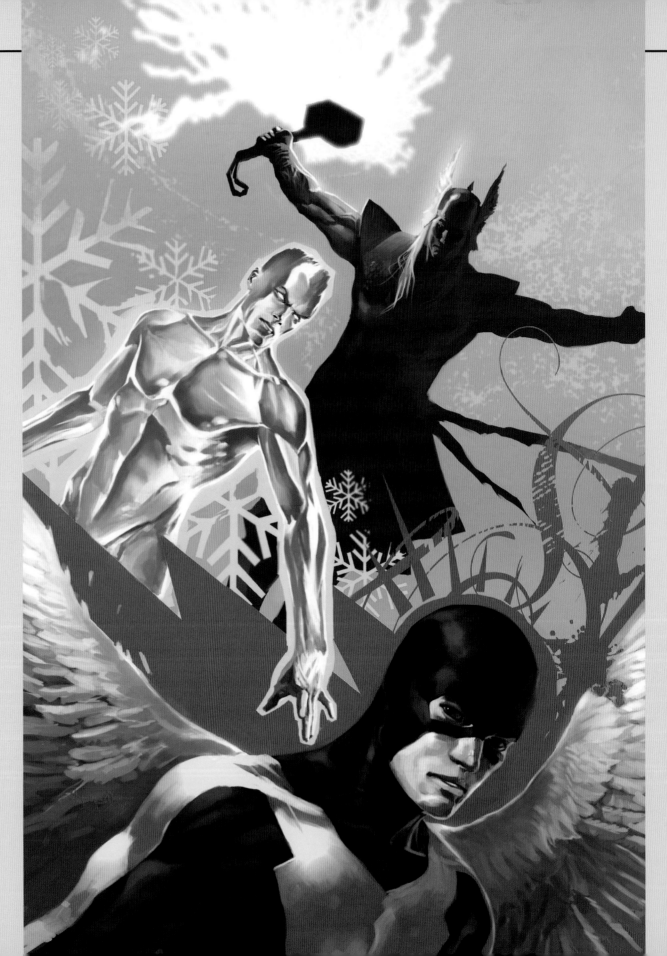

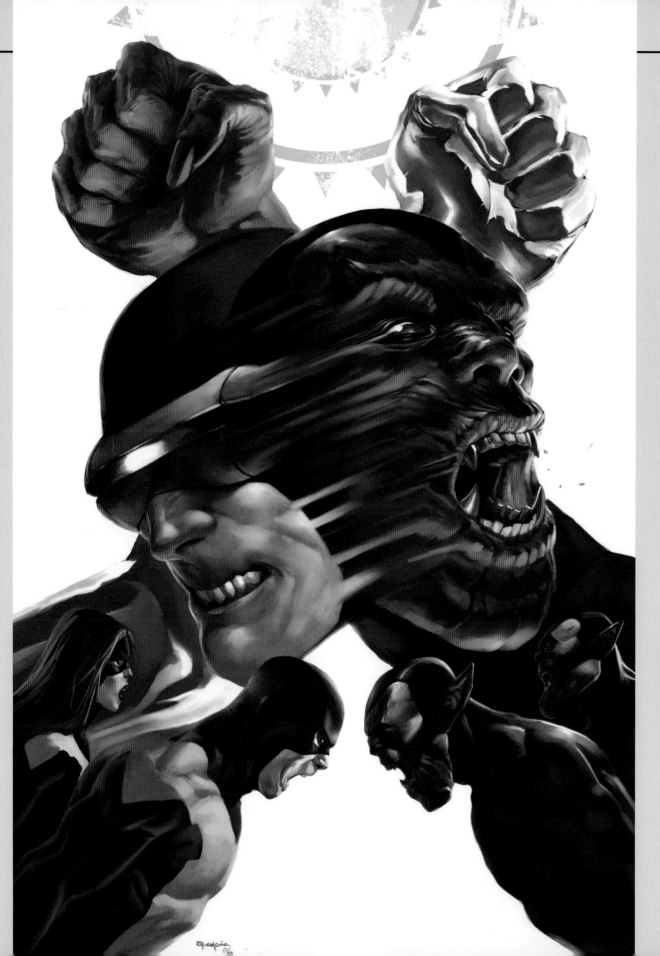

"*Officially his first work for Marvel was an X-23 piece that was used as a variant cover on one of the mini-series. And then his first official body of work would be some of the X-Men First Class covers. From there, people saw what he can do and how fast he can do it. It was great because he turned in so many different sketch ideas for each cover, and that's something that editors really liked — being able to see the various different designs they could use for their covers. He took one idea and turned in multiple, different versions of it, and that was really appealing. He just became more and more attractive to editors, and then it just kind of snowballed from there.*" – **Chris Allo**

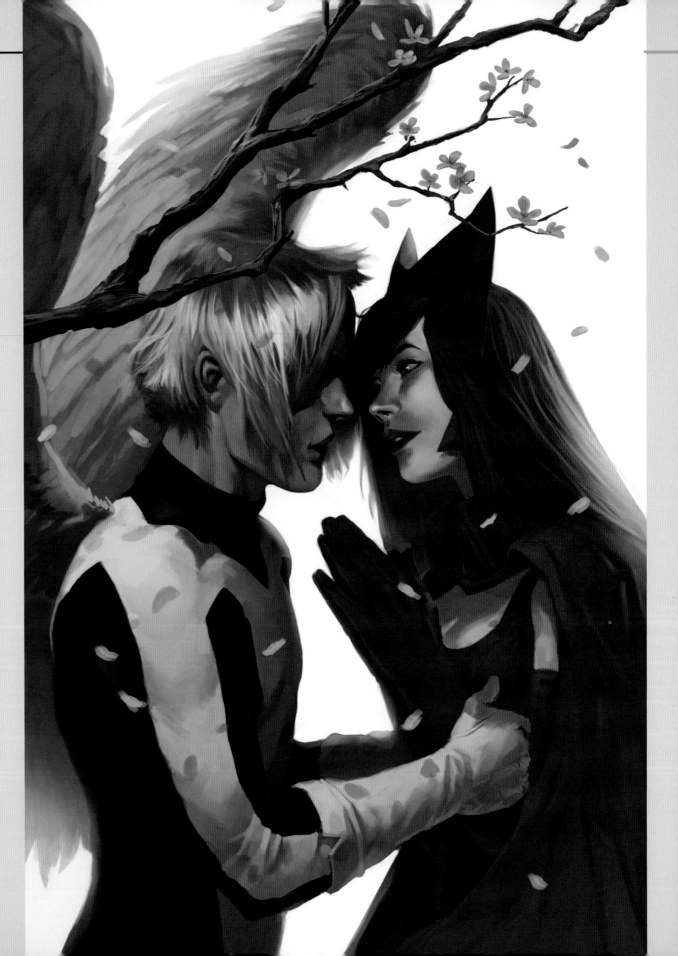

"I thought it was so cheesy when I got to the editorial description of Scarlet Witch and Angel being involved. They wanted this romantic cover from me, so I decided to go over-the-top and make it as cheesy and corny as I possibly could – make it look like a romance novel, perhaps about a summer love, the kind of book that you might read on the veranda when you have nothing else to do. It turned out to be liked by so many people precisely because of the romance angle, which wasn't even my intention. I really didn't even think about it having that impact."

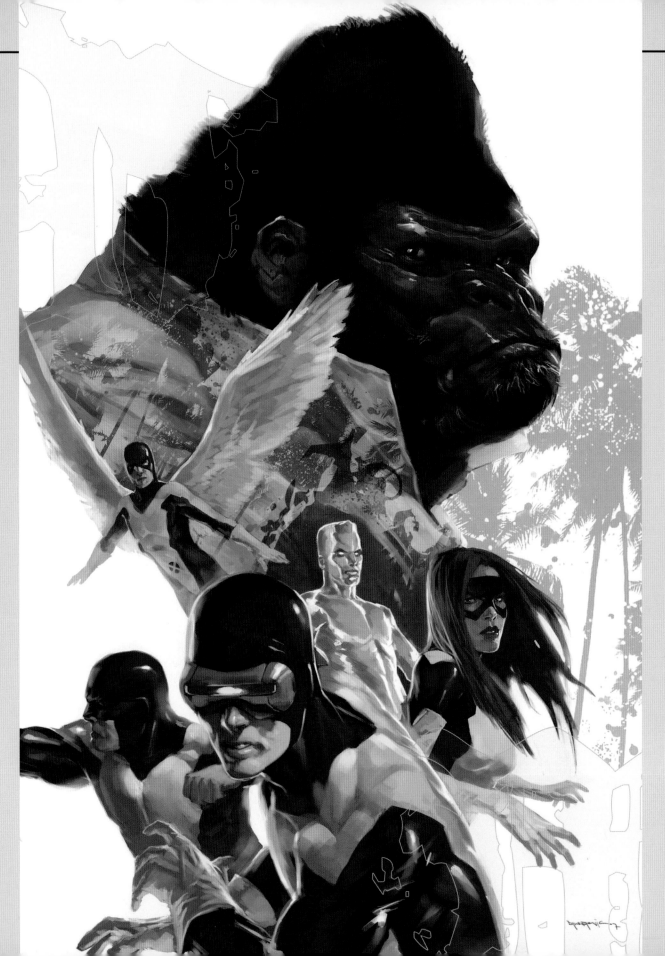

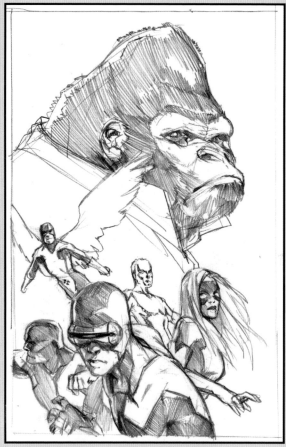

"As an illustrator, it's important to be able to draw anything. And when I don't know something I have to at least take a look at it, figure out how it works, and then go back to the drawing board and take what I just learned and recreate it in a certain form. For instance, the need to draw Gorilla Man, the character from *Agents of Atlas*. I wanted to get away from the cartoonish version that he was drawn in and just give him a little bit more realistic flair."

"At the time I did this I had no knowledge of the character; they just wanted a test piece. The description from Chris Allo went something like 'She's a 16-year-old, teenage prostitute living on the streets of New York.' I was channeling what girls I liked when I was a teenager looked like – how I might have liked them to dress – and I went for that. That was just pure intuition because I really had no idea what she was supposed to look like."

"I really like this cover for several reasons. One being that this is officially Marko's first work for Marvel. Also, it embodies Marko's transition from concept artist to comic book artist. It's raw, visceral and very edgy and has a lot of cool design elements. If you notice, he doesn't implement those design elements as much anymore." – **Chris Allo**

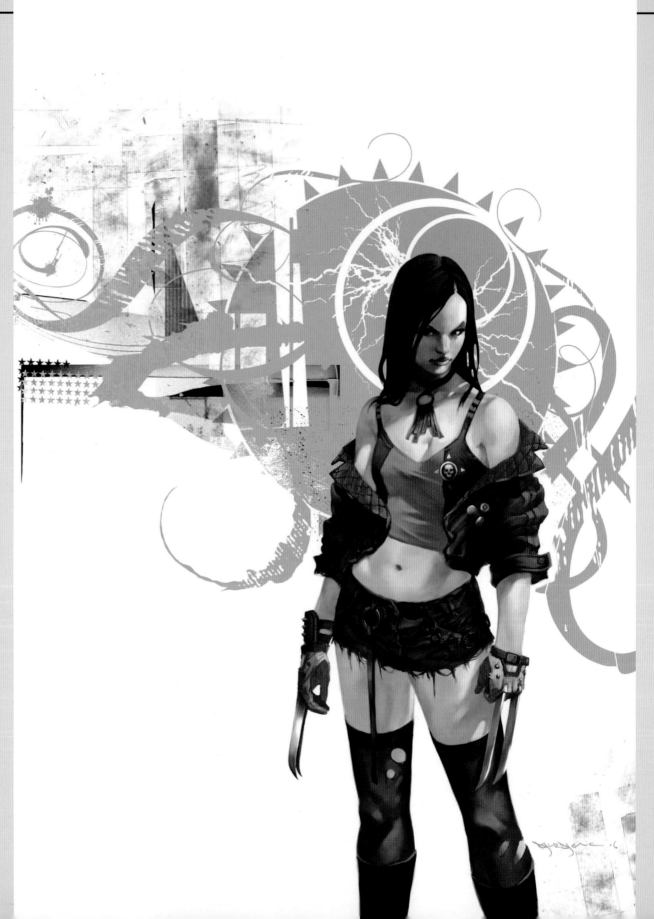

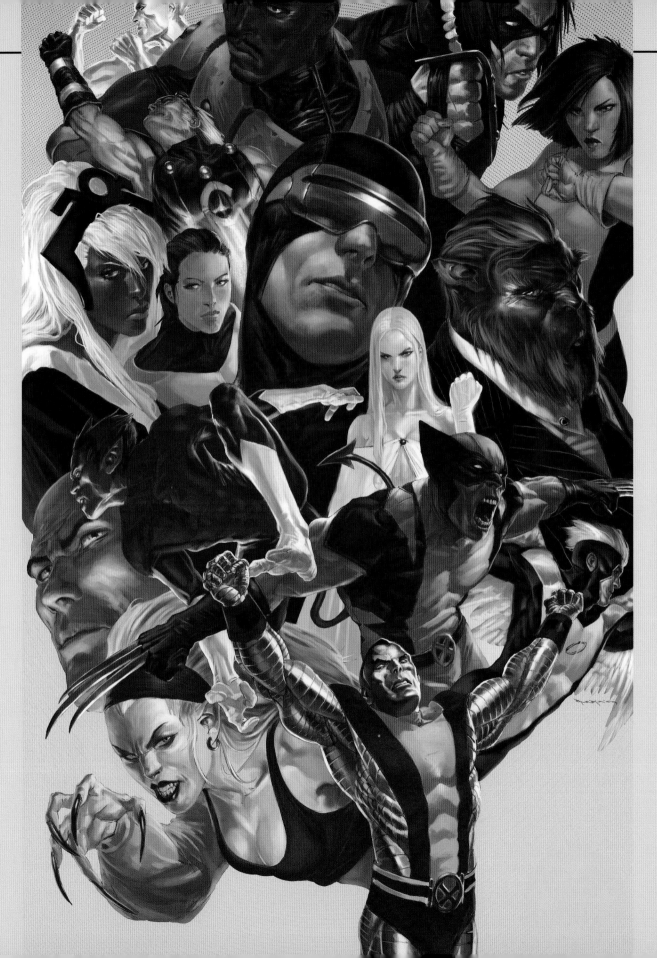

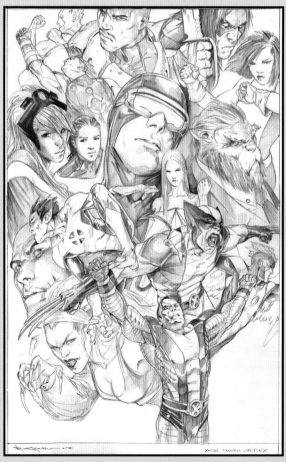

"There is so much going on here compositionally. It has a central figure, and all of the figures are blossoming out of the middle, and there is Colossus, who's basically holding up the entire X-Men on his shoulders."

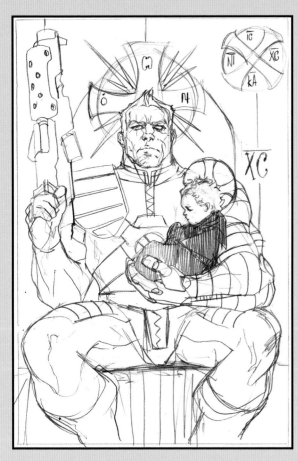

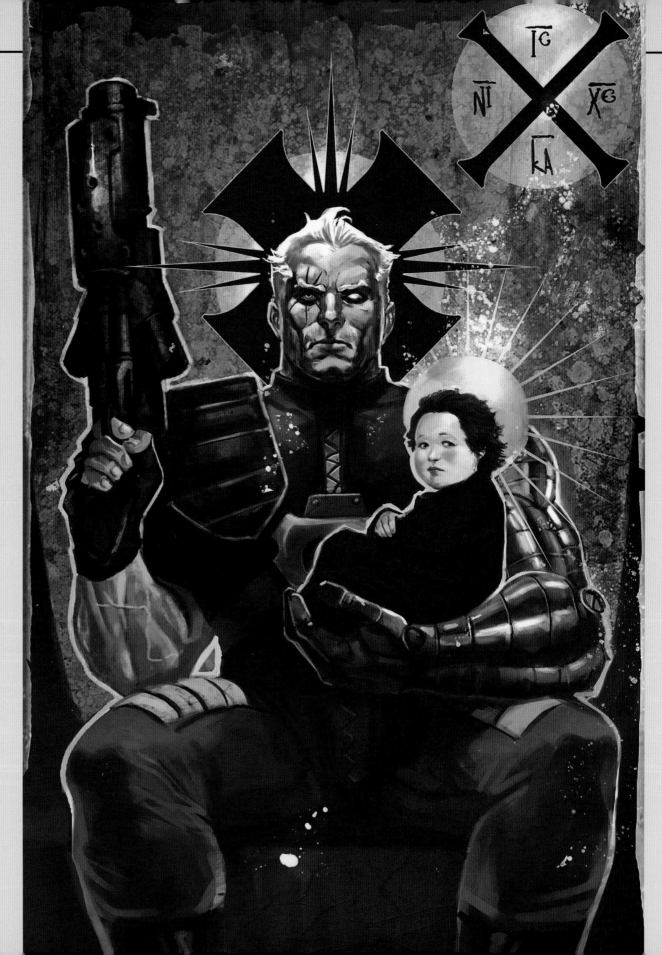

"My wife and I are both Serbian and this is an homage to our heritage. It's inspired by Serbian – or Greek Orthodox – iconography, since the 'X' is basically just a cross that is tipped on its side. This was a part of the event called *Messiah CompleX*, in which Cable is fiercely protecting a newborn child: There was so much religious imagery already in the series concept that I was wondering why nobody else had tried to take a religious theme to the cover. When I did the painting, I really wanted to put emphasis on the religious qualities of the mutant society amidst all the trials they had been going through in the past few years, and also include the classical Orthodox iconography."

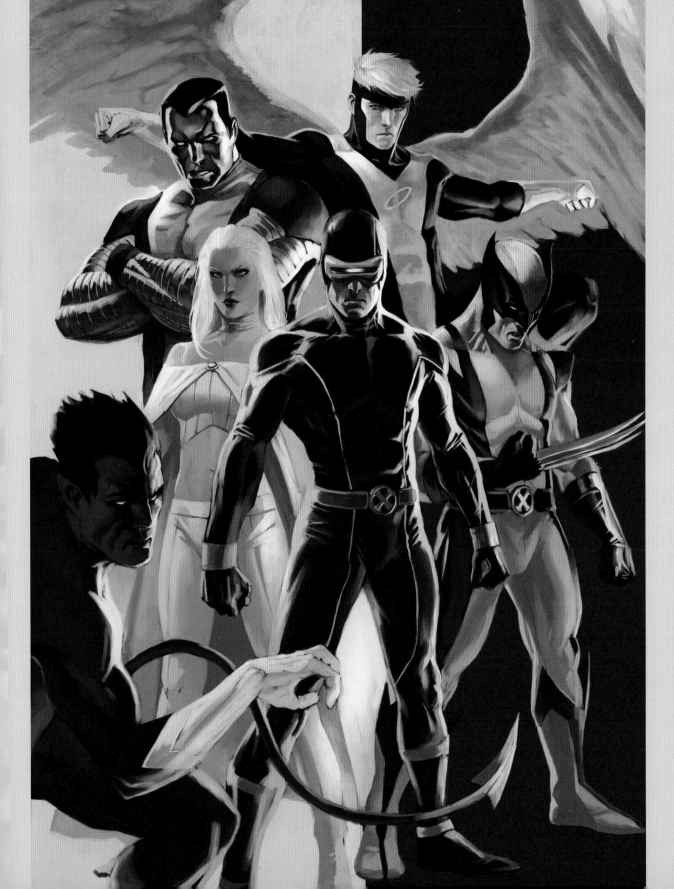

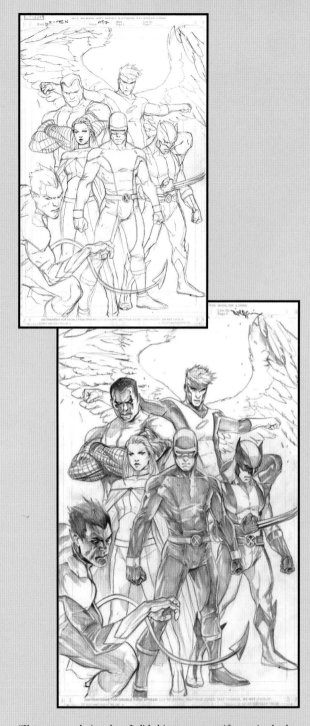

"I've got to admit, when I did this cover my wife was in the last months of her pregnancy, I was super-nervous, and also very over-worked. It was supposed to go to (inker) Danny Miki, get inked, and then go off to get colored. As soon as I got my part done I heard from Marvel that Danny couldn't ink it, so they asked me if I could paint it. I basically had a few hours to get it out of the door. It's one of those covers where I feel I could have done better."

This compact, twelve-issue series was writer Marc Guggenheim's ode to vampires – and the enigmatic Blade who lived to kill them. Staying alive for over a hundred years as an immortal hunter of the undead will get you to indulge in some inventive new ways to take out your ubiquitous targets. All part of enjoying your job, one would suppose. The subtle humor inherent in Guggenheim's stories was telegraphed by the playful sense of stylized comedy in Marko's covers. Comedy tinged with violence, naturally – and some would say ultra-violence. And that's fine with Marko. All part of enjoying his job!

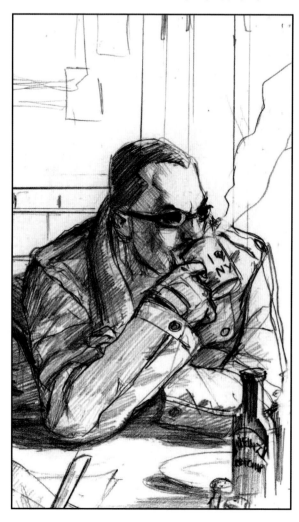

MARKO: "This was the only series where all the editors just left me alone and let me go crazy with my designs. I figured, why not take in some humor and just try to make it really funny? Blade has been done so many times already, so I felt like if all the volumes before didn't hit the nail on the head then maybe my route might really work out. People might appreciate the humor behind it."

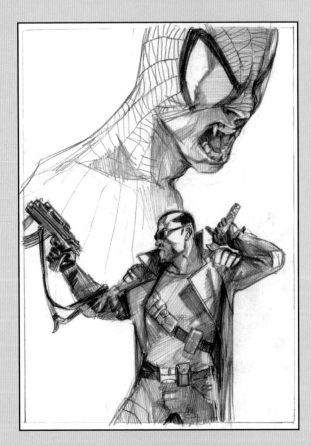

"If you look at the movie *Goodfellas,* it really shows the dark side of who we are as human beings. At the same time, however, it's a brutally humorous film. No matter how cruel and how vicious some of the scenes are, at times you can't help but laugh. And I guess I pretty much took the same approach with my Blade covers. No matter how cruel and violent they come across, they still have this sense of humor, exaggeration, and over-the-top quality that makes them stand out."

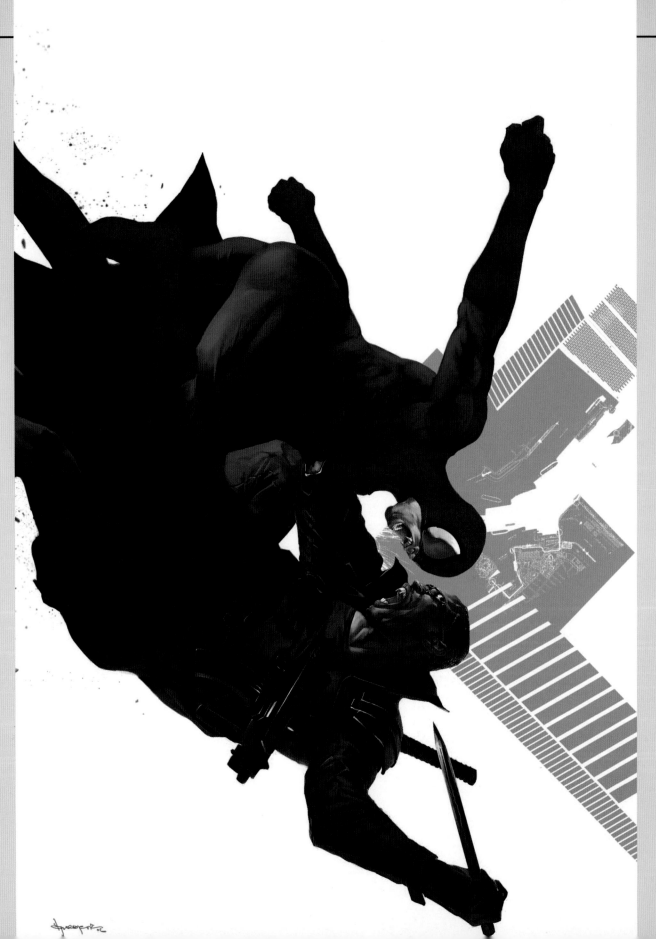

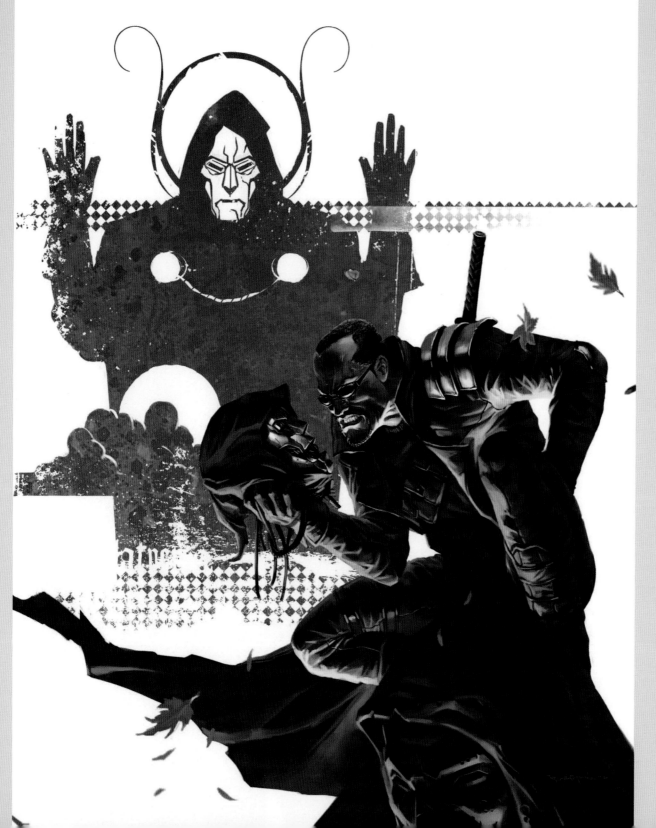

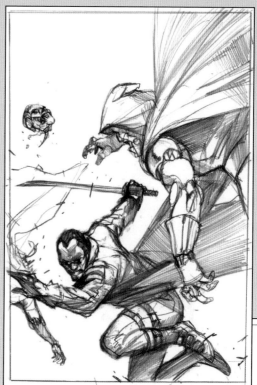

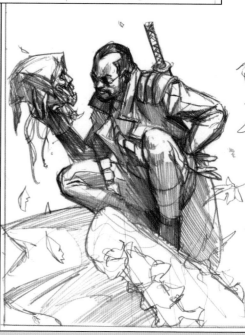

"If you look at my work in general, you can see that I shy away from exaggerated stylization of anatomy in my work. My job is to make the story behind the cover stand out, and sometimes I do that with humor, and sometimes with exaggeration. But most of the time I'm just trying to filter what the story is and make that stand out."

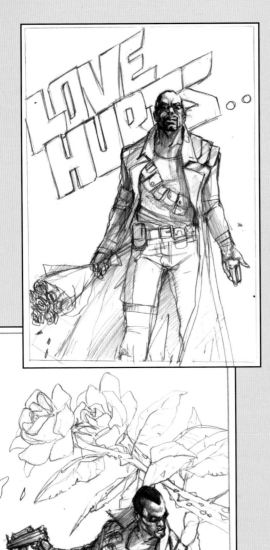

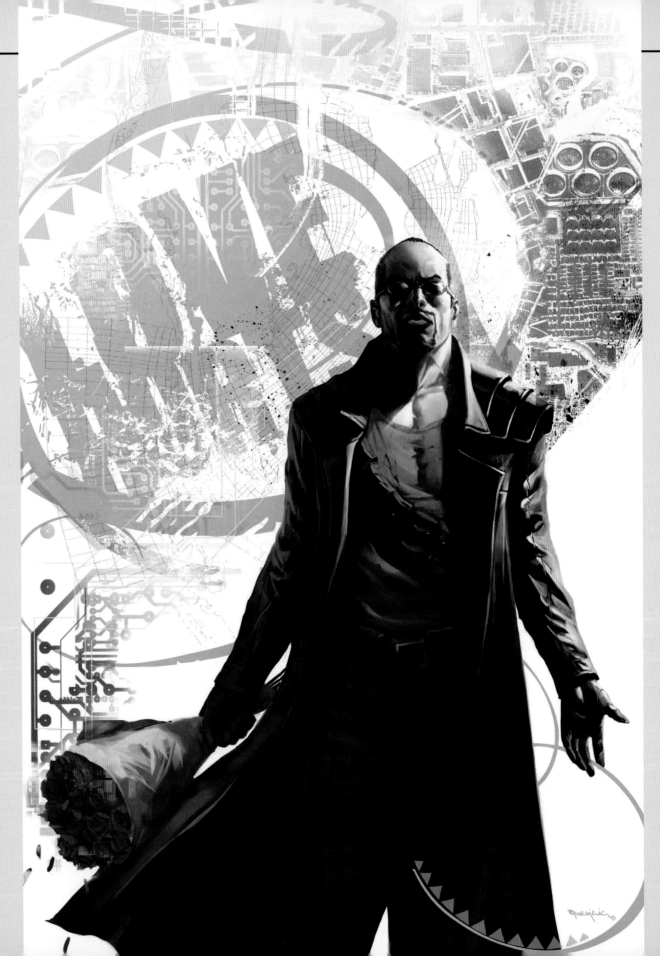

"Vampires are bloody creatures. If you rent the movie *Blade*, it's just full of gore and violence, yet it's so funny! My wife and I are cracking up because it's so over-the-top. It combines all those things that are interesting about vampires, like the stake through the heart, the beheading, putting them to flames – yet at the same time it does it in such an over-the-top way that you can actually enjoy all the violence. It's just a caricature of what we are as human beings, and I think that no matter how violent it is in these covers, it never gives you the feeling that it's unsettling; it's part of the humor."

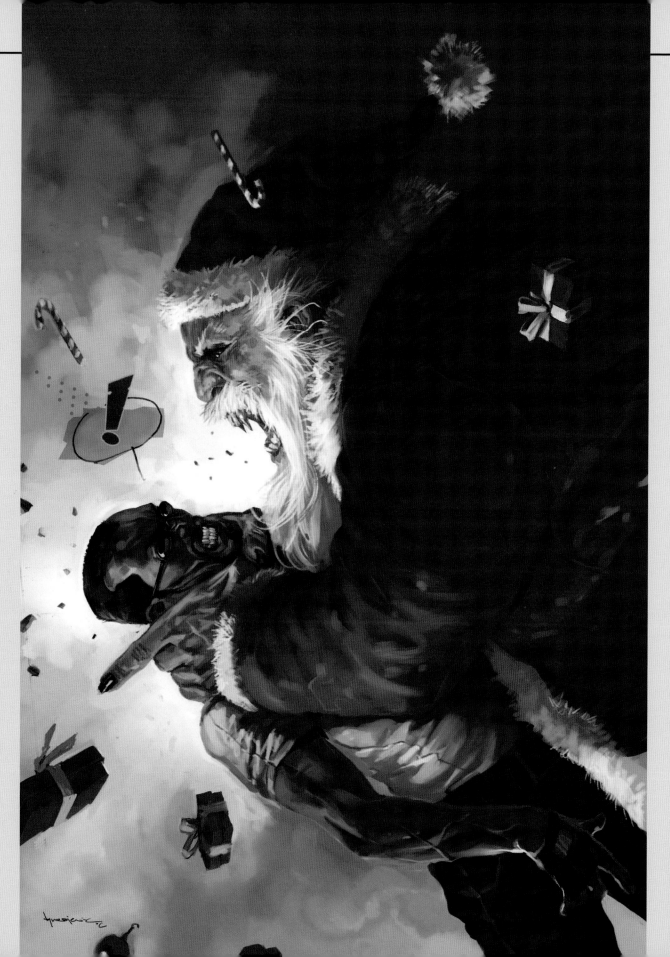

"*Blade* was a case where everyone was open to have me try out different ideas and approaches on it. And I think if you look at the whole vampire thing behind it, it's very macabre, very morbid. So you're already set up for what the covers would be like: When you deal with vampires, it's all about debauchery and crazy violence and sexuality. Those are attributes you can really play off of."

"This one ended up being such a success in terms of what the fans thought about it, but I really didn't expect it to be such a hit. It was an issue that featured Wolverine and Blade, and since they would be fighting I tried to come up with something that was easy to paint and didn't take too much time but still had a storytelling effect behind it. Since both of them are invulnerable, I was thinking, 'Man, I can just pop the claws through Blade's head and that becomes the initial image, then take the mirroring of Wolverine's face in his sunglasses, and I've got the cover done in no time!' It was such a timesaver. I was trying to capture that moment where Wolverine realizes that the guy on the other side is not dead. Those five seconds of realization really made it for me. That is, I think, the point where the cover really sold it."

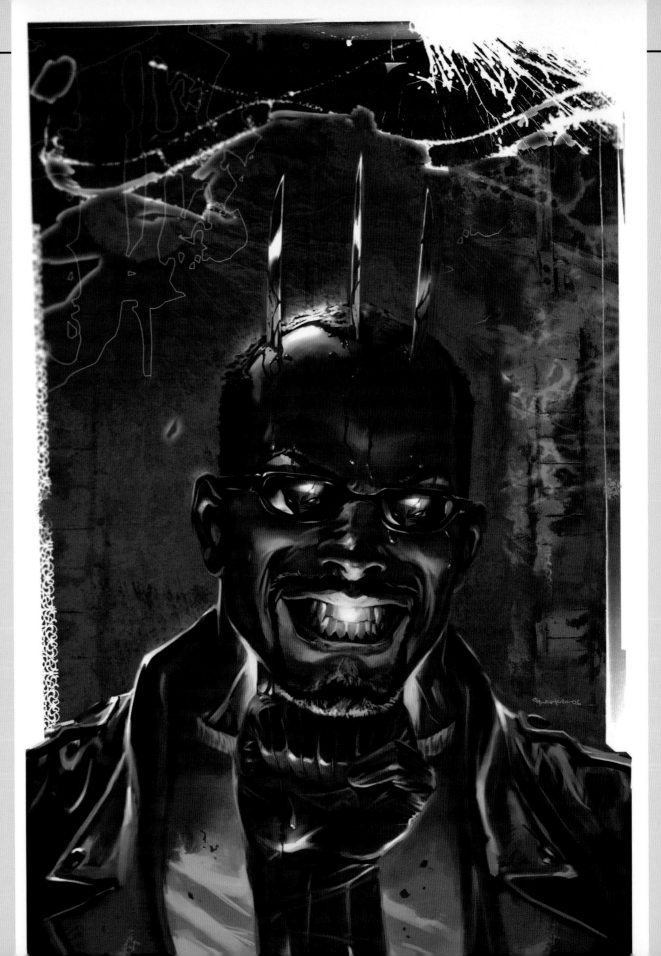

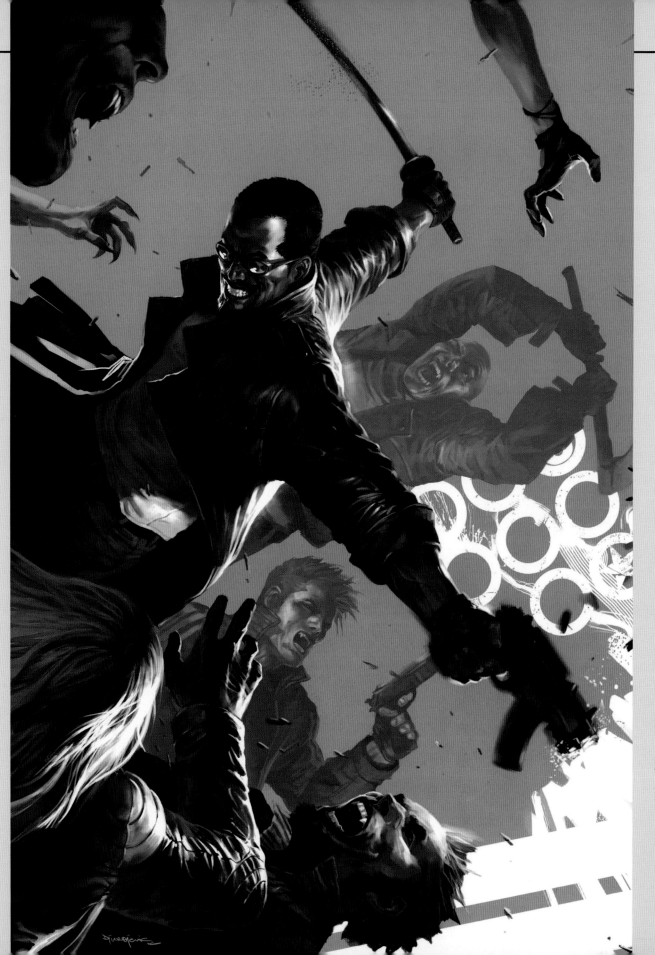

"This cover still is really one of my absolute favorites. I really love it from an artistic *and* graphic art standpoint. It's more about the color choice – the fact that all the figures are grayscale against this pop-arty orange background that just screams at you. I love it the most when I come to an image that I know will stand out on the racks. No matter how many other awesome covers are next to it, no matter how many Alex Ross covers you put next to it, this cover is gonna stand out just because it's so simplified on the color level. And it has the juice behind it.

"If it had been colored realistically, it would have been just another action piece, and that's something I shy away from. I'm not having any fun just repeating myself.

"The park bench sketch was the initial attempt, but the editors asked me to do something more generic. They always want a generic cover at least once every six issues so they can use that as the cover for the trade paperback. Everybody loved the park bench scene, but they just couldn't use it, so it never ended up being made."

"As far as ideas generated, the Blade covers are some of my best work for Marvel. But this is always hand-in-hand with how much freedom you have – when the editors are really open to you delivering whatever you want and you're pretty open to come up with great stuff. If you're limited in what you can actually say, the outcome will never be as great."

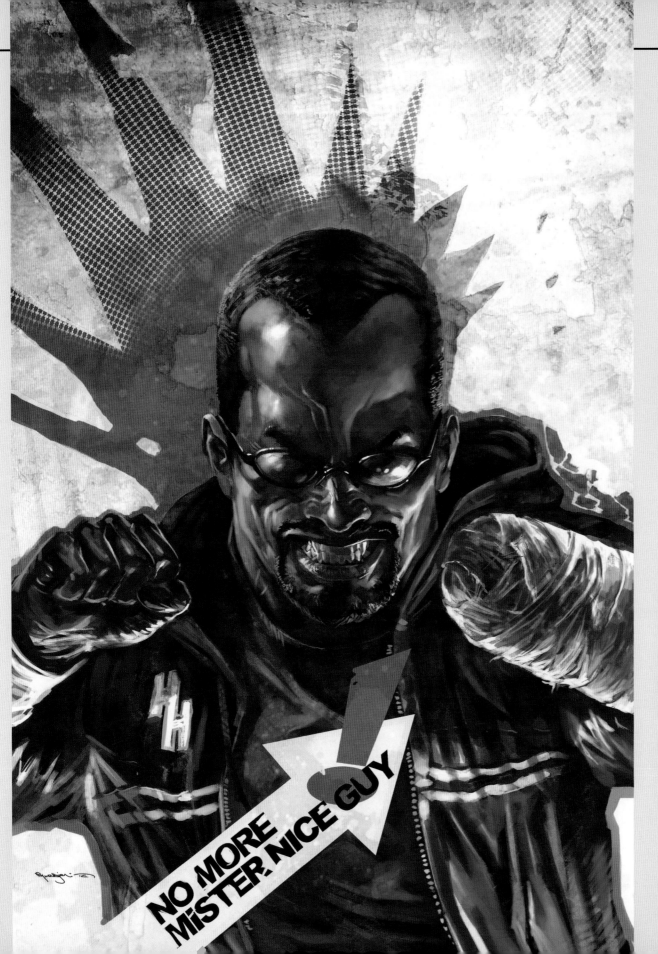

NO MORE MISTER NICE GUY

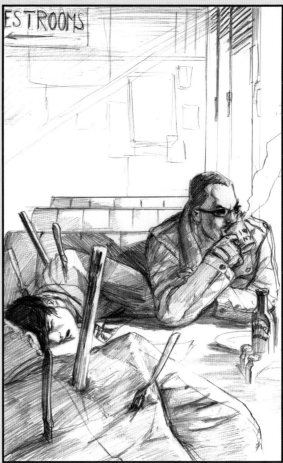

"For me, graphic design is a great solution to storytelling. I really don't think you need to explain everything in the picture by rendering it out nicely. I think that's what a six-year-old would do. I think you can come up with easier, far more readable, far more interesting solutions if you let graphic design into the mix."

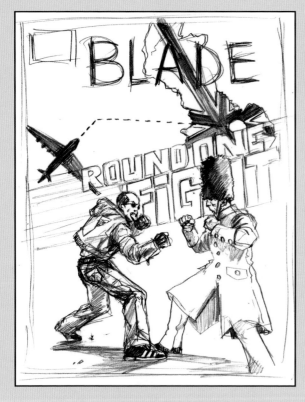

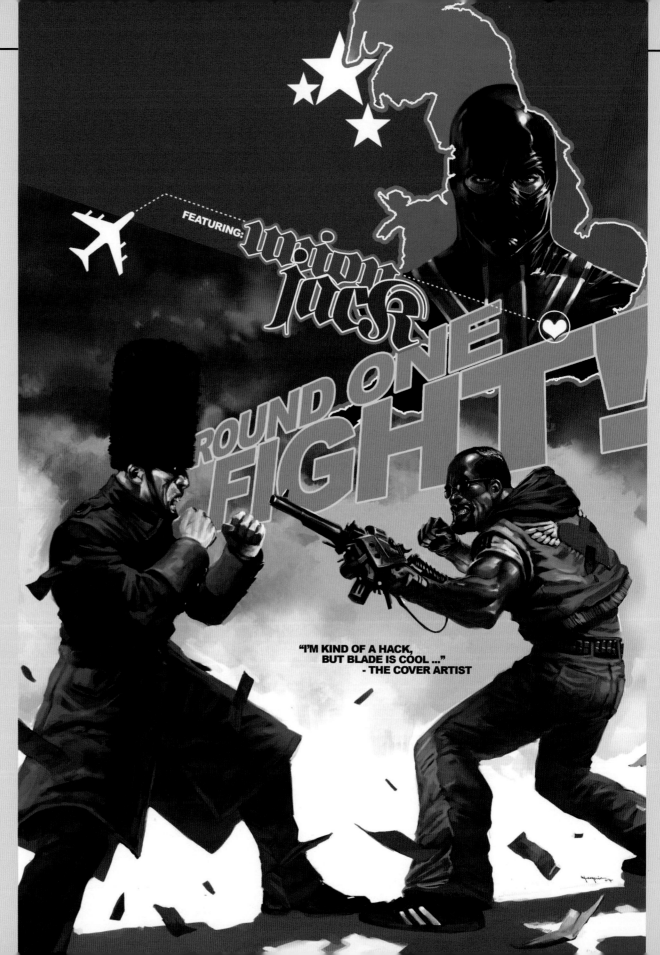

FEATURING: Union Jack?

ROUND ONE FIGHT!

"I'M KIND OF A HACK,
BUT BLADE IS COOL ..."
- THE COVER ARTIST

"This is also one of my favorites because the design includes the entire story. I managed to put the entire premise of the story on there and also managed to make fun of myself. In that issue, Blade is traveling to London in search of his father, and he gets into a fight with vampires at Buckingham Palace. There are many design touches: on Blade's jacket, there's the heart with the stake that goes through it (instead of an arrow)…the type above it which says "Round One: Fight" to push the *Mortal Kombat*-type pop culture… the pictogram of the airplane flying to London which implies the team-up with Union Jack…the simplified version of Great Britain in the background. All of that really played together so well and I was so happy with the image.

"As for the 'Hack' blurb, at that time I was browsing a couple of online message boards and people were calling me out as a hack because I was using graphic design and I wasn't painting my backgrounds fully. And I thought, 'Okay, that's the perfect thing to put on the cover. If people are that stupid that they claim I'm dodging the painting of backgrounds by using graphic design as a storytelling method, I'm just gonna slap that blurb on there and leave it as it is.'"

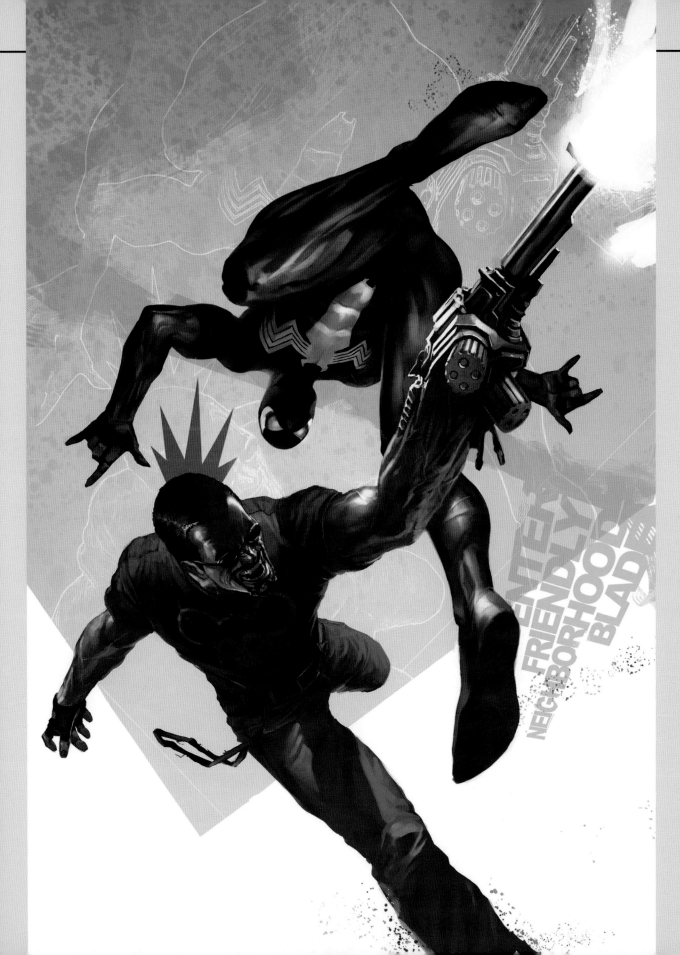

A COMIC BOOK COVER THAT TRIES TOO HARD...

FOR BEST RESULTS PRINT ON TOILET-PAPER

"Sometimes I find the funniest posts online about my work. It's just amazing. For example, people write, 'I really like his drawings but his colorist sucks!' What the #*$@? I don't even have a colorist! It's all me. Get informed. Read something up about me before you make a comment like that. People make up the worst stuff just to tear somebody down. But I can't take it seriously. I just smirk every time I read something like that."

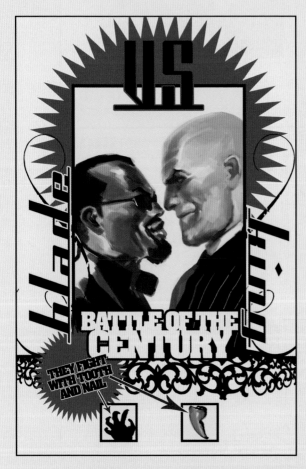

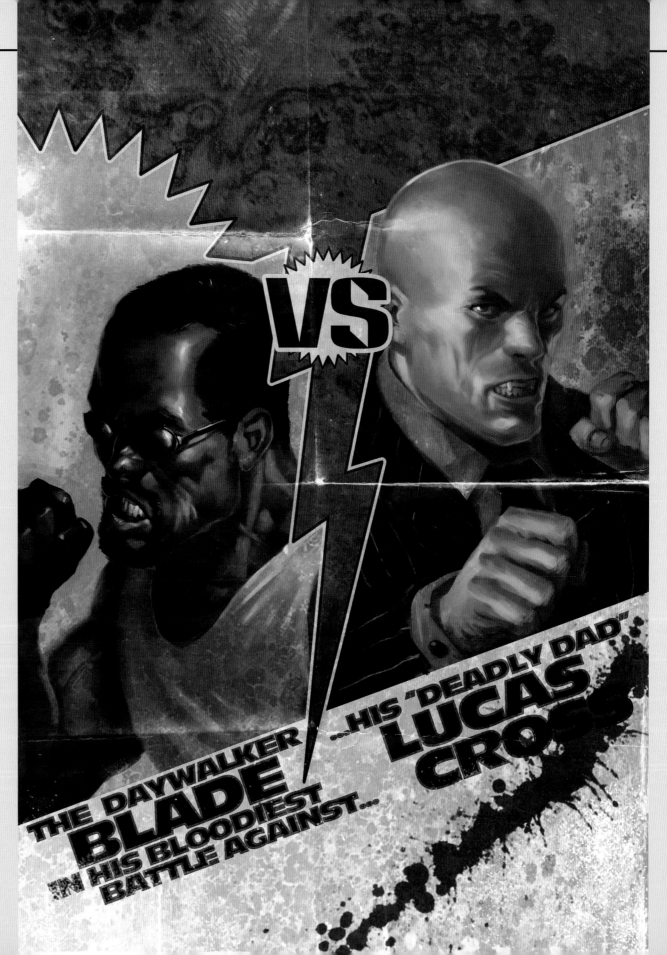

"*Blade #11* was the next to last issue. Blade would be going off against his dad, the entire series was building up to that point, and I said, 'Okay, let's just do it. Let's just take the boxing route.' To say, 'This is the final match in the entire bout.' That's what sold the book. If I would have just shown Blade literally beating up his dad, or his dad beating up Blade, it would have just been another fight cover. And I think that it's my job as an illustrator to come up with different ideas for the same theme."

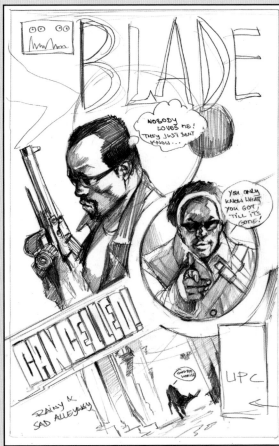

"*Blade* was one of my first regular gigs that I had. It was great because every week I would paint an *X-Men First Class* cover – which was for all ages – where I had to knock out a cover that was nice and appealing to children. But at the end of the week, I could start on *Blade* and just get all my frustrations out again! I guess that's probably the biggest contrast in my work: If you look at those two gigs – which were done at the same time – you can realize how big the spectrum actually is."

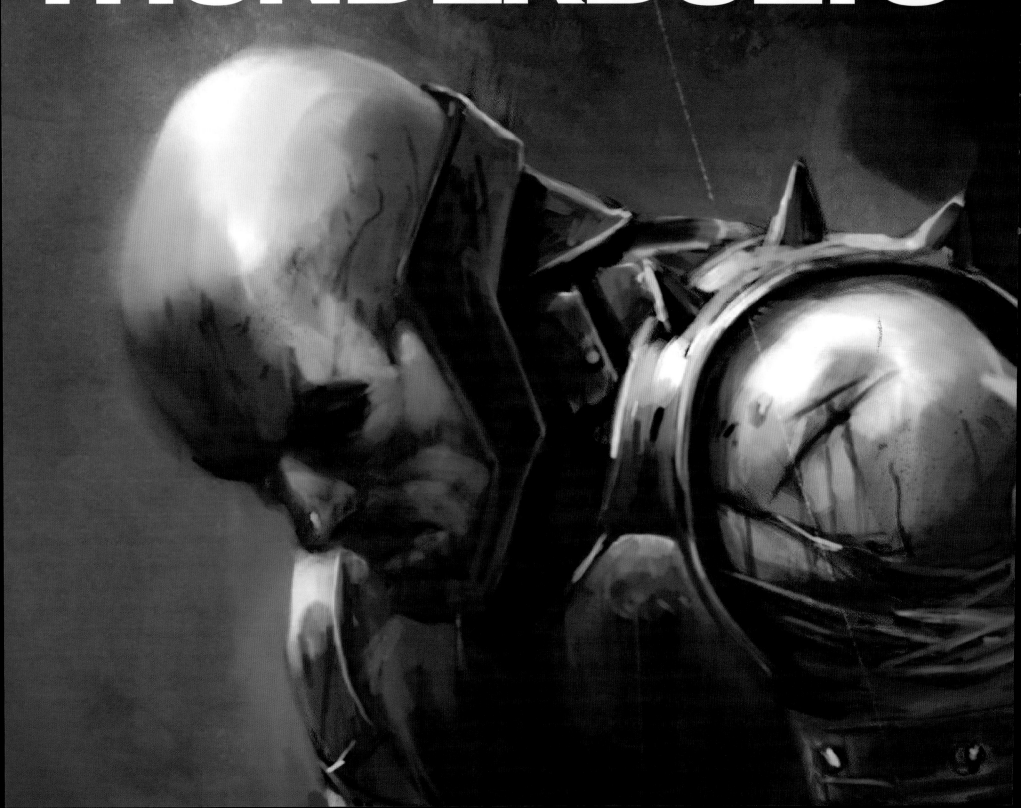

In the aftermath of Marvel's Civil War event, Warren Ellis revamped the Thunderbolts – an ad hoc team of erstwhile bad guys seeking redemption and their country's good favor – into a government-endorsed rabble of inveterate villains encouraged to play the system as registration enforcers. But no matter how good players like Bullseye, Venom, Swordsman and Moonstone think they are – and they are good – they could never hope to outwit the cunning team leader Norman Osborn. (That didn't mean they wouldn't try.) Leading the team into an unending trip of missions steeped in hallucinatory violence and mayhem, Osborn knew the weak points of each character and exploited them like the master manipulator he is.

In truth, the Thunderbolts only equal during Osborn's tenure may well have been the cover artist. During a stellar 16-month run, Marko Djurdjevic balanced T'bolts covers with insightful character studies and a riot of colors – producing works that were either calmly contemplative or gleeful in their abandon. It was a series where Marko really made his mark. Coulda made it as a Thunderbolt? No…he's too good for that!

MARKO: "Much like *Blade*, this was a very dark book that really suited my tastes. The book's editor, Molly Lazer, sent me the first scripts, and I was amazed how well they were written. Then I found out it was written by Warren Ellis, and I wasn't that amazed anymore – that's the kind of quality you expect from a good writer. It had such a nasty, gritty tone and the kind of twisted humor that I like. It really inspired me. As long as I worked on *Thunderbolts*, I was having a total blast, approaching my work with enthusiasm and a real sense of pleasure."

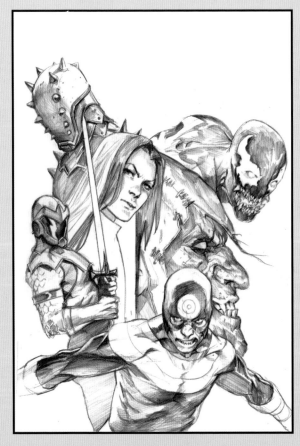

"Most of the focus here actually went into Songbird, who is the central figure. I put a lot of love into her pink hair and muted the colors around her so she would stand out the most. Of course, like most first covers, it's just a simple group shot, a character montage that doesn't really push the story aspects. I was pretty much bound to my limitations here."

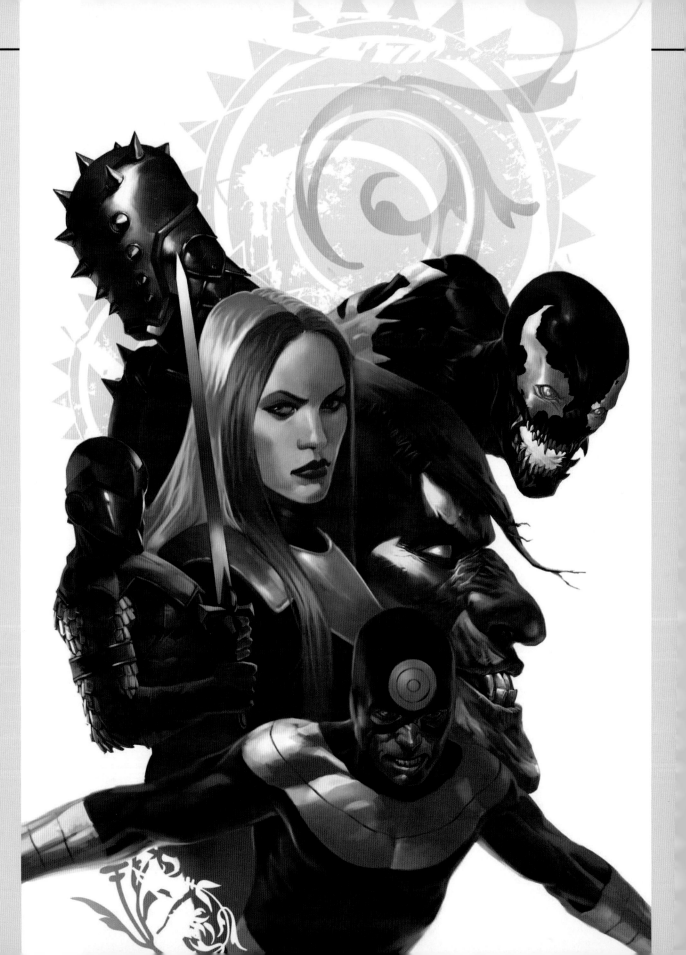

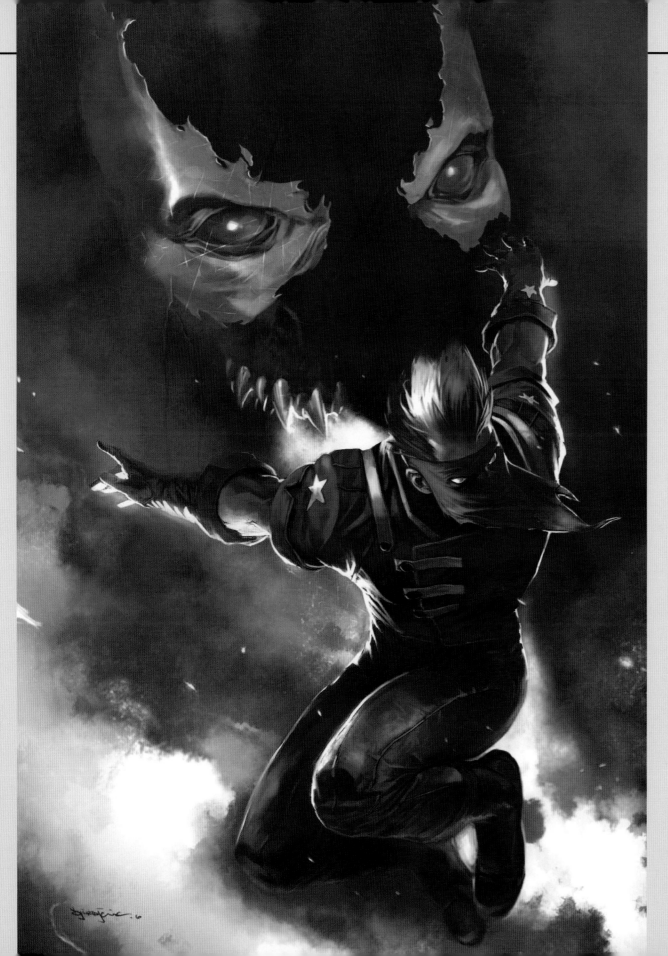

"After last issue's static montage, it's already a completely different attitude. We have Jack Flag, a character who's going to get seriously injured in this issue, running away from the threat of Venom. I wanted to give the impression that Venom is appearing in the clouds, a sense of omnipotence, that he's larger than life, even though his appearance in this comic wasn't that big at all. But it really emphasizes the danger that is approaching Jack Flag. He's just a small figure on the page about to get swallowed up by something so much bigger than he can ever hope to fight."

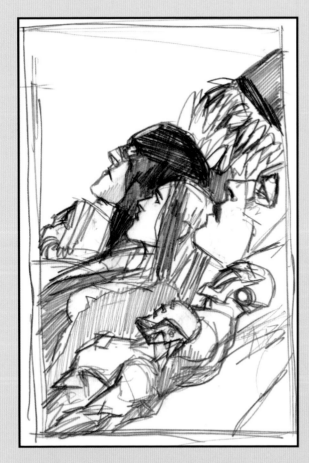

"My entire approach to comic books is through fine art, if you want to say it like that. Most of my covers take an artistic approach; they have an underlying symbolism to them…"

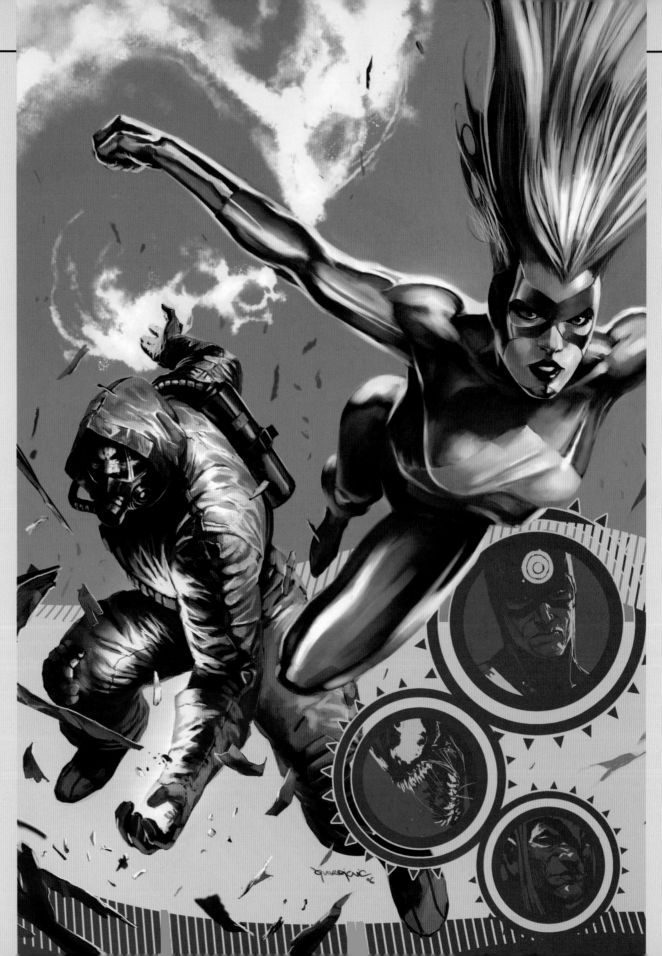

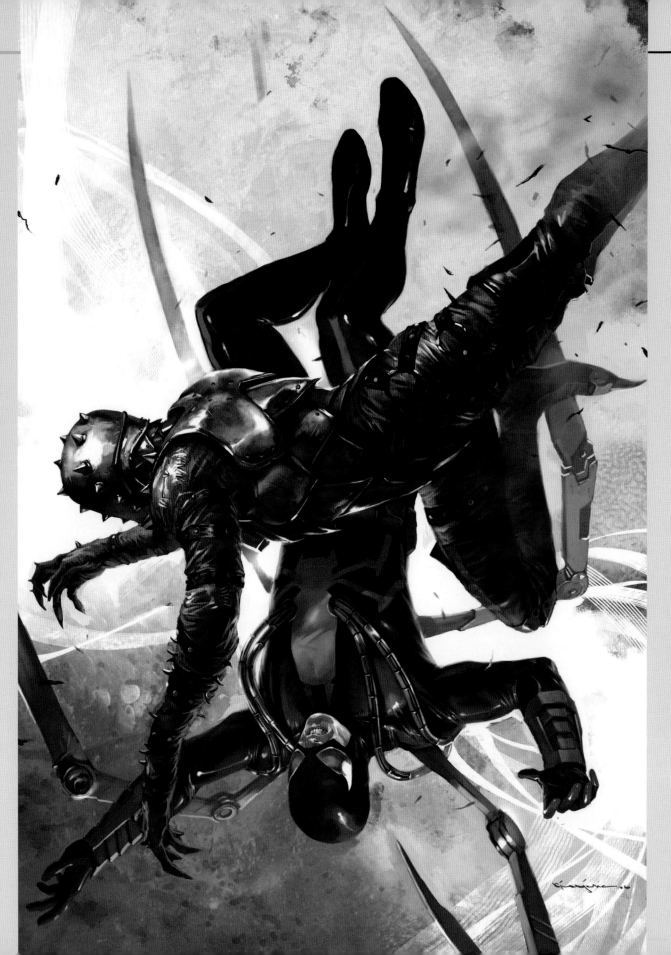

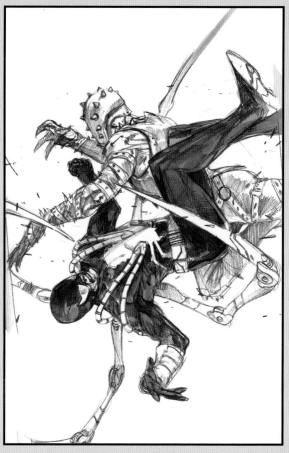

"…It's rarely about the super heroes themselves – they're something that I try to push into the background as much as possible. The super hero just becomes an actor helping translate the story that I'm telling through mood and atmosphere. They could be replaced by any other figure and the cover would still work."

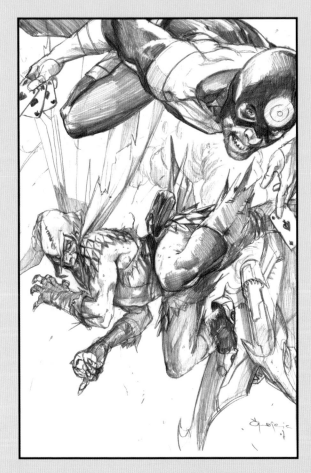

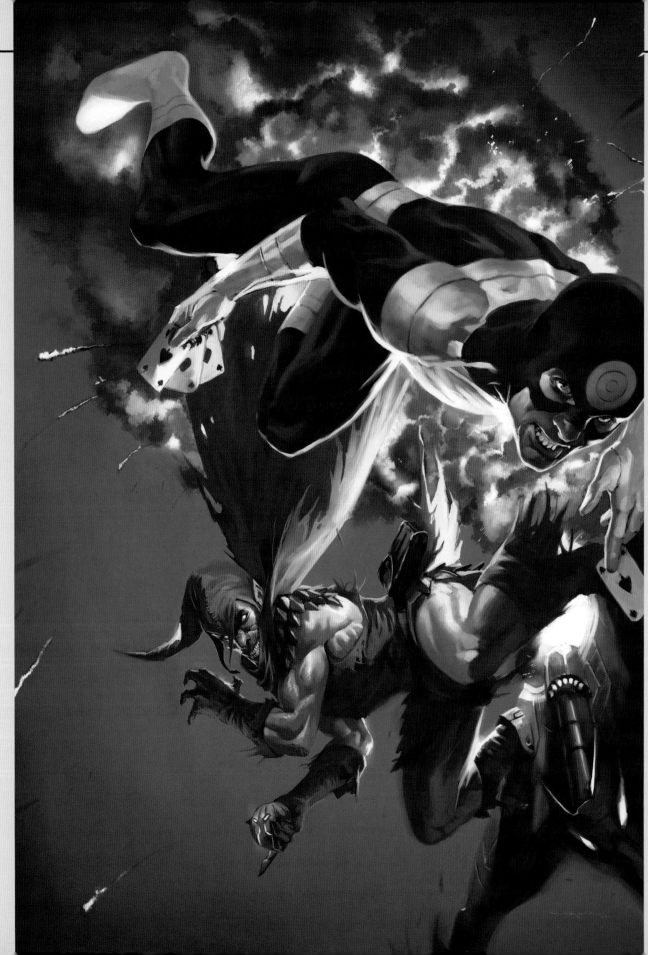

"Sometimes covers have nothing to do with what happens in the book. They may just be created from ideas that the editors throw at me, ideas that often inspire me to craft strong imagery. This works on a very simple level: If after hearing a name or a description of something I am to draw, I have an instant enthusiasm for the subject matter, I feel like I'm going to turn out better art than if I'm working off a description that doesn't hit me from the get-go."

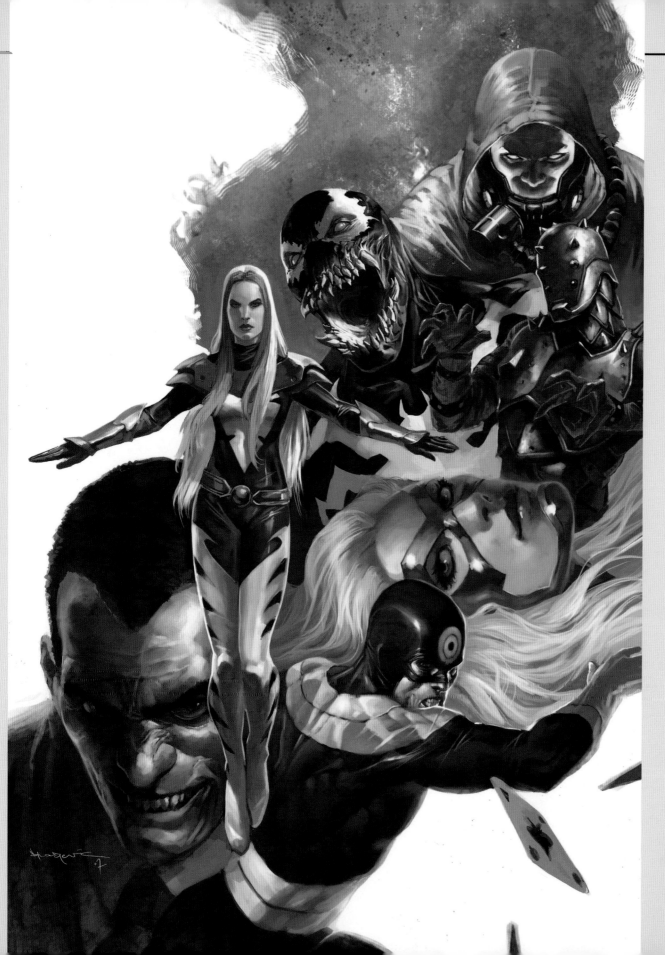

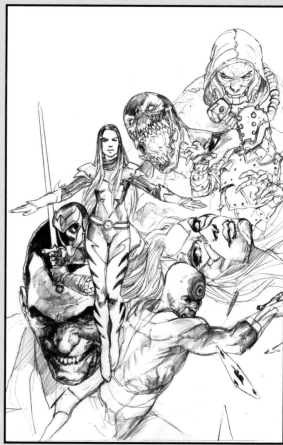

"With *Thunderbolts* – as with any team comic – sometimes you must do the 'classic group shot.' But if you look at this series as a whole, it combines all the things that I like about being a cover artist. I really like how big a spectrum I have with each of these covers. I can cover so much ground – from abstraction, then to realism, and then going abstract again. I always wanted to make something that was going to stand out on the rack."

OCT
07

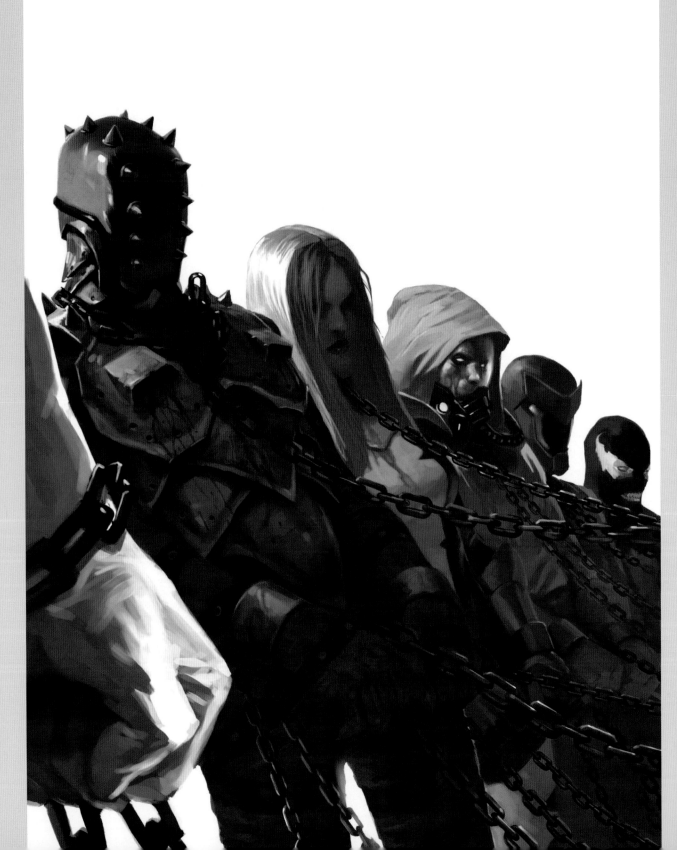

"This was the beginning of Warren Ellis' second arc, which was titled 'Caged Angels.' I knew it was supposed to be about more government pressure being applied to the Thunderbolts, but that was it. I feel chains to be such a great, symbolic item to use when you paint something; you can strip all pride away just by placing a chain on something.

"While in the first arc they were screaming, over-the-top 'heroes' who were flying around, being shiny and glorious and battling unregistered heroes, I wanted to take it a different route and show how much like children they can look just by putting those chains on top of them. Standing them all in a row, tilting the perspective slightly, making it seem even more hopeless – while at the same time more dynamic – and showing that they're, in fact, just slaves for the government."

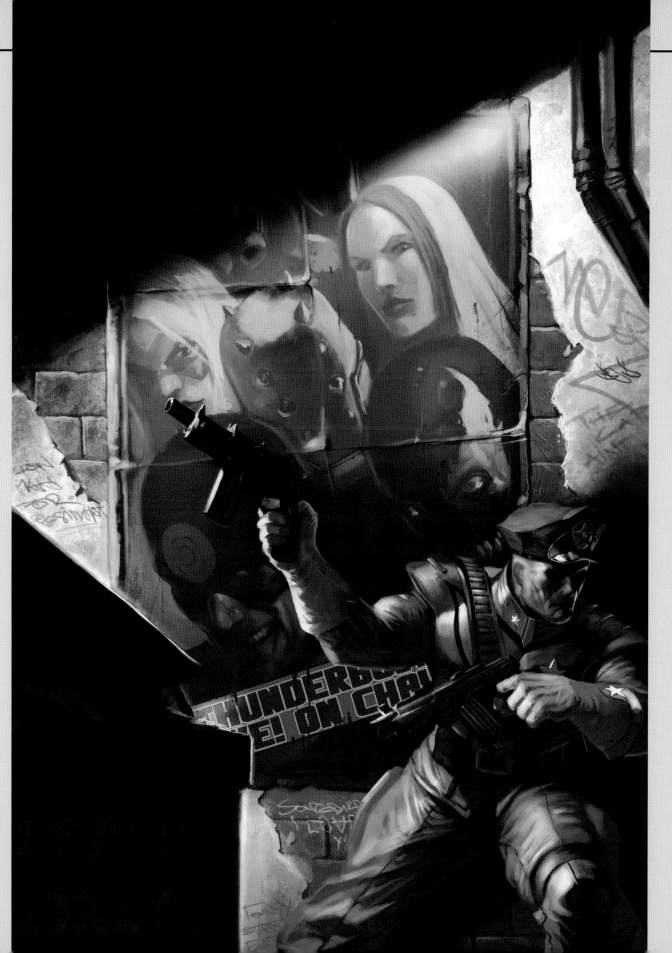

"In this one-shot, the Thunderbolts were after an old, D-list character named Americop. I remember I got reference drawings, and I couldn't even make out what his costume looked like; I really got a headache over that. But to me, the nature of this character is that he doesn't really understand the world around him, because he's one of those exaggerated characters that talks to himself. That inspired me to put an emphasis on the part of the image where he is completely ignorant that he's being watched. I did that with the poster, placing all the Thunderbolts on the wall looking down on him, basically following him around through the eyes of the poster. He's completely oblivious, already in a trap."

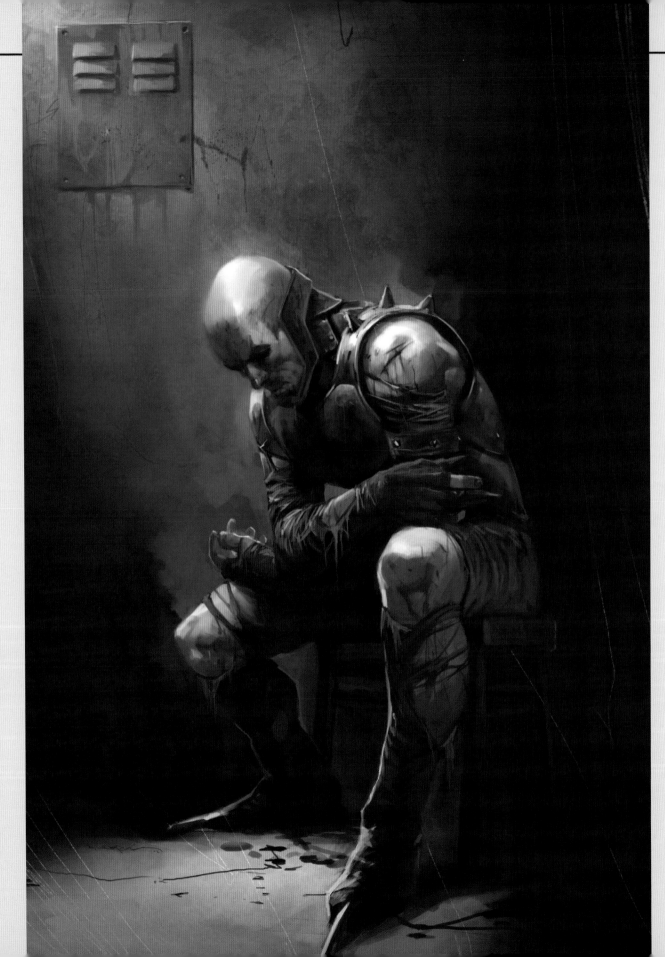

"In this case, I thought it was very exciting to get the chance to show a super hero in a broken position, sitting in his cell. I think it's something that you don't see a lot in comics.

"The element of realism is something that is really important for me as an artist, and I think real world situations should be applied to super heroes in the same way as they apply to us normal human beings, because that helps to make the super hero more grounded, it helps the suspension of disbelief and the relatability of the imagery.

"In my mind, I think I would have the most fun showing beaten-up super heroes riding home on the Metro, nursing their wounds after a big fight. I think I could paint that for the rest of my life and be happy! So with a situation like Penance sitting in his cell, having this shredded costume on, being all bloody and curled up – it really developed a lot of that kind of emotion for me; it was a very intense picture for me to paint."

———————

"I really love this one because it evokes elements of the classical masters. It's really simple and really powerful. The lighting, the composition, the stark room, the body language and expression all evoke the weight of the desperate situation Penance is in. A really great piece of work." – **Chris Allo**

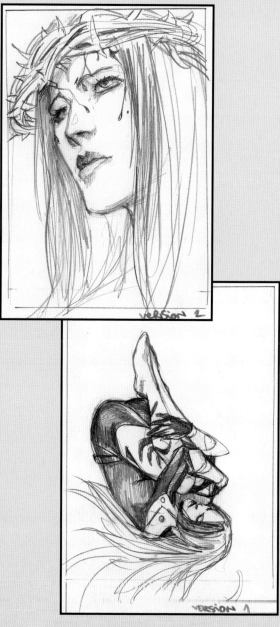

"This was an issue about Songbird being under constant attack, being forced over the edge, trying to defend her position within the Thunderbolts – all while Moonstone is blackmailing her. I knew I had to figure out a body language for that because just showing Songbird standing in the corner and crying is not going to sell the book.

"Thematically, I have placed Songbird in a womb, a fetal position in which Moonstone glares over her, seeming to have her life under her thumb. The pink diagonals represent the heartbeat readouts of an electrocardiograph monitor. The womb-like position, the tight focus of the circle around her, and the proportional size of Moonstone in the background was my way of producing a feeling of pressure, a feeling of external danger."

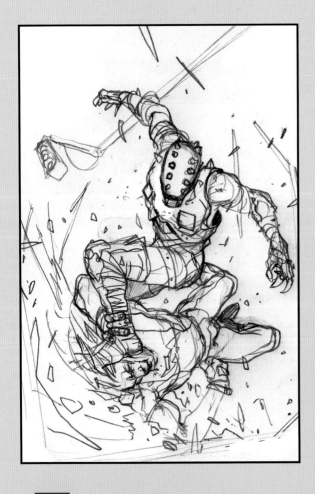

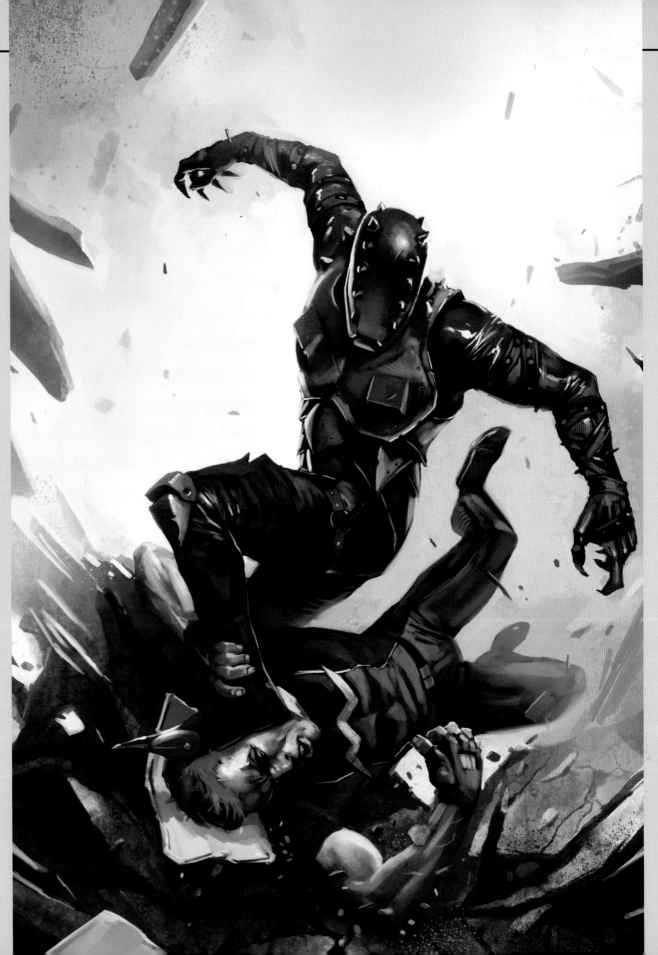

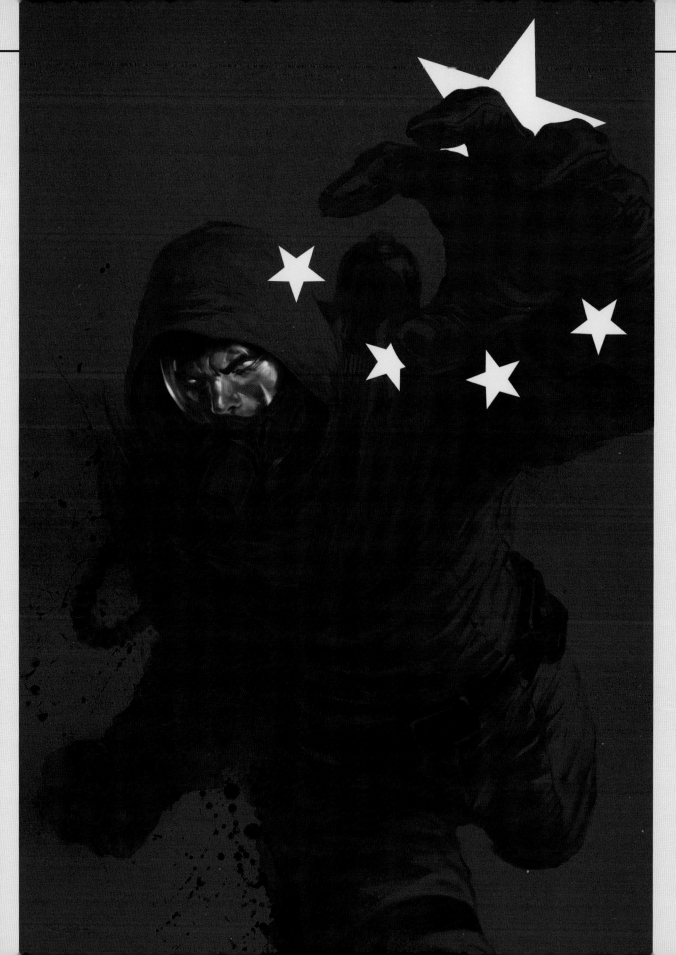

"A couple of things were really interesting for me with this design. I wanted to make the character part of the flag. At the same time, I wanted to make him reach out of the flag, towards the viewer, to show that he's part of China, but at the same time he's coming for you.

"I tinted everything red except for his mask and the stars. The stars I couldn't tint because otherwise the identity of the flag wouldn't have been understood, and the mask I didn't want to tint because green is a complementary color of red. It's the strongest contrast between two colors that you can get, and the fact that such a small part of the image is green, and the rest is red just makes the green pop even more.

"The editors asked me to show Radioactive Man as the Chinese representative of super heroes in America, to show him carrying himself as an elite member of the world's heroes. That is why I wanted this cover to be iconic and have a lot of punch.

"I kept the entire right side very cleanly rendered, while the entire left side is broken up with sprinkles and splatters, giving the impression that it's all falling apart. This is a device I use a lot when I want to achieve a certain form of drama: using contrasting ways of approaching an image, like going from a neatly rendered description to something which is very sketchy and very loose. In this way, I can show the entire spectrum."

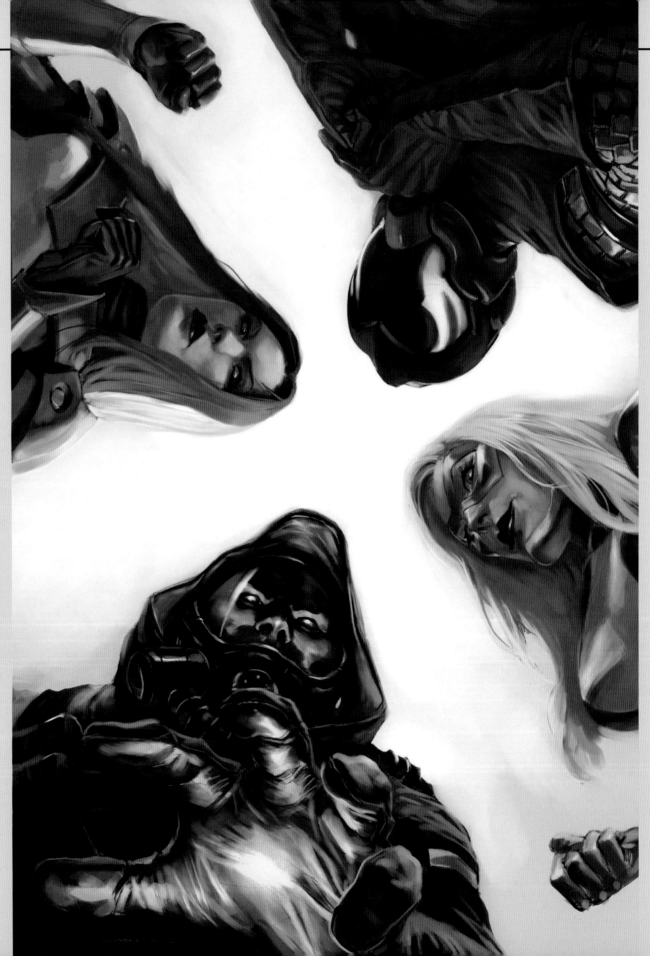

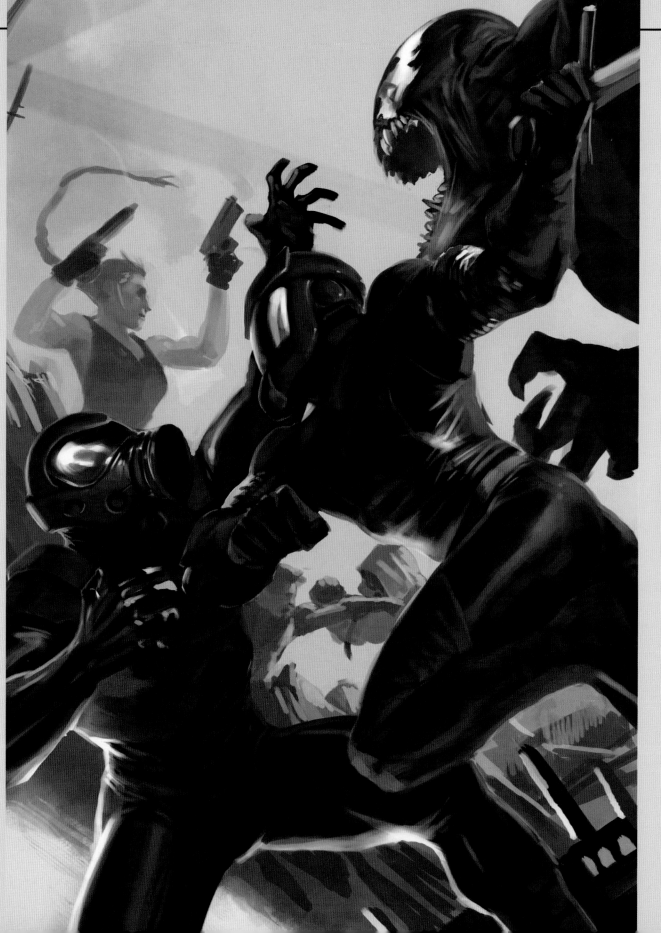

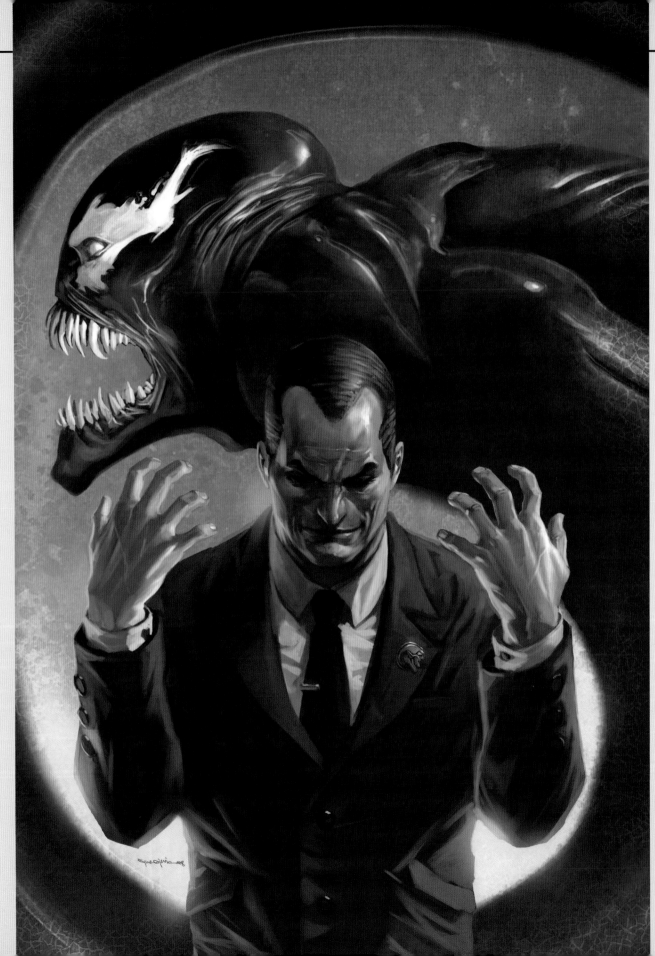

"If you locate the colors you want to push, and you know what you're doing colorwise, it can have such a nice effect. You truly have the chance to tell the entire story of an image with the way you use color. It's a very conscious decision for me every time I do it. I just try to come up with the right combination of colors that will sell the content for me."

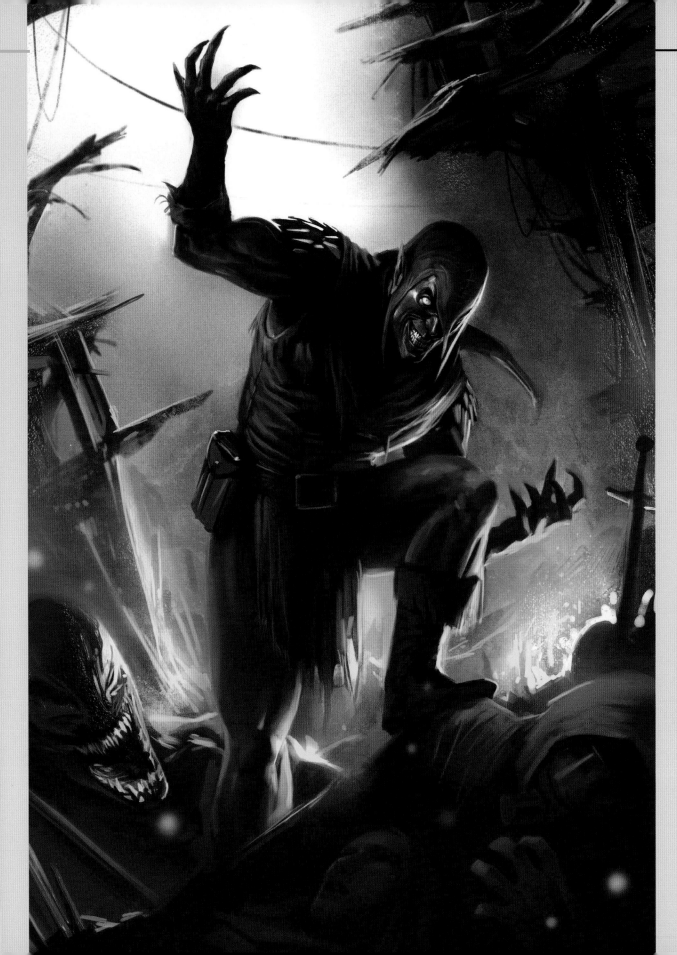

"Warren Ellis was leaving with this issue, his whole storyline coming to a conclusion. I only knew that Norman Osborn was going to go nuts, and there was going to be a lot of action, a lot of craziness in that final issue. With Norman turning against his Thunderbolts and heads rolling, I decided I wanted to describe the moment of the aftermath, the moment of 'crazy Osborn' being triumphant and standing on top of the heap.

"Again, I go for a contrast: It is a picture that is tinted in greens and is very muted in the way it's colored. But then you have his red hand, which is the strongest contrast in terms of color scheme, and it affirms the visual qualities of the story in the same way as the *International Incident* cover."

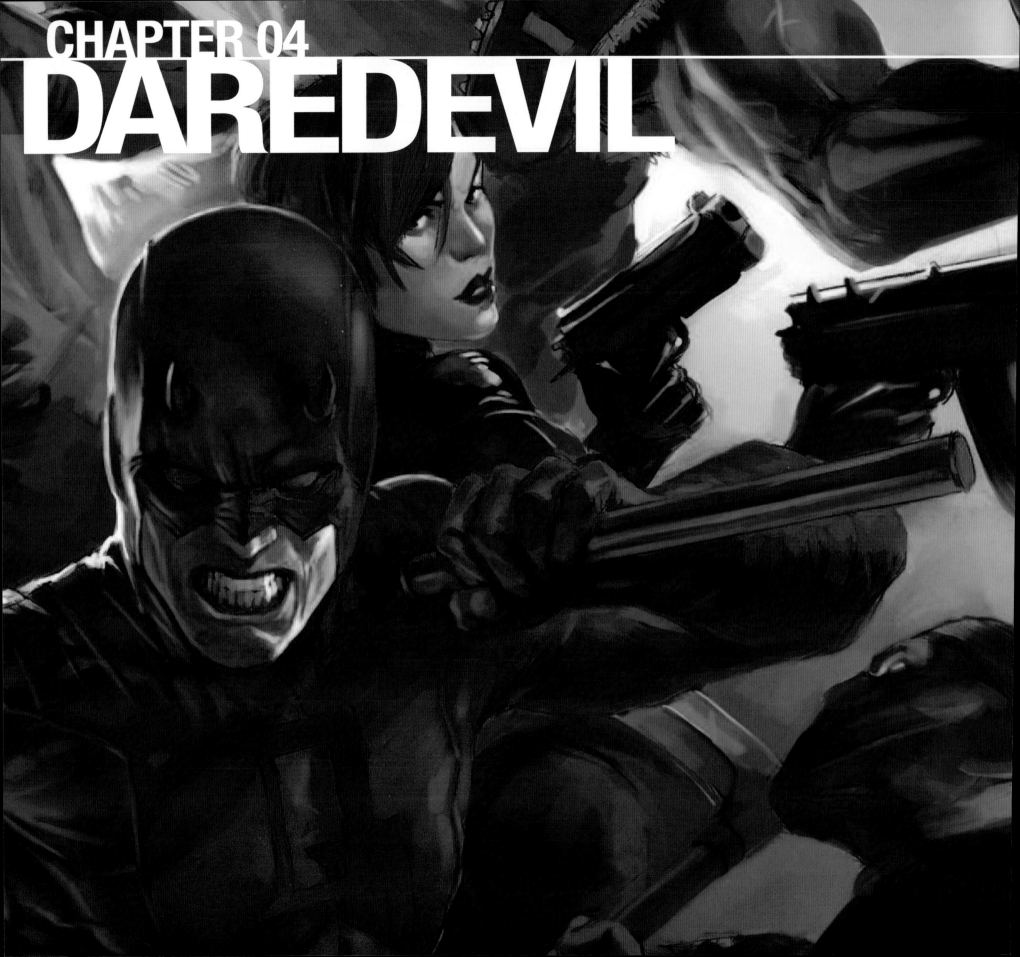

DAREDEVIL

If Thunderbolts *was Marko's breakout book,* Daredevil *is the title where fans first began certifying his star quality. Holding down the front covers of the Ed Brubaker and Michael Lark series, he formed the third part in a trinity of talents that helped further the evolution of the franchise that had, for the last ten years, been at the forefront of Marvel's latter day creative resurgence. Daredevil was also the first time Marko would work on a monthly basis with editor Warren Simons, establishing a relationship that to this day flourishes with a bond of mutual respect. As editor, Simons is charged with finding cover artists that can intuit the feel of the interior story and then translate that into both a creative and saleable piece of art. He quickly realized that in Marko, he had a winner – on all counts. 'He's trustworthy, he's fast, he's reliable, he's got a great understanding of art,' plus, Warren adds, 'he's a really sweet guy. That's a nice asset for any artist.' That's the kind of editorial assessment that'll get you regular work!*

With Daredevil, *Marko explored the murky darkness right along with the blind super hero, a world where Matt Murdock's super-powered sonar may deftly compensate for his lost sight, but it's always navigating his passage through the darker regions of his soul that requires a set of completely different senses. This run of covers features easily some of Marko's best work, and it's a run that he completes in 2009 with not only a great sense of personal satisfaction, but the unqualified esteem of his peers, especially his boss. Says Simon, "I've told him not to let it go to his head, but he doesn't know how good he is."*

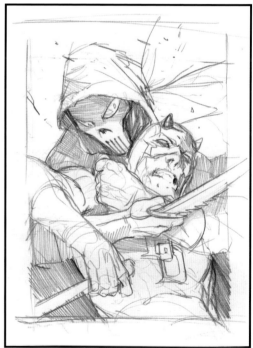

MARKO "I have a more personal connection with Daredevil than virtually any other Marvel character. He's a street level character, he's not super strong, he's blind, he has only one super-power and that's to navigate the world in his own blindness. Everything about him is very realistic. The comic worlds he inhabits are full of a gritty, film noirish atmosphere, where he's constantly attending to real world issues – far more than any other character out there. I've seen more stories of drugs and violence and depravity in *Daredevil* than in any other book. The feelings of loss and tragedy follow him no matter what he does."

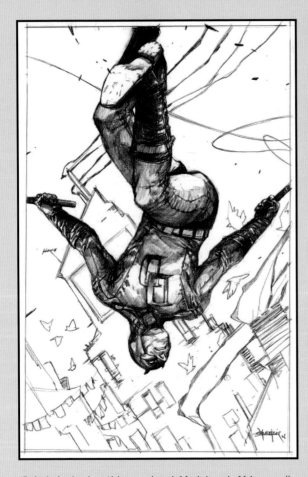

"I think there's a beautiful energy through Marko's work. He's an excellent draftsman, with a superior understanding of anatomy from a strictly rendering standpoint. There's such a fine representational quality to his stuff. He's also the kind of the artist that you wouldn't be surprised if he has an encyclopedic knowledge of art history, because the guy came to us almost as a fully formed artist with a comprehseinve understanding of perspective, anatomy, and composition. That's quite a combination." – Warren Simons

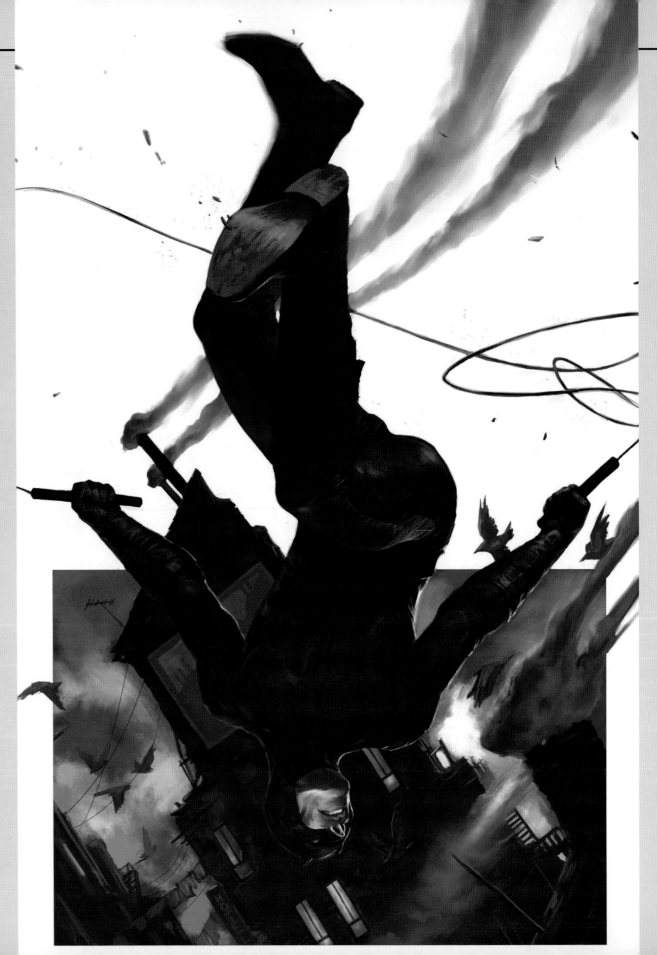

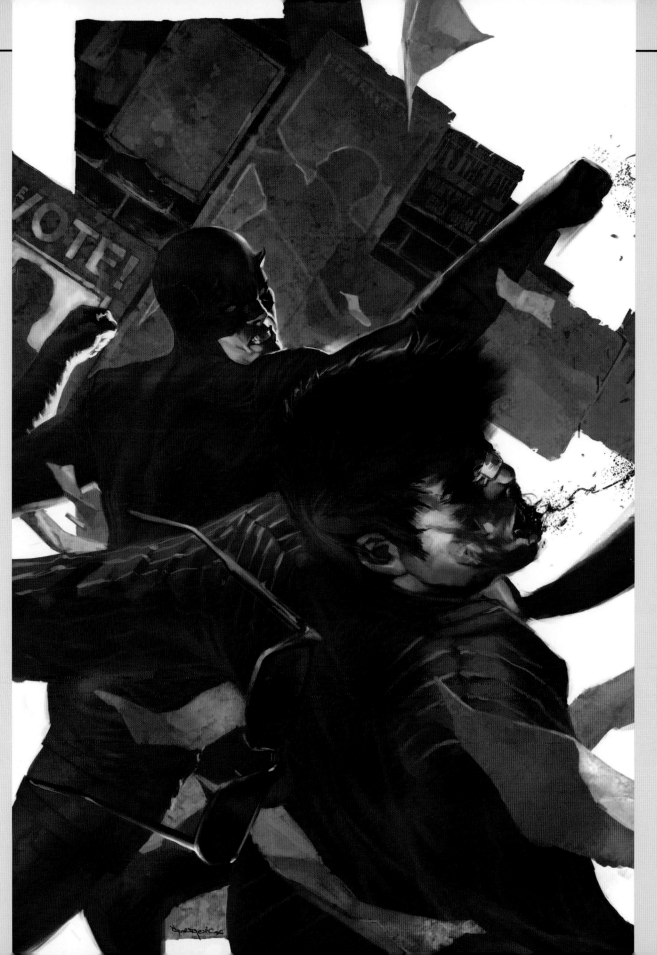

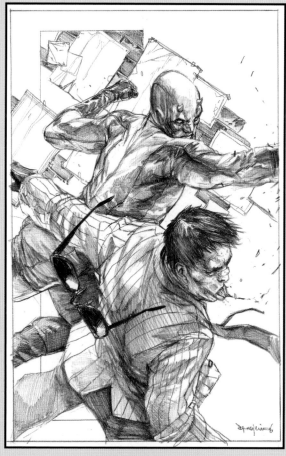

"As his editor, I also get a sense that he cares about the work he's doing. He cares to make sure that every single piece is going to be terrific. He's not a guy who ever cuts a corner, even if he's underwater. And that's just a very different mindset than a lot of guys have, as if he's aware that every piece of work he's doing might be framed and put up on a wall somewhere. He is creating art that will be around for a very long time; he's not rushing, he's really trying to put his heart into it. And that's also a huge thing for an editor like me, to work with a freelancer who cares about the process, who cares about what he's doing."
— Warren Simons

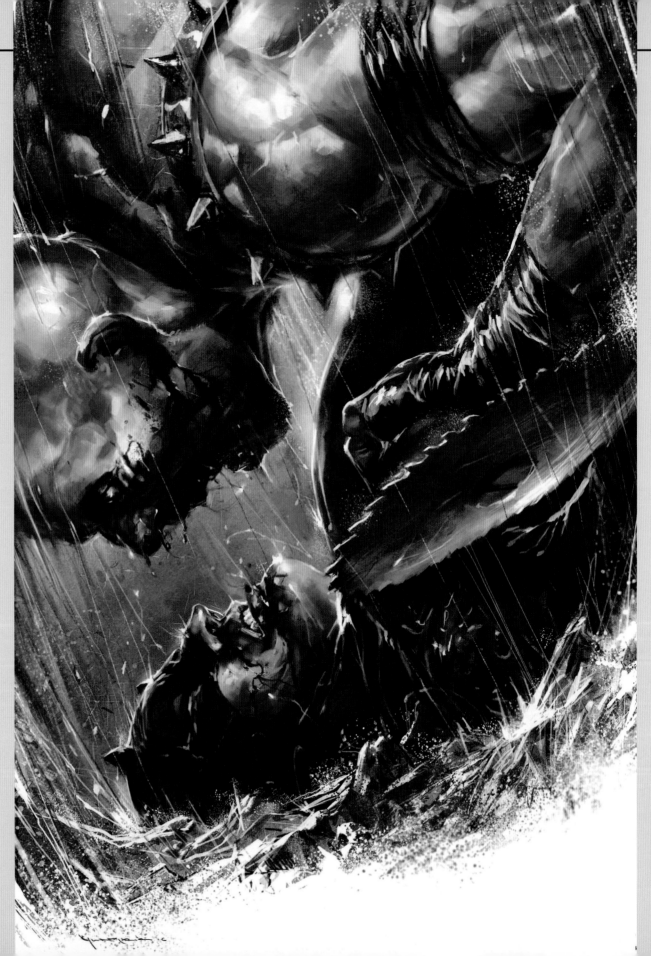

"Warren wanted me to design a cover and had no clear ideas for it, so I asked him if I could take a shot at something new. I sat down and sketched out this idea of Death playing the violin. I don't know how I came up with this concept – it just popped up in my mind. It was the first synapse firing that day. There was no real meaning behind it, except for it making a striking visual. Sadly, I turned it in, but it got rejected. Warren liked the other sketch I completed, which was a kinetic shot of Daredevil dodging bullets. That was approved for #98, and this sketch was never developed into a cover."

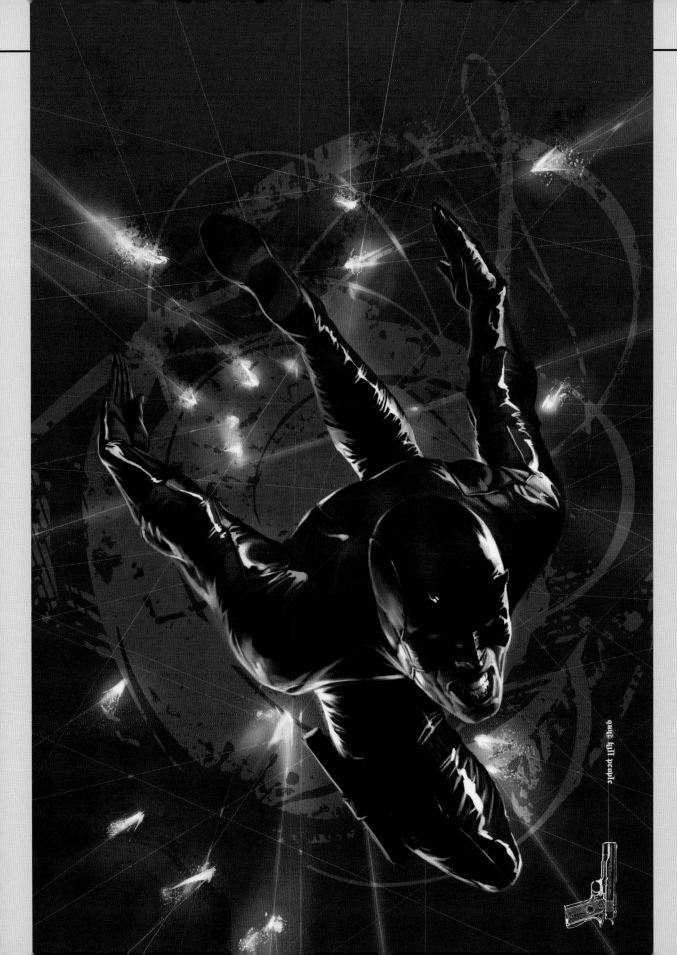

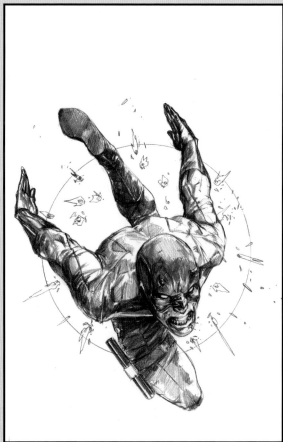

"Sometimes you look at Daredevil and the coloring will make it look like the guy has just been dipped in red paint and is otherwise naked. I would rather reveal his costume to have both texture and depth. I really wanted to give his costume the feel of something like a really super-tight leather or latex costume – the kind of material that would actually be a little bit thick to protect him when he's in a fight. With the nature of these costume materials, you can confidently go into the lighting and find form with it, instead of just making it red and flat and boring. That was my earliest focus when I was working at Daredevil: to really make a costume that works."

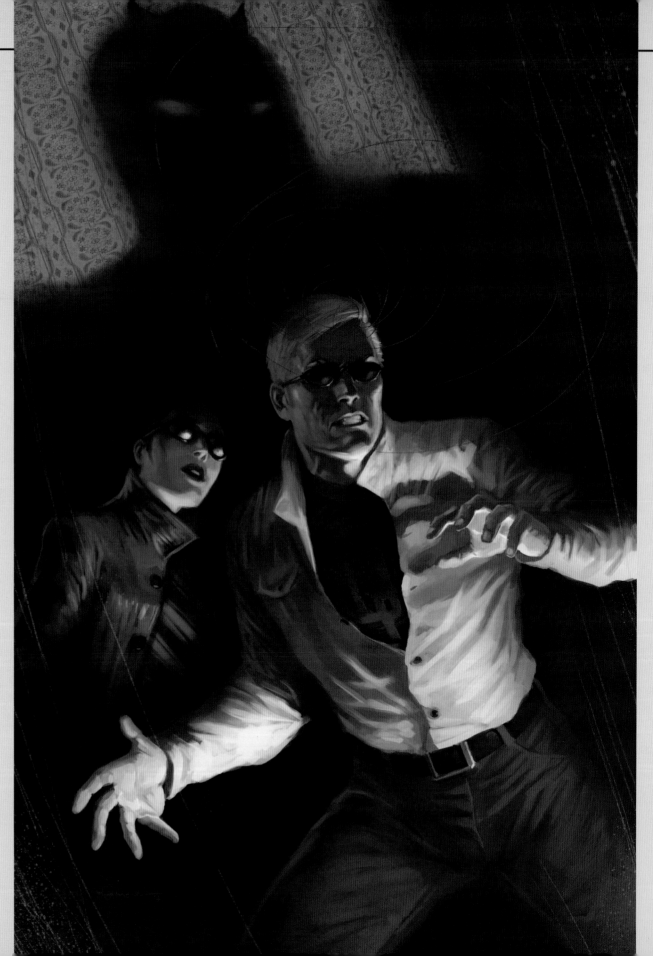

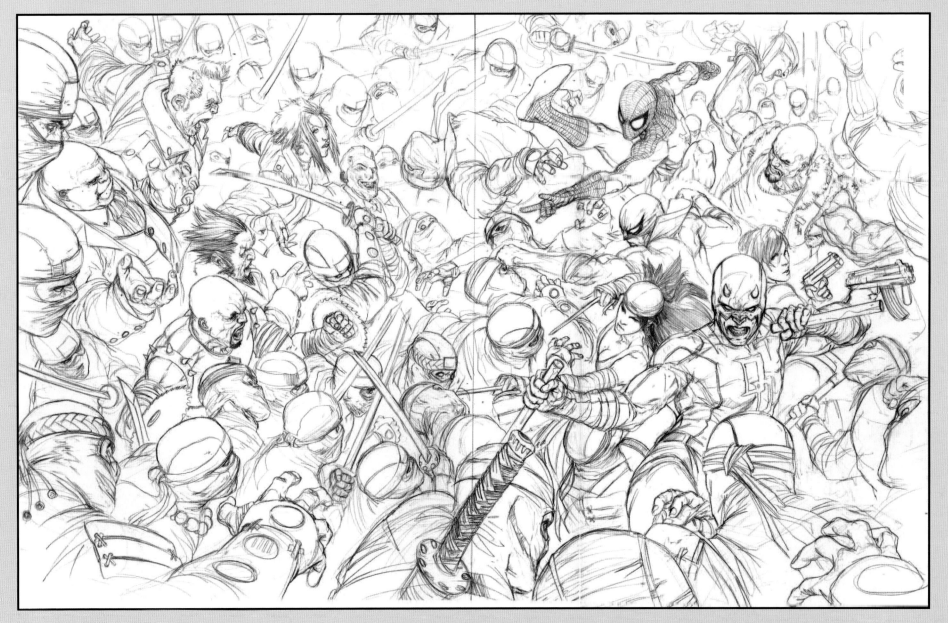

"There was a lot going on in this one. It was a real pain to complete, but it was actually a lot easier to paint than #500 was. Here, I employed a simple trick: I kept the majority of the image dark and illuminated it with a sole light source – Iron Fist's glowing hands. Through this I was able to define the forms really quickly and just give it a little bit of bounce lighting here and there. I think the tougher part of this painting was just accommodating the amount of characters in there. If you do a full count there must be thirty or forty characters in there. There are so many swords crossings, and bodies interlocking, so much overlapping. From a drawing standpoint, that's a really tough thing to put across, and from a painting standpoint even more so.

"Editorial thought it was a good idea to show all of Daredevil's opponents on one side and all his protagonists on the other side, with all the ninjas fighting down the middle. Artistically, it might not be the deepest or most symbolic cover I've ever painted, but it's definitely one that was a huge achievement for me in terms of adding sheer mass and getting that many characters interacting in one piece.

"If you ask me what my painting preference would be – a claustrophobic mass of bodies fighting and struggling or just the lonely guy in the alleyway while it's raining – it's definitely the lonely guy in the alleyway while it's raining. I can imbue a picture like that with so much more emotion and so much more story through adding direct and indirect details or just general atmosphere. A picture like this is very obvious, very in your face. There's no room for interpretation left – it pretty much says everything once you look at it."

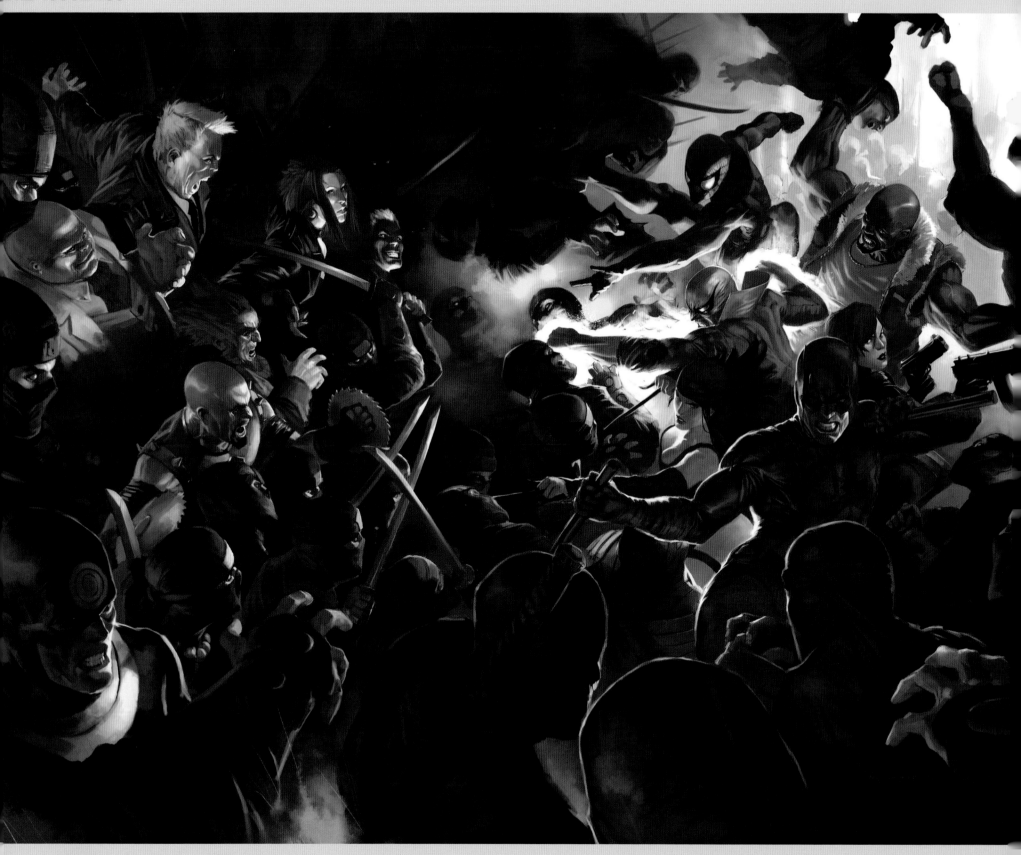

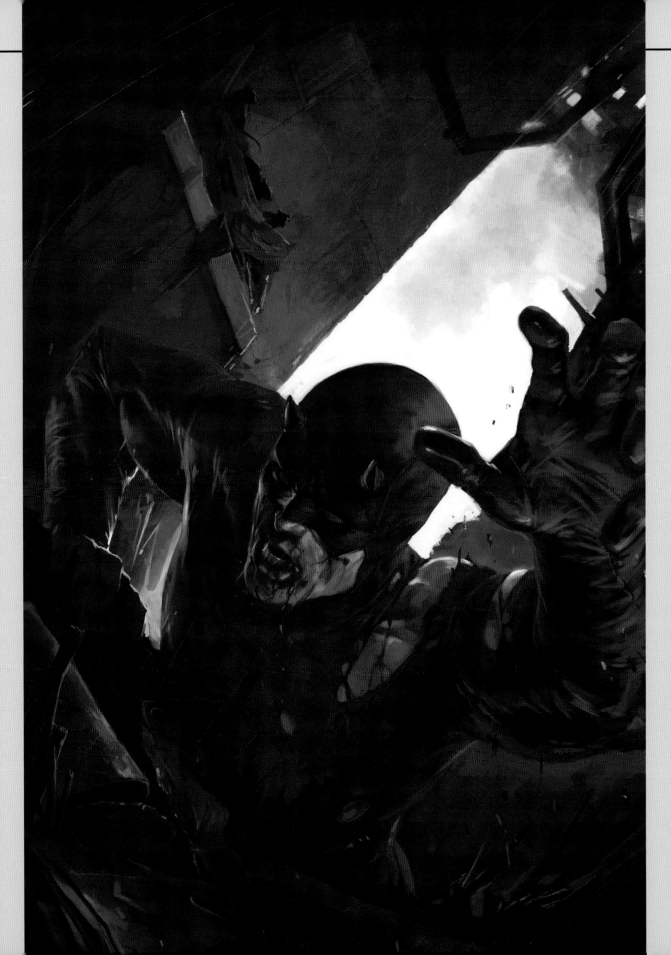

"This image is the complete opposite of #100. It's a simple composition of Daredevil being beaten up in an alleyway. Everything here – the posture, camera angle, lighting, and mood – was so much fun for me to paint because the subject matter was more personal. You can make a closer connection with the character because he's alone, you can put yourself in the situation he's in. As the painter, I've got to deal with that for the entire night while I'm working on it. To a certain extent, I put myself into the kind of emotional state he's in to be able to convey the emotion that he's feeling – which is being lost, being beaten, having nobody near that cares about you."

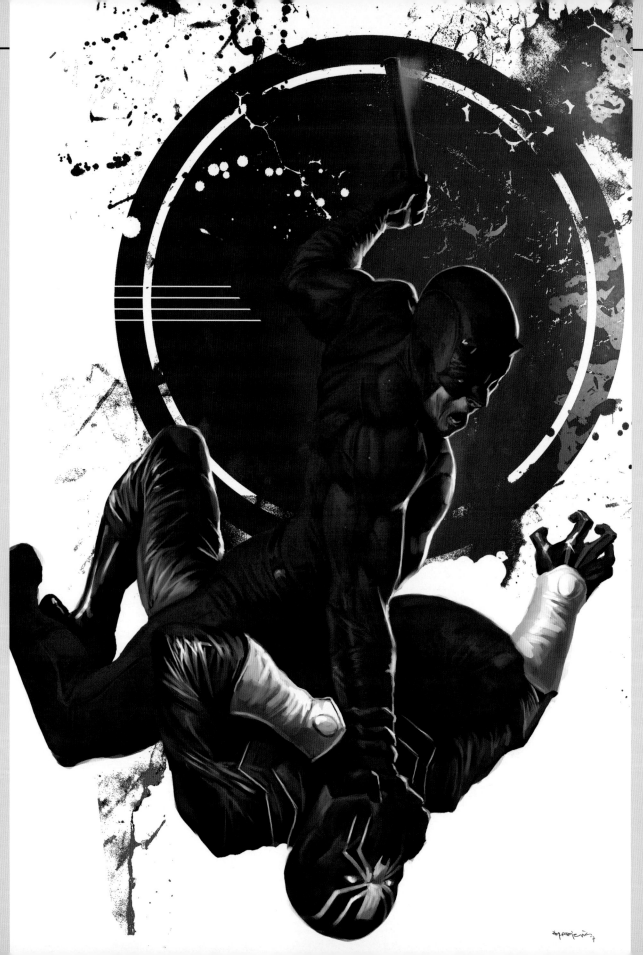

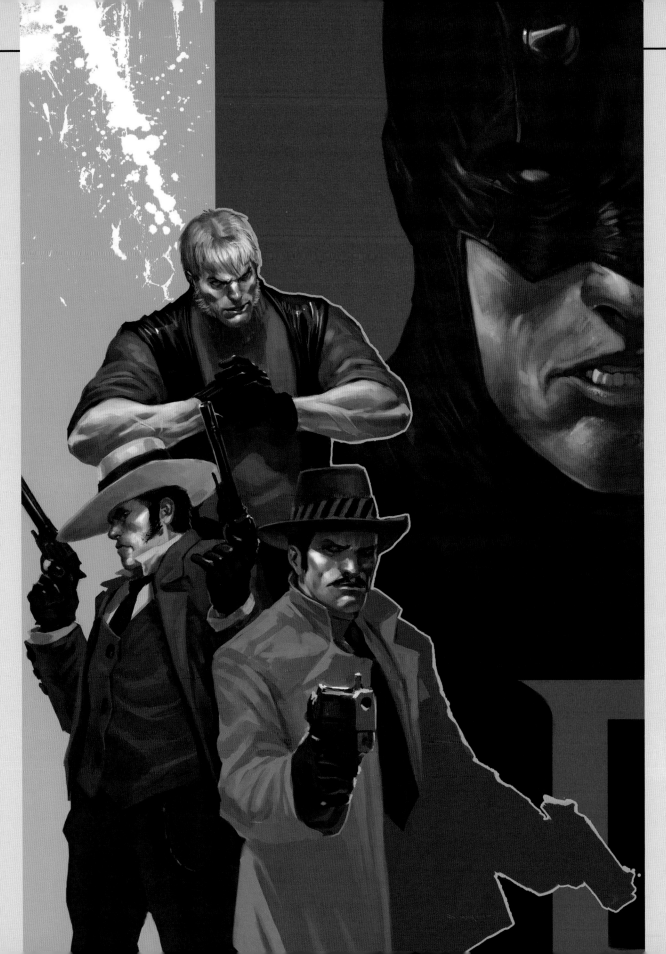

"I don't know these characters, the Enforcers. The first time I saw them was when Warren, my editor, sent me some references and a request to feature them on a cover. There was the option of also putting Daredevil in there somehow, so I scaled them down and I painted the huge Daredevil face on the right side of the image."

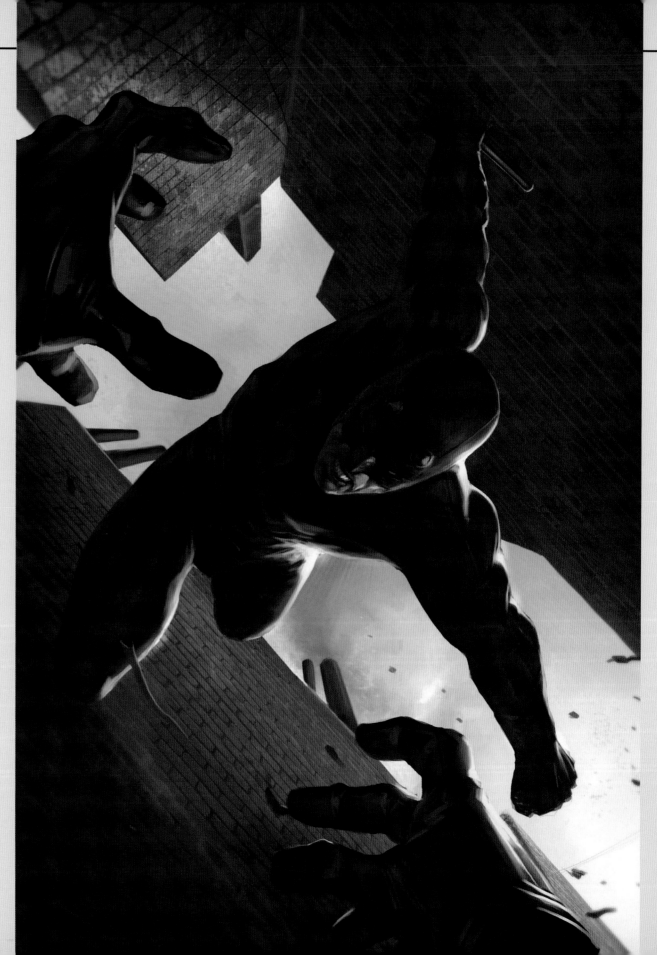

"I was idle for a few days with nothing to work on, so I whipped up a sketch of Daredevil dropping out of the sky from a rooftop, flying down towards the viewer. I turned the sketch over to my editor and got approval for the concept. I had completed the entire image of Daredevil – I was almost done – when I had the idea to add the hands reaching up towards him. I sketched them in real quick just to see what it would look like if I were able to subvert the perspective and make the viewer the villain. And it worked!"

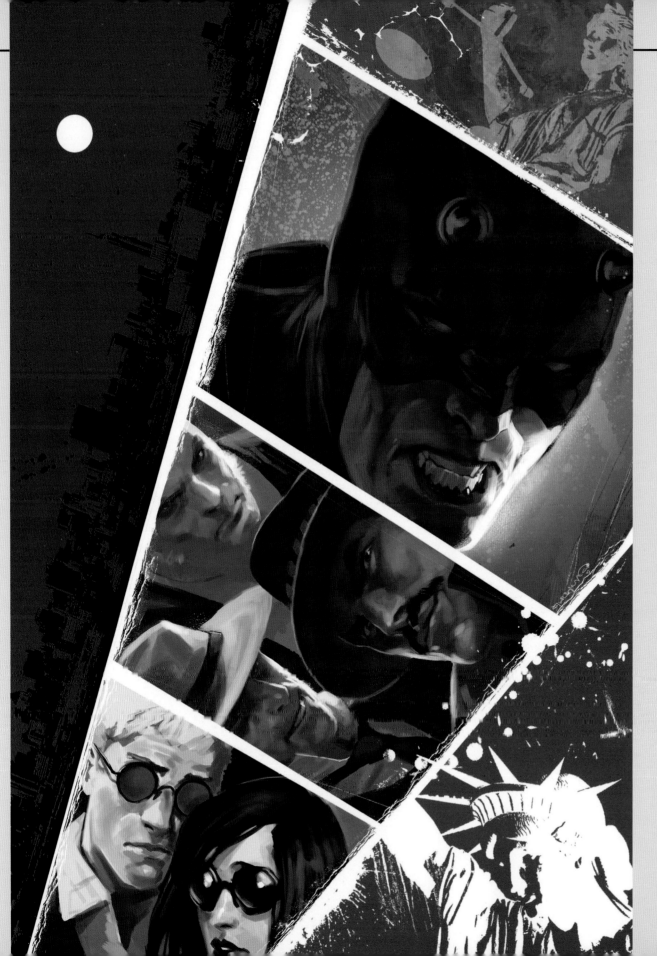

"This is based on Ed Brubaker's idea. He gave me a list of things he wanted referenced on the cover and to build them up in a montage like an old film noir movie poster. The montage eventually included the Statue of Liberty, the statue of Justice, New York City, Matt Murdock, the Enforcers, and Daredevil.

"Sometimes with *Daredevil* I would just ask for descriptions because – after working four months ahead of everybody to ready the covers that needed to be solicited – often the story wasn't even written yet. It's important for me to make sure I'm not painting something that has nothing to do with the story."

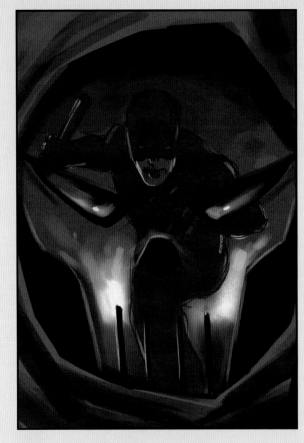

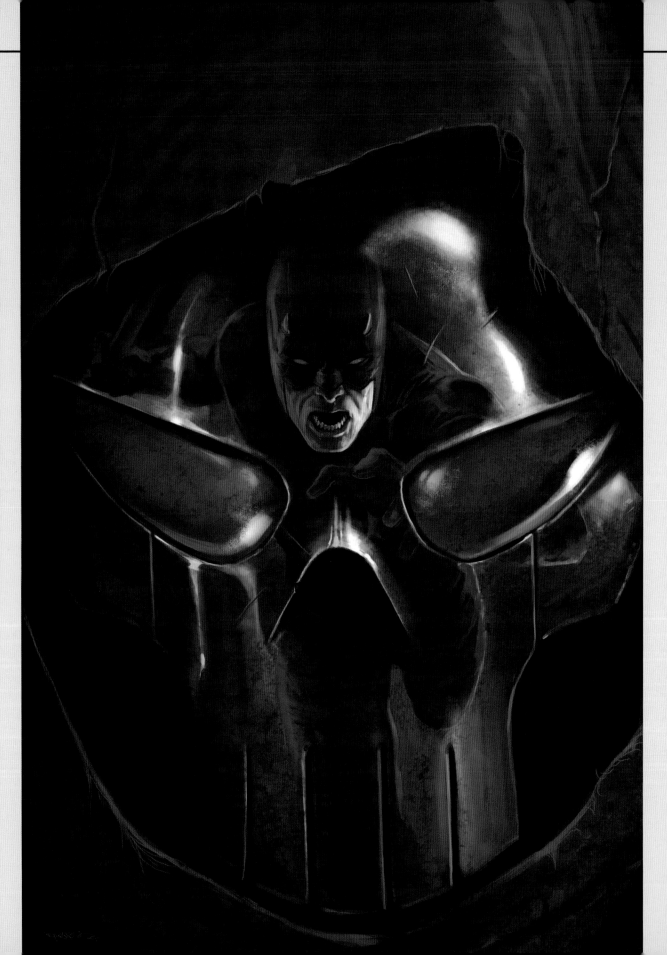

"This cover was to the finale of the Mr. Fear and Daredevil storyline, the culmination of everything that's occurred in the past twelve issues. When I found out that Mr. Fear comes out on top in the end, it made me laugh really hard because it's such a rarity when a villain actually gets the upper hand and keeps it throughout an entire storyline.

"That conceit really charged me up. When I sat down to paint this, I wanted to convey how smart and how much larger than life Mr. Fear is compared to Daredevil, so I began by enlarging his face mask over the entire cover, allowing just the smallest reflection of Daredevil off his mask. I wanted to imply Daredevil's looming defeat, how he is so much weaker – so much so that he's trapped in Fear's plot and there's no way out for him. And I really felt that the immediate danger of that translated well in that image.

"My original sketch had a more orange tint to it, but I'm so intuitive with colors. I don't follow a strong set of rules by the time I get down to painting. I just want to make it work in the end, so I'm always open to making adjustments during the process. That's one of the things I love about digital, how it allows you to experiment. You're not bound to a certain set of ideas, you can be flexible within the process of creation."

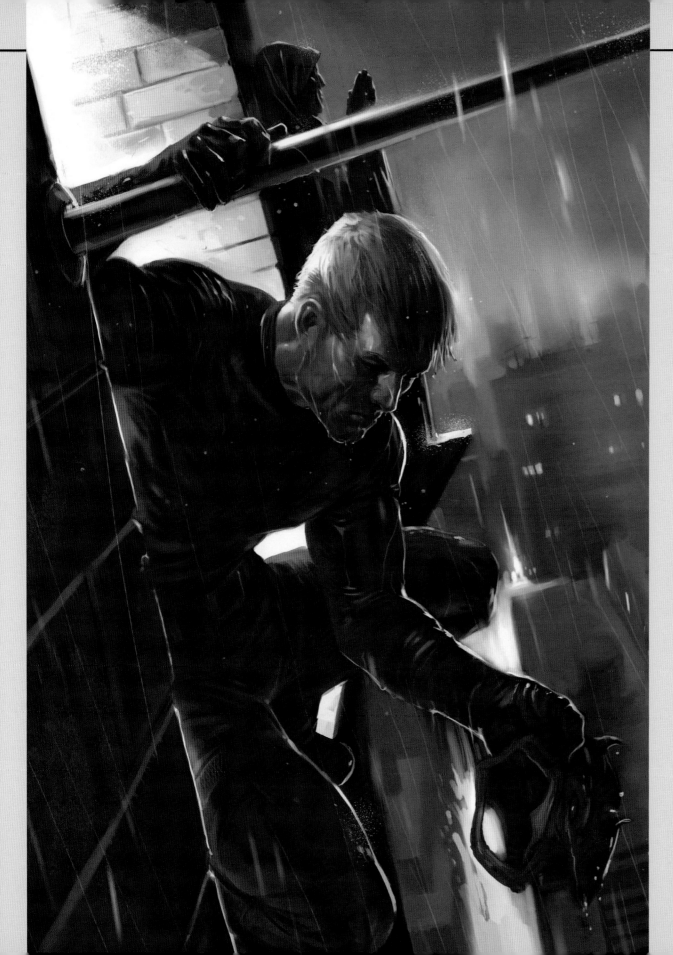

"This image was a transition piece between the finale with Mr. Fear and the next storyline. It was also a transition from Daredevil as a being of light to exhibiting more of a dark side. There's a lot of contrast in there between how huge the character is compared to the city he protects. He is cautiously estimating this step from light into darkness, from the warm light of the window, which symbolizes his past, into the dark future, which we find out more about in the next issue – and I set this up in the contrast between blue and red. The vastness of the city, all the life that is pulsating down there – he is being a silent watcher, absorbing everything but completely removed from it all. To this day, it remains one of my favorites."

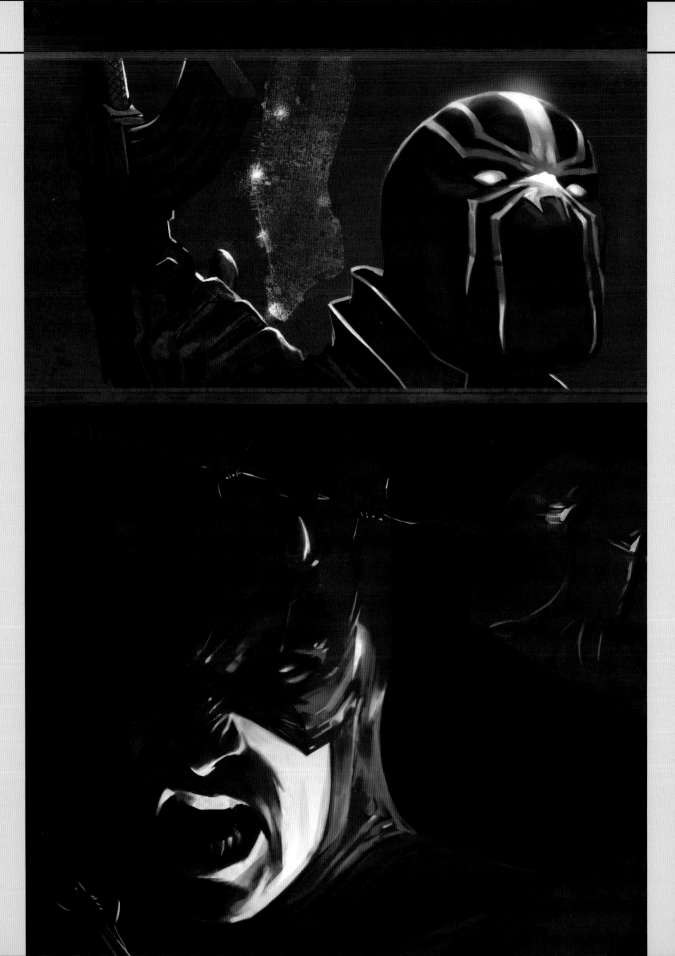

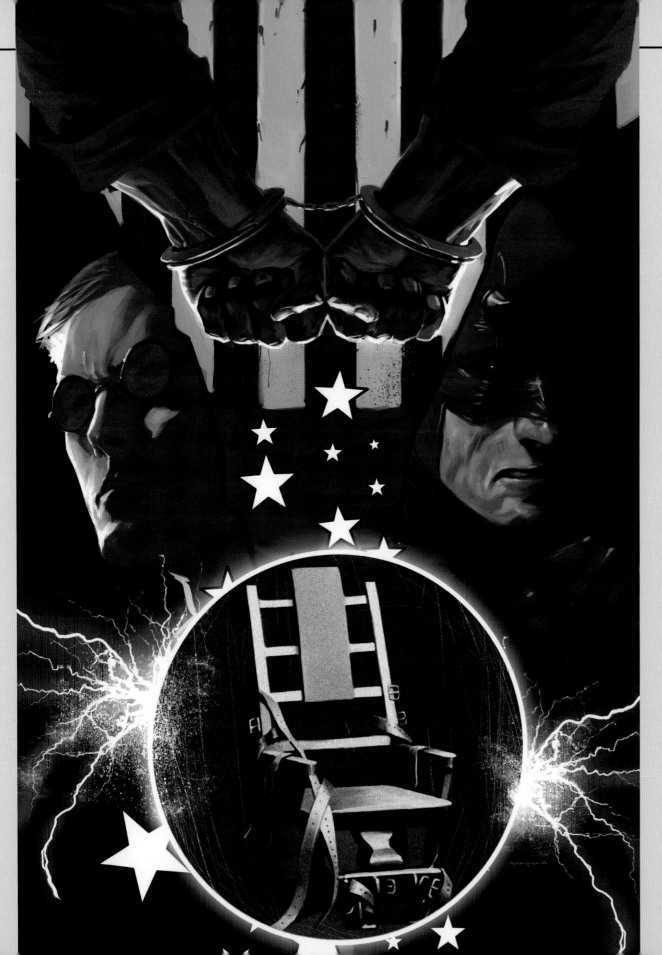

"I had placed the figure in the electric chair in the sketch, but I decided to remove it because that would have sped up the timeline of events to the very end – showing the death sentence actually being applied. I decided I would rather show the progression to the end rather than the actual act of execution.

"On that cover there's also a nice hidden Easter Egg. If you zoom into the left hand coming from above there's a tattoo on the inside of his arm: 'We die alone.'"

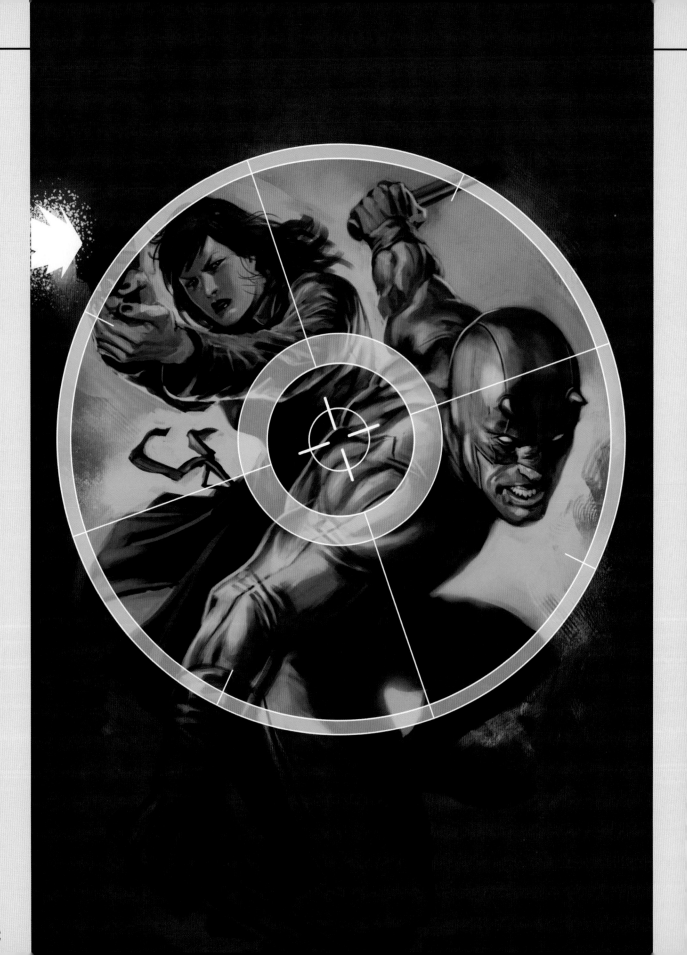

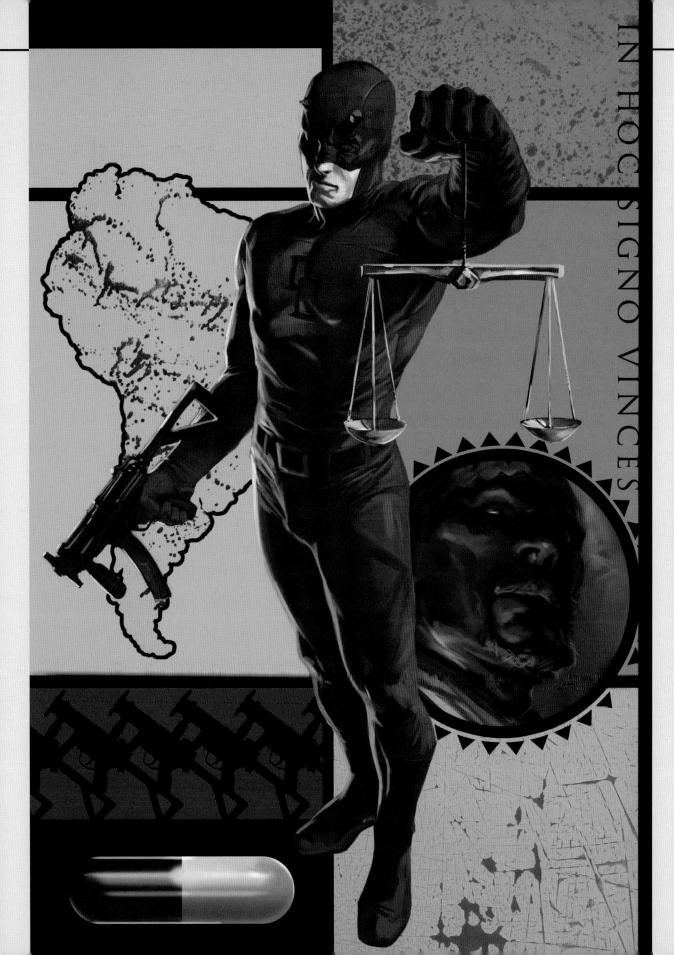

"I read the most amazing review on this cover the other day, and it shows just how confused people can be when they are reviewing my stuff. This reviewer claimed that he had figured out my political motivation behind the cover, how Daredevil represents my version of the 'white man' ruling over Africa. Obviously, he's never had a geography lesson in his entire life, because otherwise he would know it's South America I was depicting!

"I did have a clear idea of what I wanted to do with this cover, however. The American map definitely plays into the fact that Matt Murdock is trying to protect from the law the leader of a South American drug cartel, one that is smuggling drugs and weapons into he United States. Matt Murdock is holding up the scales of justice with an image of his client inside. At the same time he has to figure out where all the of the weapons and drugs are coming from, and it's the classic Daredevil story of the lawyer finding out that he's protecting the wrong guy.

"I had developed quite a lot more design effects with the drugs and guns in the sketch version, but my editor didn't like it. He thought it was too abstract and that the antagonist was getting too much room, with Daredevil not getting enough."

"Having your work misunderstood happens all the time. But after doing this for almost thirteen years now, I'm so over the odd critiques about my work. At a certain point you have to realize that you can't please everyone. So many times, whenever I think a picture is great, some fan is going to come along and say the picture is the ugliest thing he has ever seen. And whenever I hate a picture – and this happens a lot – some fan is going to say that it's the best cover ever. If you try to direct your talents in accord with the tastes of other people, or by what people see in your work, you're just going to go crazy. There's not going to be anything left in your work that's *you*."

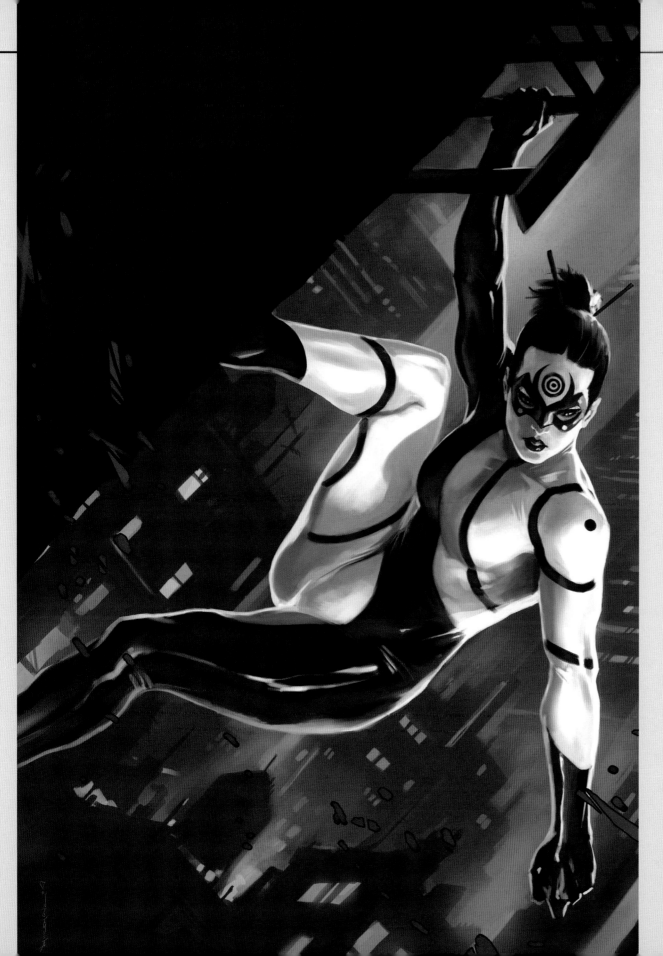

"Artistically, I don't have too much fulfillment with this one. I can't say that I really proved anything except for being able to draw a sexy chick in a tight suit. As far as the colors, I find that a bit more remarkable. I like stark contrast, and in this piece I like how the black and white of her costume really contrasts with the bright orange in the background. I have a lot of fun in creating such contrast in backgrounds that are completely monochromatic. Here, the city is covered in the colors that you would never see a city in. There is no lighting situation that would ever cause a city to look like that. But it is definitely the prerogative of an illustrator to play around with that; we have far more freedom than do photographers."

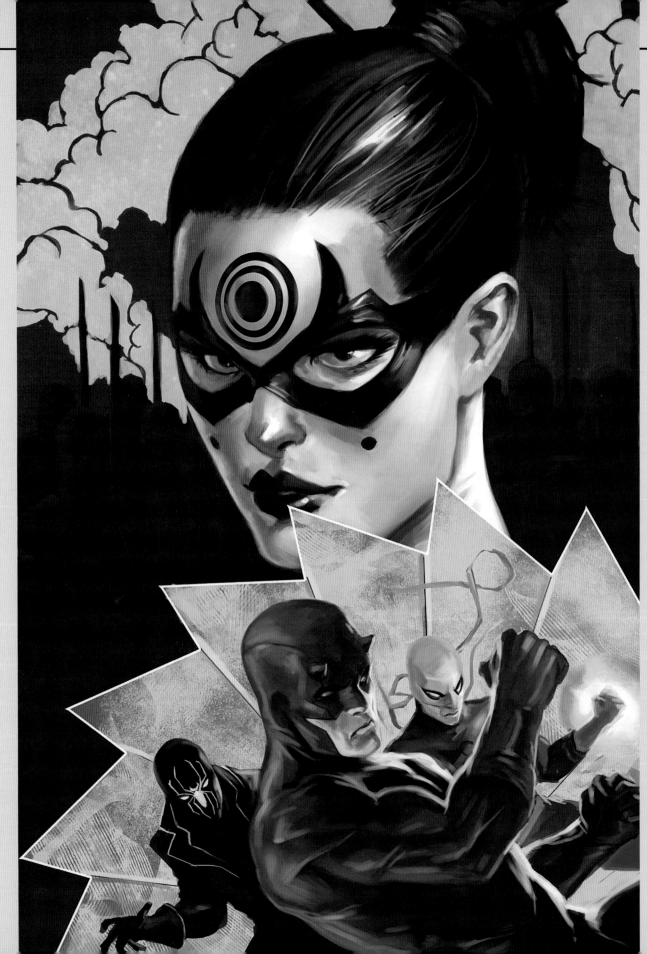

"Most of my covers are complementary in color. Either they're blue-orange, or they're red-green, or they're purple-yellow. I work with those contrasts just because the complementary colors already do most of the work for me. Using my cools against my warms easily establishes a certain atmosphere. If you look at all the Daredevil covers I've painted so far, you'll see that I always put blue into his costume just to cool the costume down. It helps to show a reflective light source and gives more form and definition of volume; if you were to keep it all red, it would just get mundane after awhile."

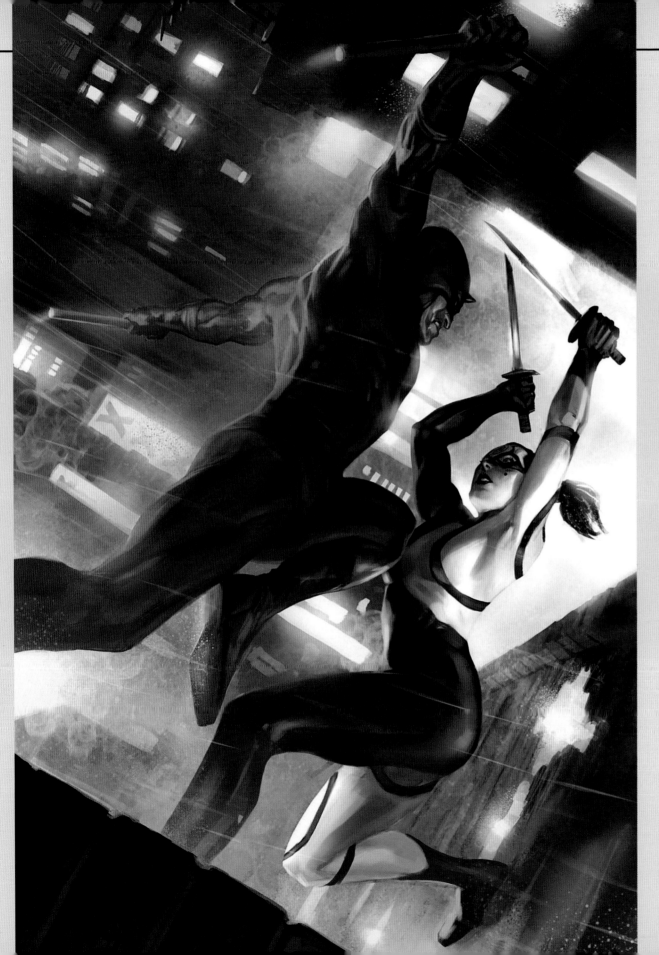

"I wanted to convey the feeling that these two characters have perhaps just leaped out of a window, so I projected a light source behind them that indicates there is some action that has happened over there that we're not seeing. I tend to do that pretty often – placing light sources outside of the picture – because it gives you the opportunity to entice the imagination of the viewer."

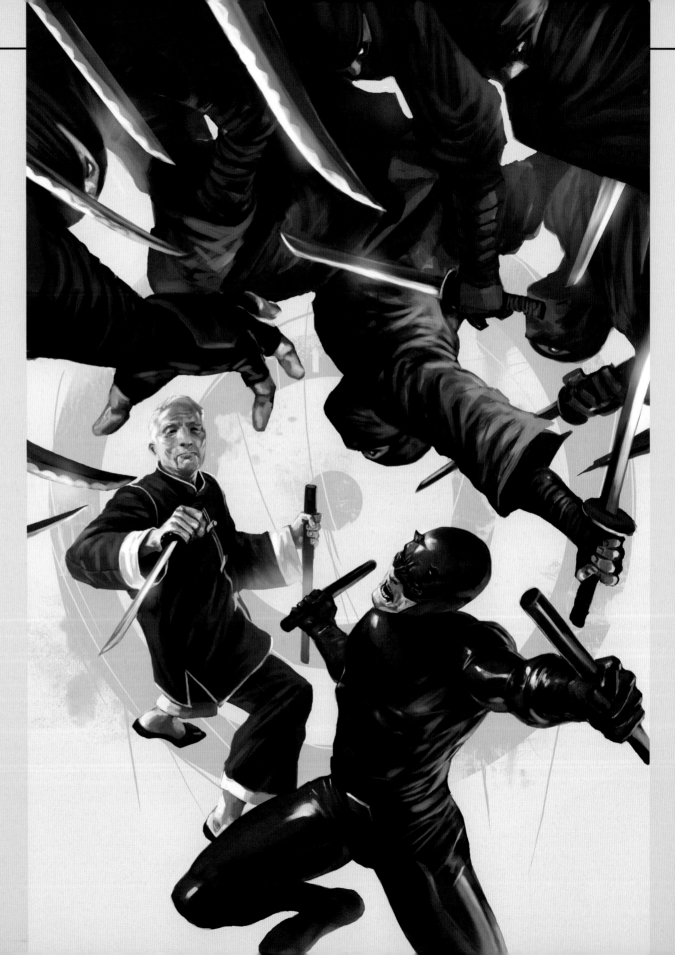

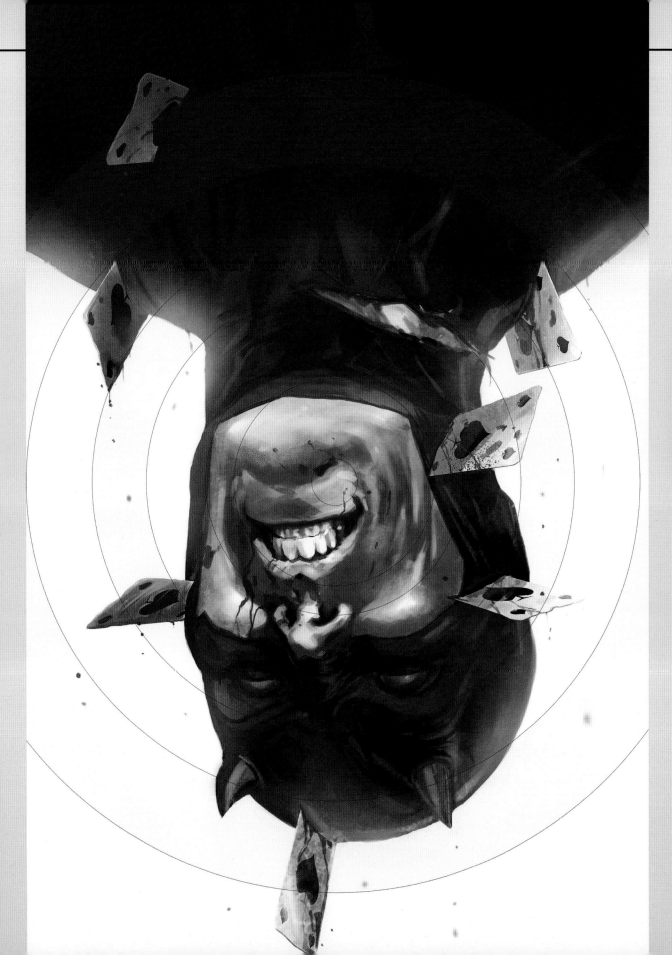

"This was a cool concept because it was so simple. He's hanging upside down as if he's lost it, with the classic Bullseye card knifing into Daredevil's face. The Bullseye symbol in the background gives the whole thing a unified look. It's the first time that I realized that if you deploy a Bullseye symbol like that, it can also represent Daredevil's sonar. It reinforced with me how much the two characters actually have in common."

"I wrote out in my scribbly, sketchy handwriting a message that says, 'Only death shall part.' In this issue, the Kingpin loses his family to the Hand. The Hand assassins kill off the whole of his new family that he's built up in Spain while in exile. I wanted to avoid the obvious; I didn't want to show the literal killing – like Kingpin holding up a dead child, for instance. I made a choice to convey the emotion on a very subtle level and with the splash of red and the scratches and dirt. This foreshadows the deaths rather than shows them to you."

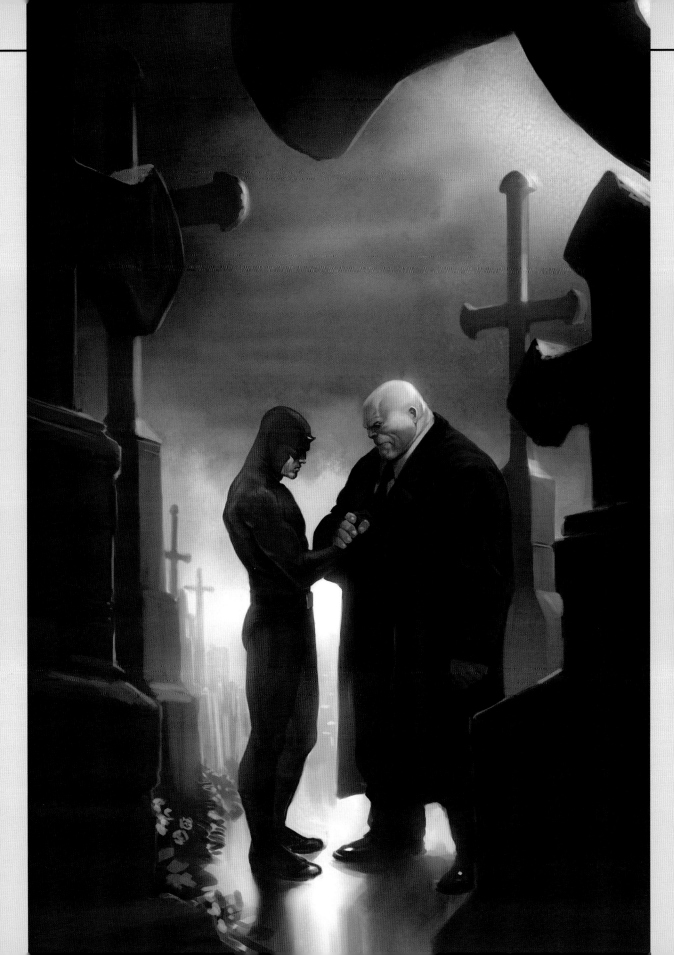

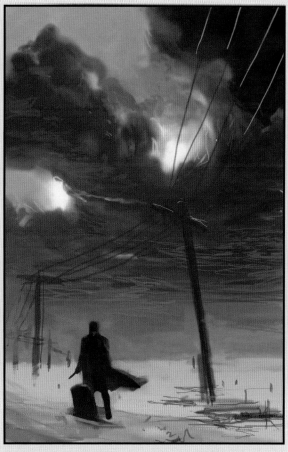

"A very evocative scene of Daredevil and Kingpin making a pact. After I got the description from Ed, I knew this would make for a very striking image. I think the initial request included the desire for rain in the scene. But I thought it might be better to just pick up the scene after rain had already passed through. That's why the ground is so reflective. I also really wanted to push the perspective in the piece and make the characters relatively small, giving those crosses around them a very looming, imposing nature.

"Ultimately, Kingpin is the major archnemesis of Daredevil. But even so, you can only be the nemesis of somebody if you share a lot of things in common with them. There's a deeper connection than mere confrontation. One cannot live without the other."

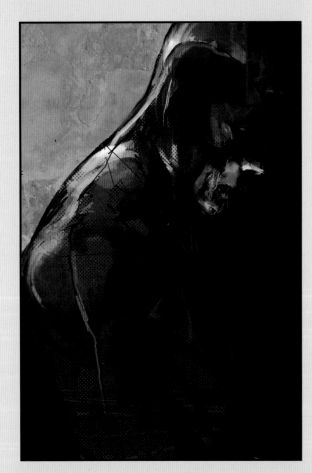

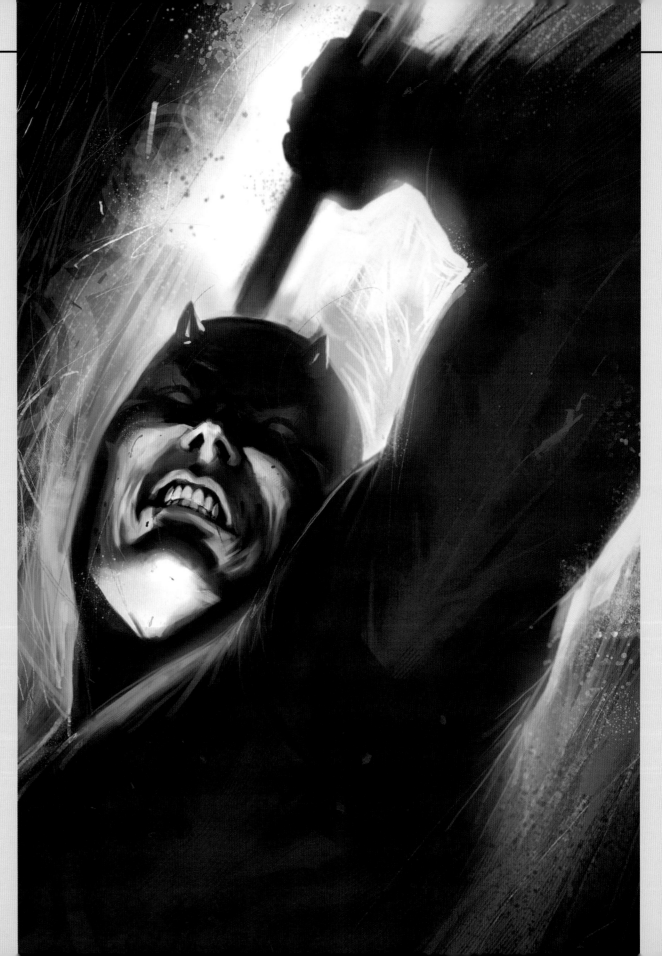

"This one came together rather quickly. After entertaining the idea of a few other concepts, I decided to depict Daredevil in an overwhelming rage. In my mind, it's largely a filler cover. My main intention with it was to make it interesting in the way it's painted, to try and bring out the rough and vulgar qualities and bring it in line with Daredevil's emotional state. It is definitely different than the more polished covers I had been doing."

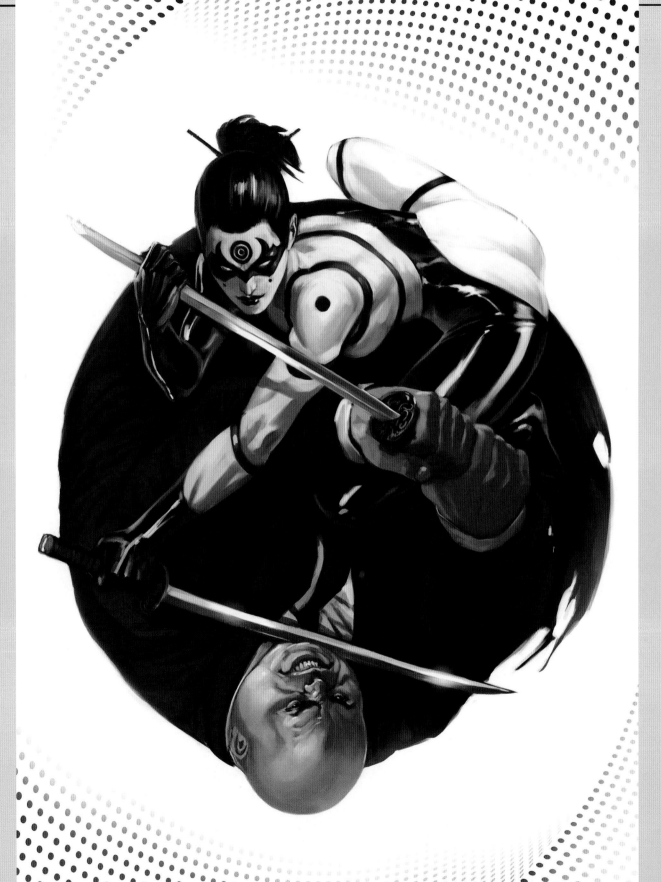

"I chose an abstract way of interpreting the yin and yang, with the female power of the yin on top of the male power of the yang. I really wanted to show Lady Bullseye being in charge, to subvert the symbolism by showing the formidably powerful Kingpin as the one who is in danger here."

"This gatefold cover was my final bow with Daredevil. Altogether it must have been a week from the initial sketch till the final painting, making it the longest time I have ever spent painting something. As far back as eighteen months before I completed this, I knew this milestone was coming and my concept was to do it as big as possible and go out with a bang.

"From the beginning, I wanted to show the whole sweep of Daredevil's life – all his dearest lovers, all his greatest enemies – past, present, future. When I sat down to begin, it just flowed out of me. It came together organically: all of his lovers and his mother on the left; on the right side, you have all of the villains and allies he has had through his life; and then the middle is all concerned around Matt.

"The face of Matt Murdock functions as a huge negative space up there. I drew him the largest because I think the book is ultimately about Matt; Daredevil is just a costume that he puts on. The placement of the yellow costume, the red costume, and Matt as a child highlights the transformation from boy to heroic figure. More symbolism includes the white roses, which represent death; the cityscape behind the Kingpin as the playground for all these characters; the Ace of Spades, a constant reference throughout the entire series. And then, written in blood on one of the cards – 'fin de siecle,' which is French for 'end of the century,' or more for our purposes, the 'end of an era.' I wrote that into the design because this cover marks an ending point for all of us on the book. Ed Brubaker and Michael Lark are both leaving, and so am I. This cover stands as an ode to what we've accomplished over the past 28 months."

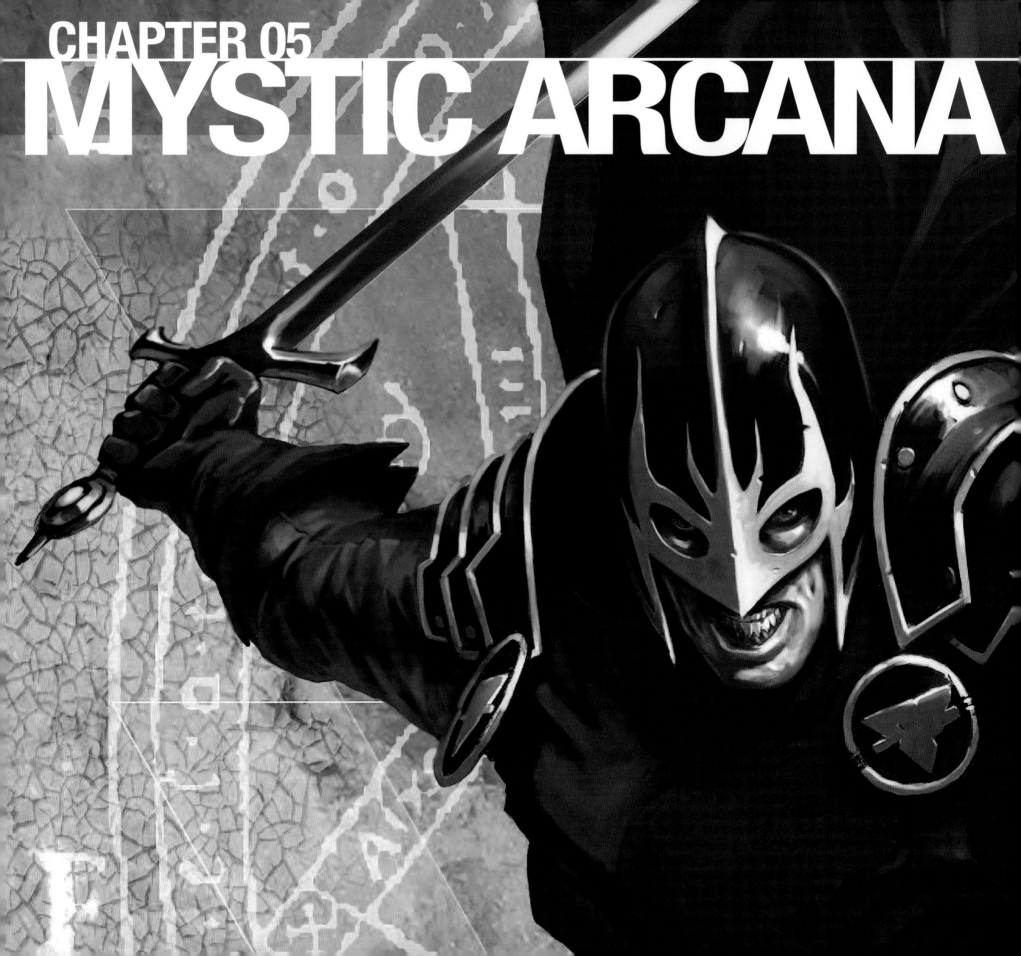

Great comic book covers don't come together by magic — except when they do! If that counterintuitive logic makes sense to you, then you'll find yourself at home in the (literally) magical world of *Mystic Arcana*, the 2007 mini-event masterminded by writer David Sexton that threaded together Marvel's rich legacy of characters, all of whom shared a decidedly supernatural bent to their super heroics. Marko's series of covers to the *Mystic Arcana* one shots and attendant supplemental books featured stunning figurework set against dreamlike backgrounds that proved transfixing. Series editors knew Marko's gift at quantifying the abstract world of visual imagery would come in handy when fashioning these meticulously crafted doors to the worlds of magic. All that was left was for the readers was to open them. That's the job of a cover artist — it's not exactly magic. Except…when it is!

MARKO: "Medieval history is one of my major sources of inspiration; I'm a real mythology and history geek. I don't necessarily believe in magic, but I find it fascinating nonetheless. Things like the Tarot, mystics, or the Druids are engrossing to me and I can lose myself in their worlds of abstraction."

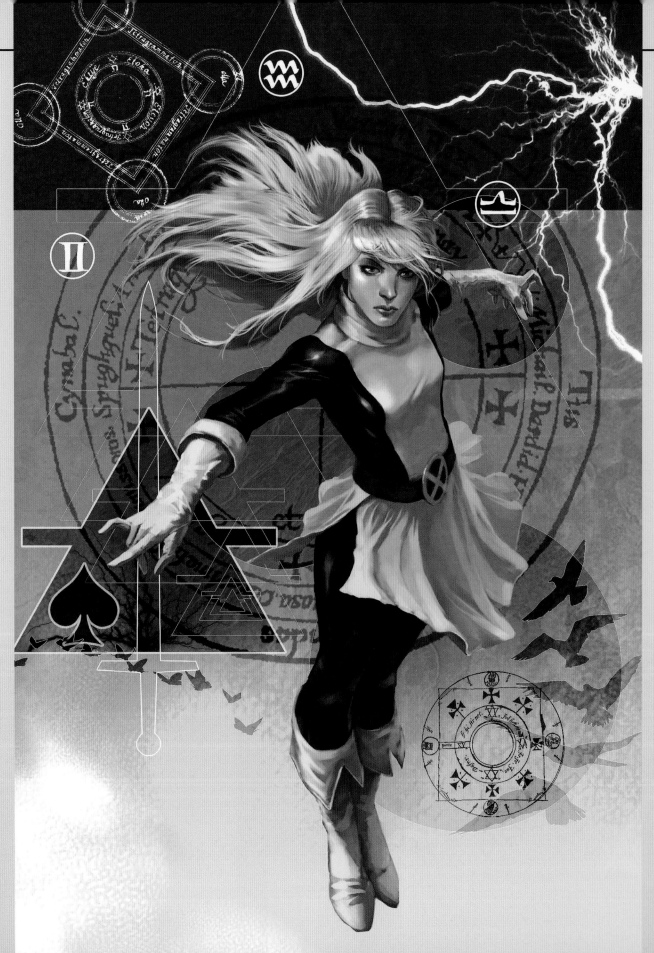

"The editors gave me the setup, that it was supposed to be the characters of Magik, Black Knight, Scarlet Witch and Sister Grimm (of teen comic *Runaways*) in four iconic shots. They also added that they wanted to have each of the characters represent a particular element. All the other designs that I added to the mix were my inspiration, trying to figure out the best way to represent air, the best way to represent fire, and so on."

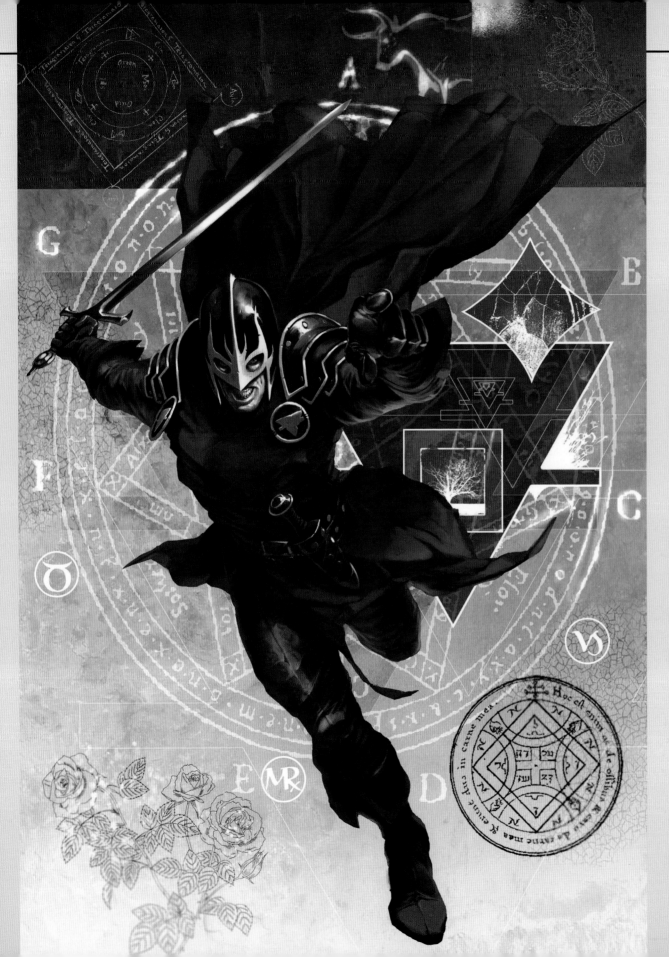

"*Mystic Arcana* was a four-issue mini-series featuring four different mystic-oriented characters. '4' is a very strong magical number and that numerical strength is something that I wanted to emphasize through things like the zodiac, the elements, the deck of cards – right there you have a rich pool from which to find inspiration."

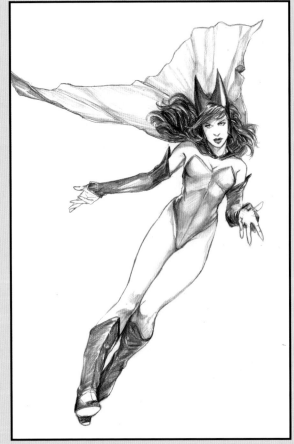

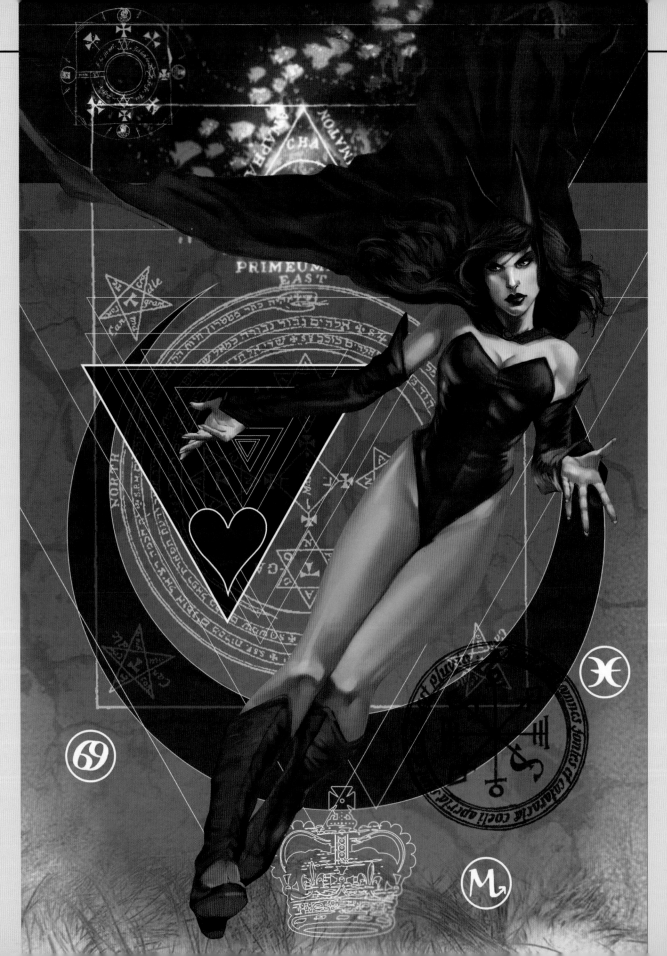

"You can see with the color schemes and the approach to detail how the number 4 connects the disparate elements together. If you look at the Black Knight picture, for example, there's a pictogram of a fiery bull over his forehead. There are the birds flying in the Magik picture, or the fish swimming in the Scarlet Witch picture – these subtle references to the character's element unifies the group of covers."

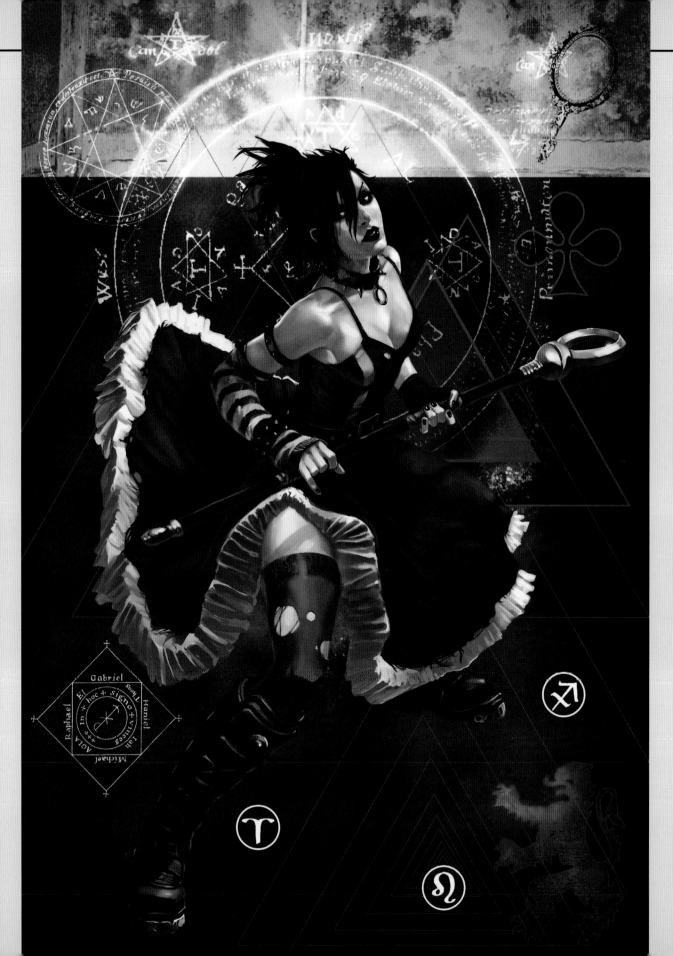

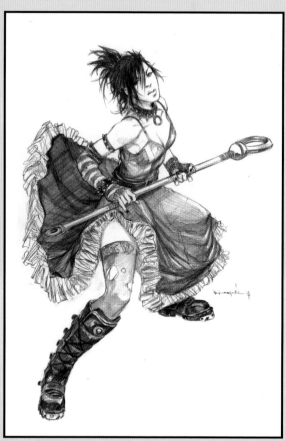

"Super hero covers can sometimes be very limited in what they can and cannot do, but *Mystic Arcana* was one of those series where I felt the freedom to take a few more liberties. It wasn't easy, though I would love to do more of this kind of thing."

"Handbook covers are tough to do. Editors always ask for a million characters to be included on there, but you get the same payment as if you had just painted one! But you have to dig in and do the overtime to get the job done. For the *Mystic Arcana Handbook*, the ensemble was full of characters from the '70s that I hadn't ever seen before, and to a certain extent I had to redesign them a bit from their original conception. It's not one of the covers where I tell everyone I've achieved many great things, but it definitely turned out okay for the time spent on it."

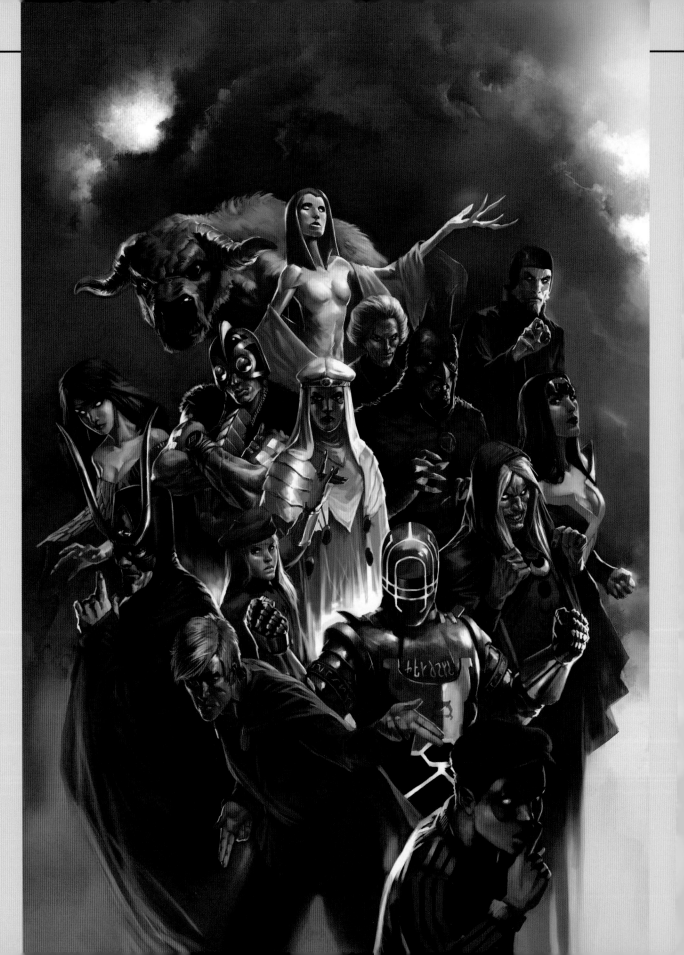

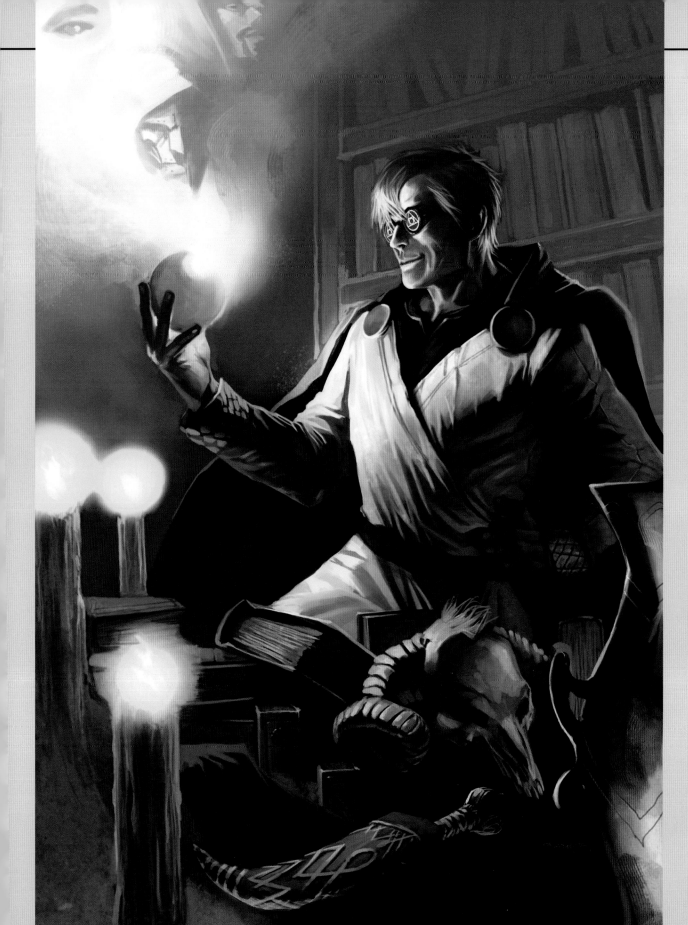

BOOK 3
SCARLET
WITCH

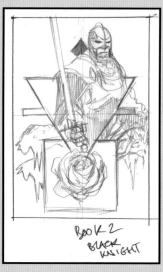

BOOK 2
BLACK
KNIGHT

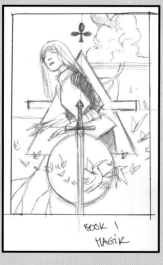

BOOK 1
MAGIK

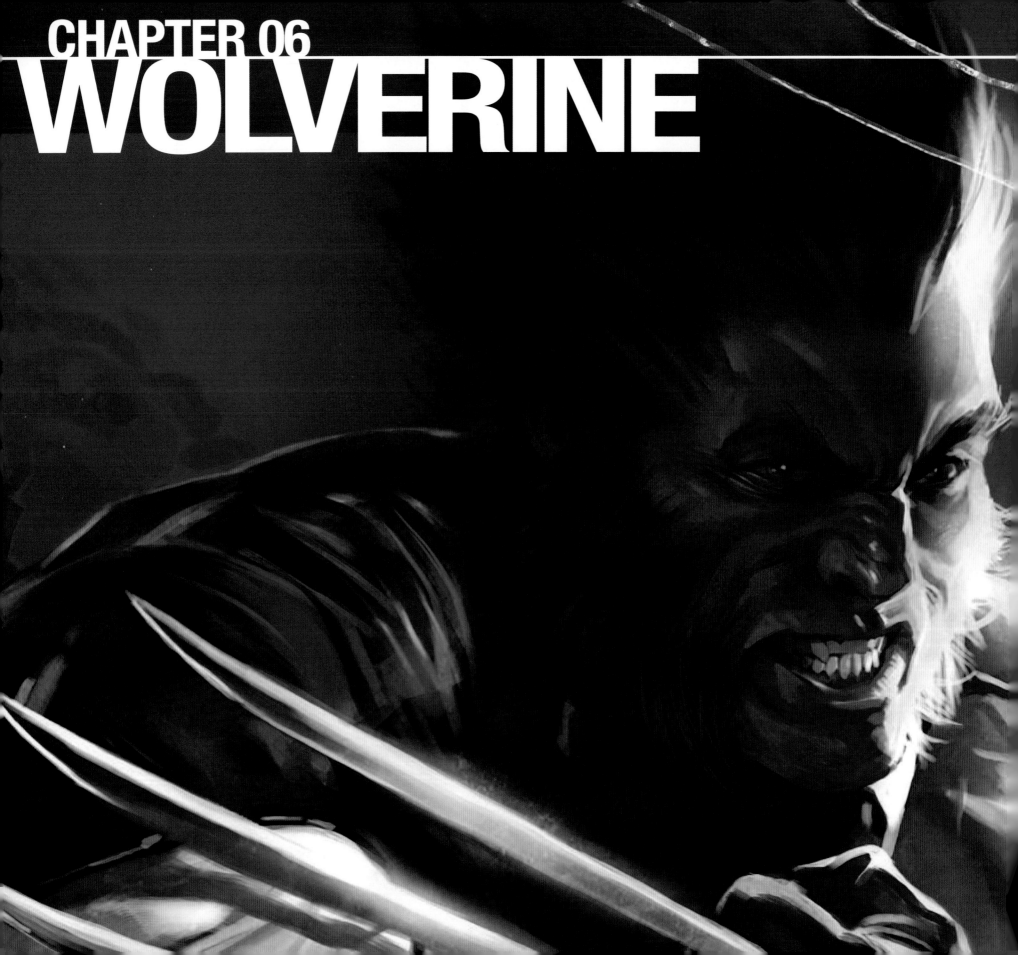

CHAPTER 06
WOLVERINE

Wolverine's the best there is at what he does, and what he does is appear in lots of comic books! As a member of the Uncanny X-Men and X-Force, and headline attraction in various other monthly titles that bear his name, the character now rivals Spider-Man as the most ubiquitously popular Marvel hero. One of the these titles has, in the last three years, begun to chart out the vast expanses of Marvel's most closely kept secret — Wolverine's dark, traumatic past. Daniel Way's Wolverine: Origins explores the continuum of Logan's life from his birth to his present, exposing the sundry dark figures behind his manipulation. During his journey, he's found a son he never knew he had sired (or, perhaps to put it more pointedly, the son found him — claws extended!) and he's had to reconcile himself to a century long life full of despicable commissions of violence and murder. One of these episodes was a reminiscence on Wolverine's wartime activities in World War II. It was during this time that Marko took the role as Origins cover artist, whereupon he highlighted the marvelous team-up between Wolverine, Captain America and Bucky with excitement, action, and the drama befitting that momentous period in world history.

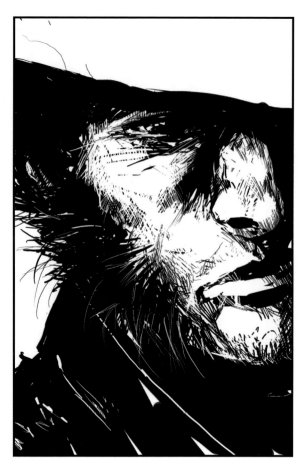

MARKO: "I was a big X-Men fan when I first started reading comics, but believe it or not I never had an emotional connection to Wolverine. I don't know why. I guess it's because I don't have a Napoleon complex or something. I'm pretty tall myself, and I don't suffer from any complexes in that direction."

"Joe Quesada's design of Daken, Wolverine's son, is a good clean design. It's not overdone or too complicated, but at the same time has a certain iconographic form to it. Daken is definitely readable from afar, which is important, because when you reduce the character to an inch or so on a comic book page, his identity and personality still has to translate to the reader.

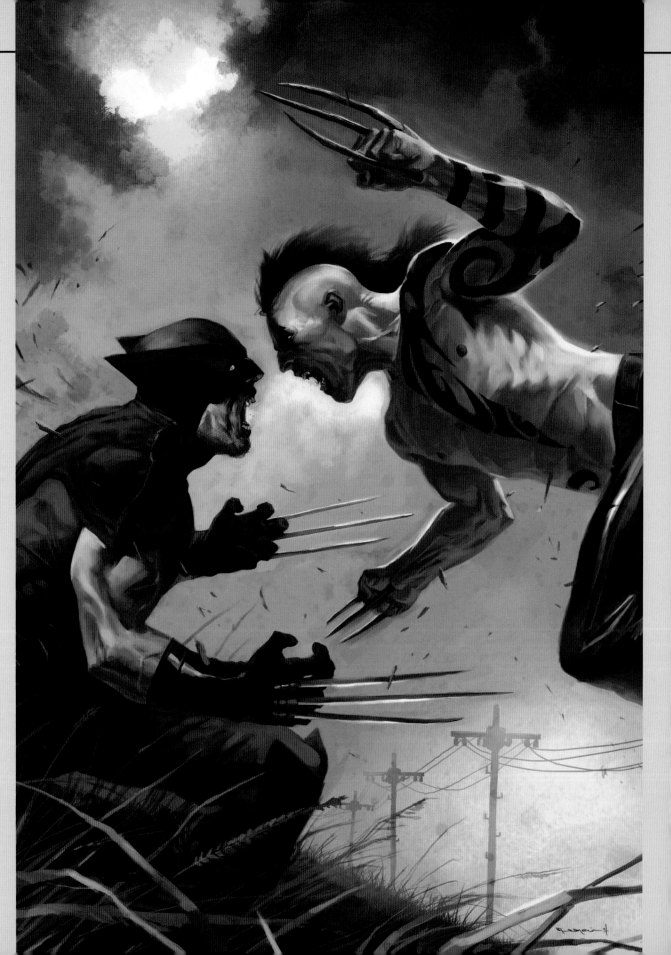

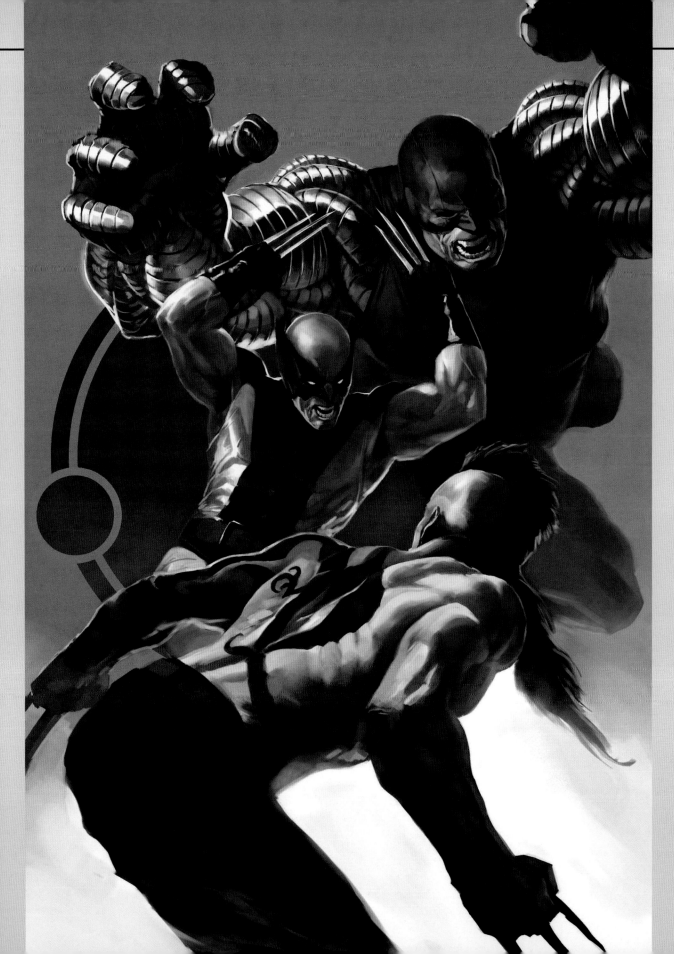

"I find that giving a character a tattoo is really costume enough. That's something that you can work with, and Joe did it in a good way."

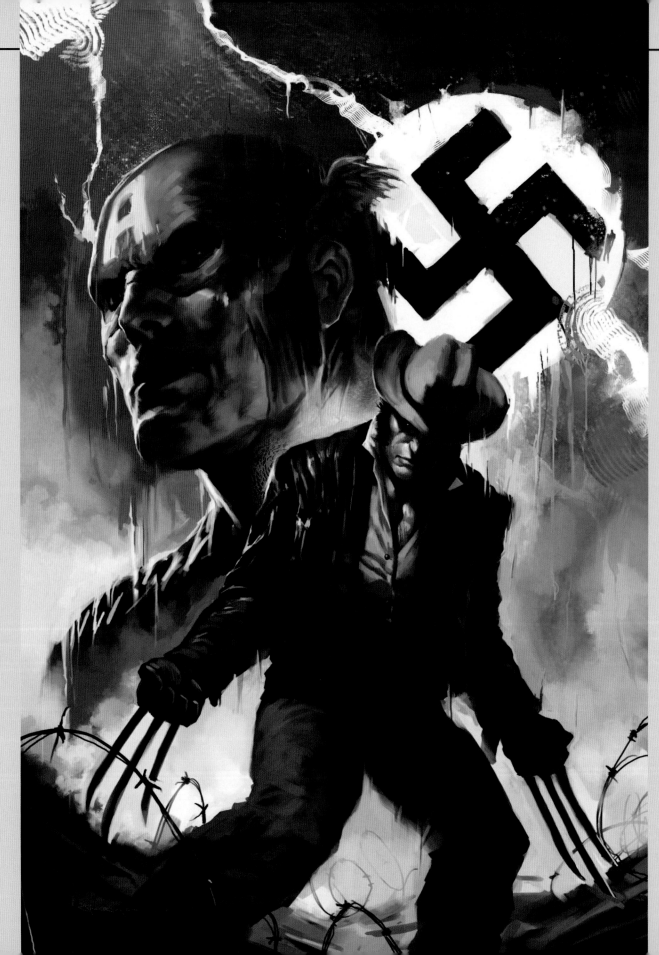

"World War II is a very iconic period in human history – maybe the most iconic period in human history – because nothing has ever represented evil in a more insidious way than the manner in which the Nazi regime represented themselves with their graphic design and iconography. Whenever you slap a swastika on something, you can really make the cover look evil."

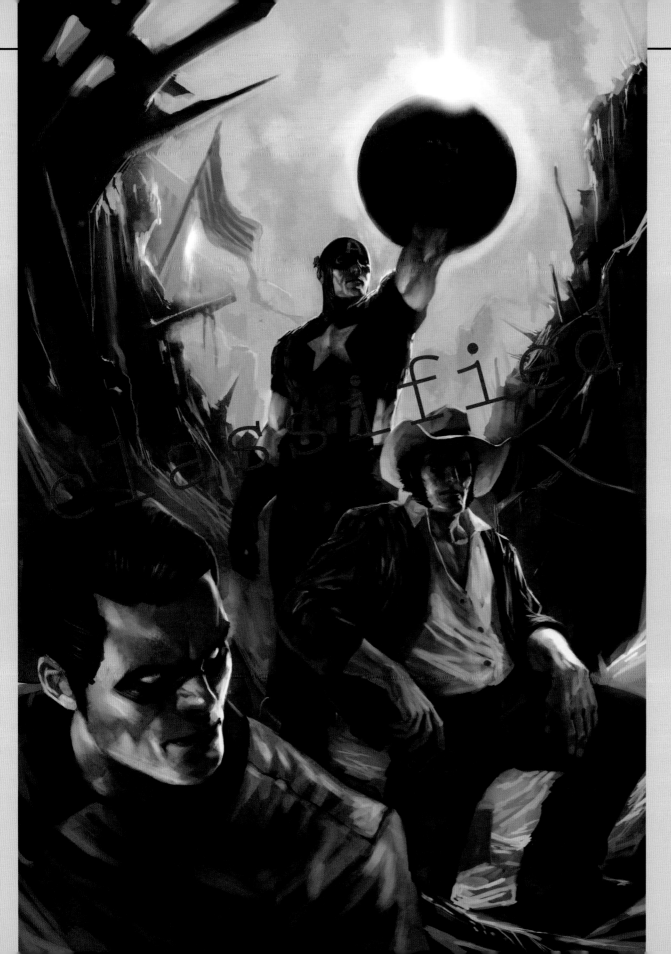

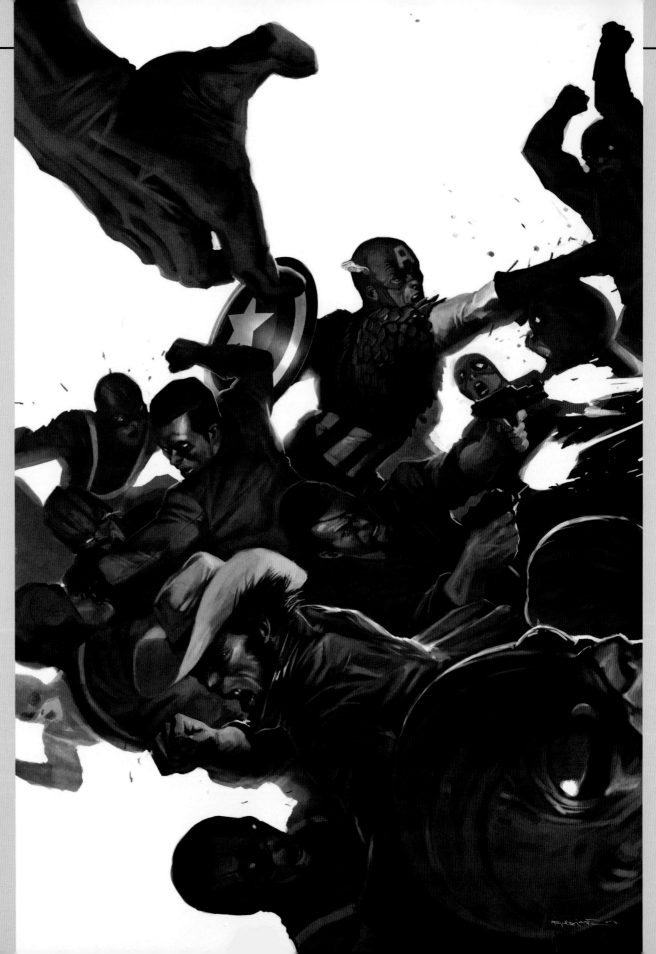

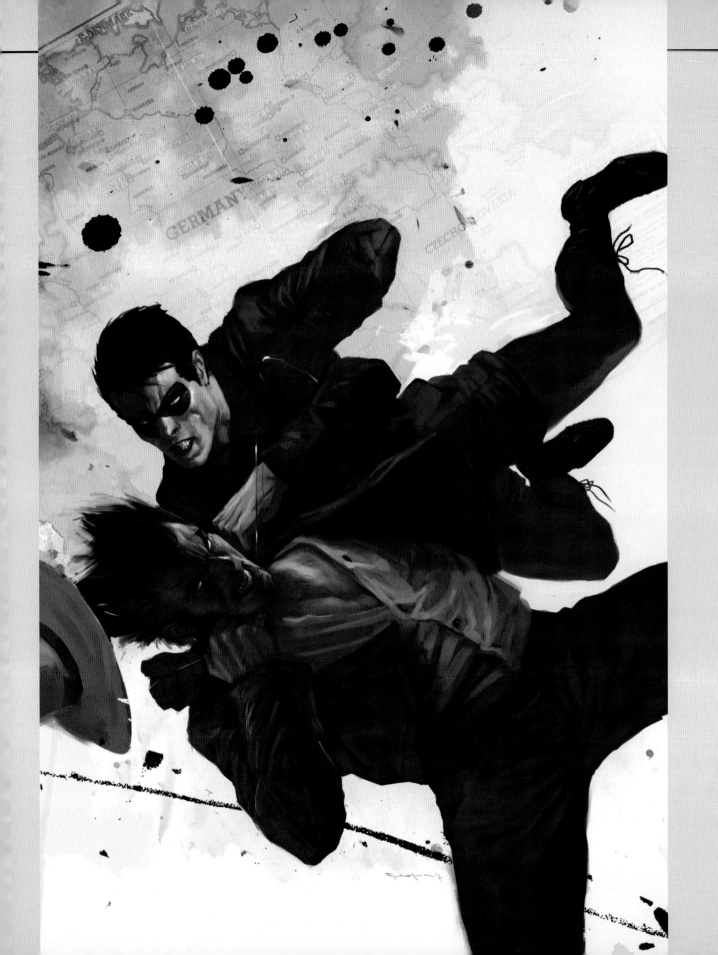

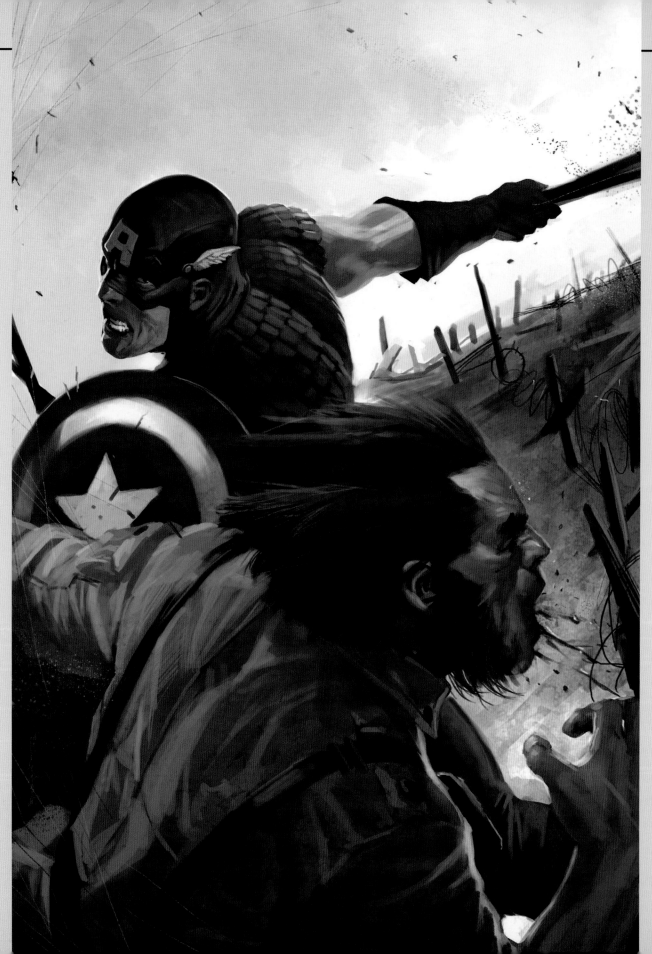

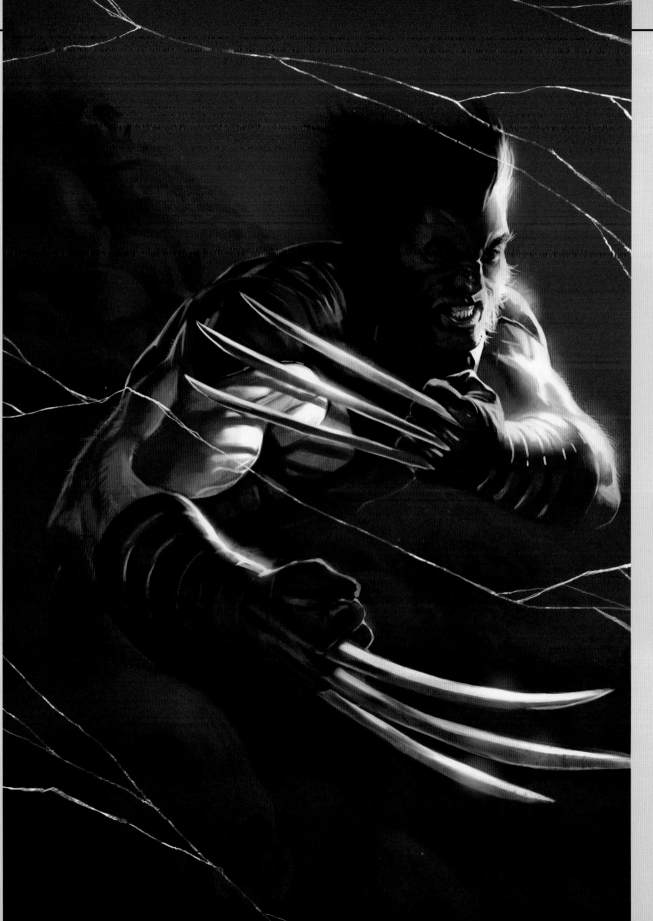

CHAPTER 07
SPIDER-MAN: ONE MORE DAY

The four-issue Spider-Man crossover event One More Day *brought an end to the marriage of Peter Parker and Mary Jane Watson, a move that, needless to say, was very controversial. Though its storyline launched a well-received "Brand New Day" revamp – a new look at the character and its universe – many fans were rankled that attempts to keep Marvel's most iconic character fresh for a new era also meant upending the twenty-year (in the real world, not comic book time) marriage. Despite much hubbub about the storyline on the inside of the books, the OMD variant covers by Marko were universally hailed. The artist produced a series of spare character studies that were light on design effects and explosive, attention-getting colors, but as engrossing as anything he'd produced in his career. It was an appropriate and respectful way to see Peter and MJ fade into white…*

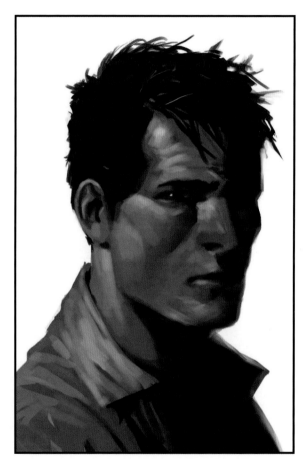

MARKO: "As simple a concept as there is: The description for the covers was to show four characters, each on a white page, and reveal through their emotions a little bit more of the story. And by 'reveal,' I don't mean explicitly showing any plot points or events. I mean transporting the mood that is established in the book.

"That is an essential part of being a good illustrator, revealing dimensions of a person's soul through body language. It's what you can do with a character when he's not engaged in action; so many covers are full of action, which is nice, but you can only draw so many faces that are grinning or in anger before it starts to get really boring."

"I have such a personal connection to those four, because in their simplicity their body language brings you in to the essential parts of their character: who they are now, why they are standing here in front of us, how they are responding to their world…

"So you have Spider-Man, who is shot from above looking at his hands, basically wondering what he's done, how he got to the place that all his decisions have brought him…"

"And then you look at the Peter Parker image, which shows him clenching his fists, realizing the choices he's made have been catastrophic and that he needs to do something about it. His face is almost completely shadowed on one side, which reinforces the tension inside of him. There's only a little shimmer of light hitting his eyes, so it's not the Peter Parker with a happy disposition you are used to seeing – it's a very somber and very thoughtful Peter Parker, somebody who's been more or less pushed into a corner and has to make some bold choices."

"The next one, Mary Jane, is in a stance that implies acceptance. When you can't change things anymore, where the only thing you can do is just clasp your hands together and stare into nothingness for a while to rethink what's happening around you. Again, that stark lighting completely shadows half of her face on one side, which is just pushing the mood into this somberness, into this helplessness, into this anxiety and anticipation of what's to come, what is next to be revealed…"

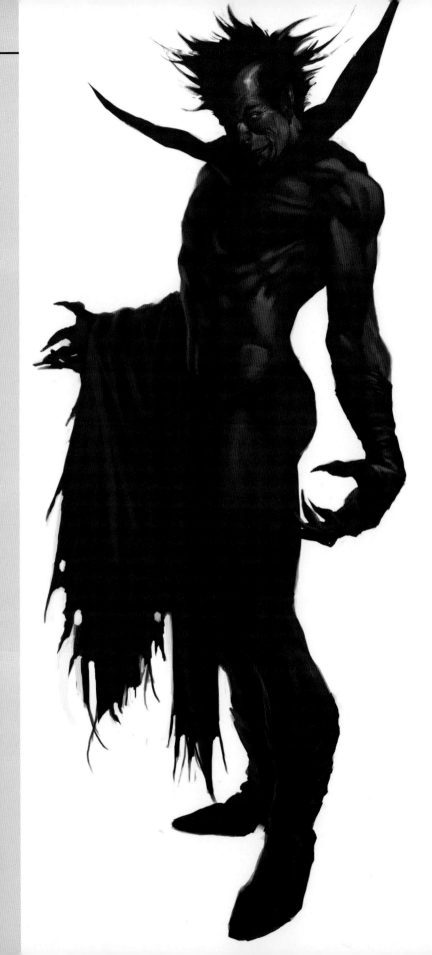

"And the revelation is Mephisto. At the end of the race, we see the winner, with his entire pose exuding triumph, basically saying, 'What do you want? I won.' He's the only one looking directly at the viewer; all the others are looking away – they are not including you in their thoughts. Mephisto looks straight at you and wants you to know his plan has come to fruition. 'Look at what I have done.'"

Riding in from out of nowhere, Ghost Rider has taken his place among the most iconic characters in the Marvel stable – in the stable, that is, when he's not burning rubber through the countryside leaving demonic hellfire in his wake! Thanks to a popular motion picture release in 2007, the character of Johnny Blaze has entered the mainstream pop culture lexicon as a heroic yet tortured soul afflicted with the violence of a Satanic curse. This frightful character nonetheless carried with him a slightly offbeat, quirky quality courtesy of Nicolas Cage's performance – and it was this dichotomy of hellish humor that was sustained in the contemporary Marvel comic.

By contrast, when Marko was assigned to draw Ghost Rider covers upon the arrival of new writer Jason Aaron, the artist saw the character clearly as a storm trooper of the apocalypse, a primal force of nature through which the judgment of Hell was portioned out to those who believed – and especially those who didn't. This Ghost Rider was not one to take the microphone at a comedy club in his off-hours; he was a form of retibution that was almost Biblical. It was this savagely prophetic vision of the icon that most powerfully manifested in Marko's drawings, particularly in his incisive sketches.

MARKO: "Before I started on the Ghost Rider covers, my original sketches of the character emphasized my interests: I was thinking of going in a more spiritual direction with the character, a more religious route – because, in my mind, there are so many religious aspects wound up in his character. The name Ghost Rider already classifies him as a spiritual being – the 'ghost' makes that clear – and on top of that, the word 'rider' comes from the German word that means 'a rider on a horse.' After reflecting on that, I see him now as some kind of an apocalyptical horseman that is just using a bike instead of a horse, dragging all of Hell behind him."

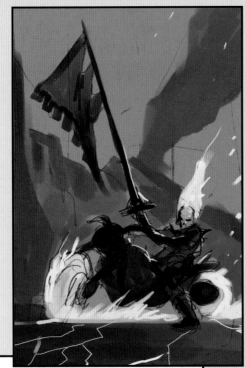

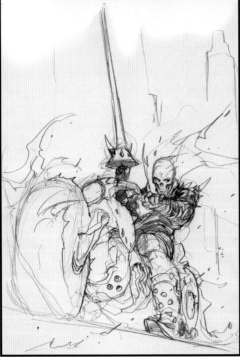

"In my concept sketches, I equipped Ghost Rider with a lance, which supported the idea of him as a horseman of prophecy. There's another sketch image where he's holding up the scales of justice that are falling apart in his hands, also a symbol of the time of the apocalypse when hunger strikes the earth."

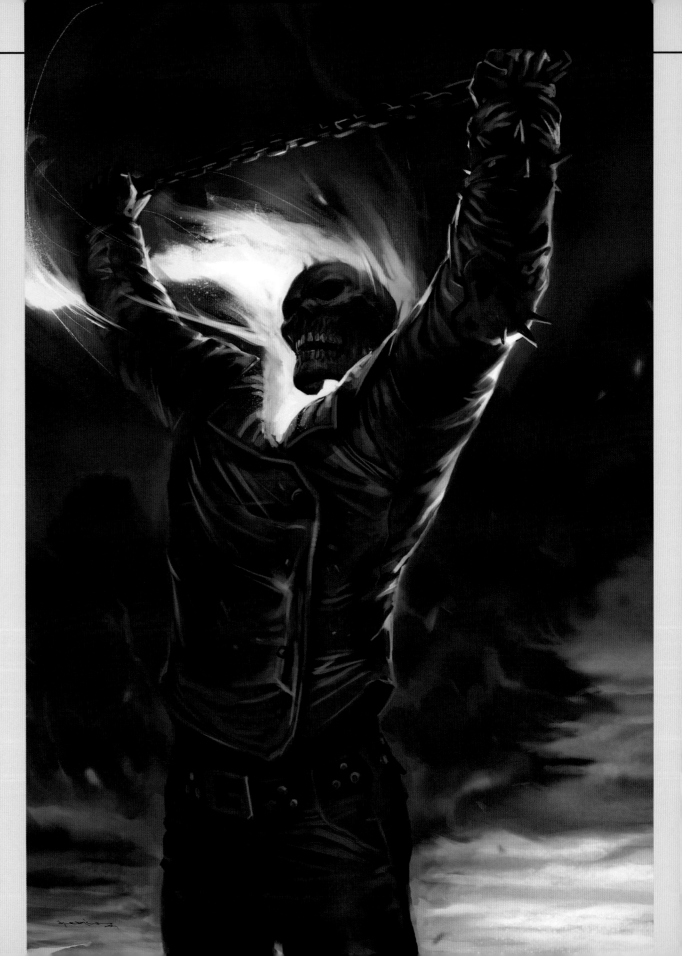

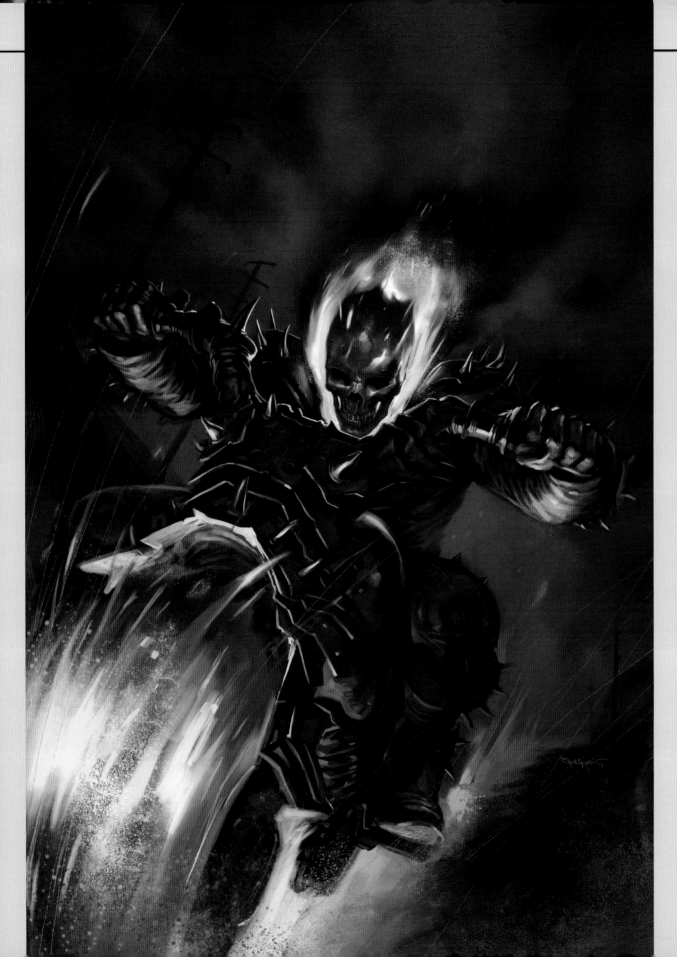

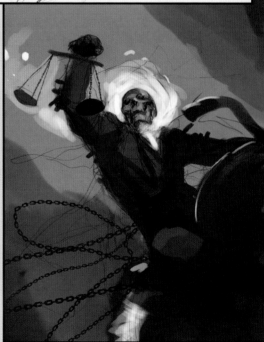

"These religious, prophetic aspects of Ghost Rider were all part of my initial attempts at outlining where I wanted to go with the character – and I really wanted to even go deeper with it – but it didn't fit the story that the writer was telling at that point. He wanted to go for more of a comedic route, and all the seriousness that I wanted to bring into the covers didn't really line up with that."

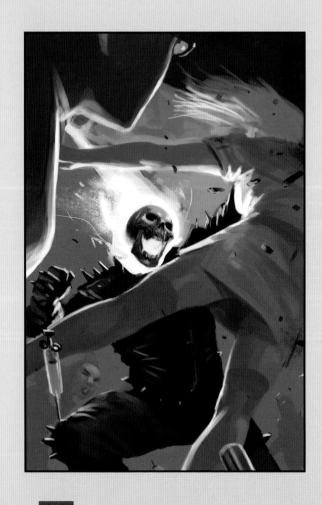

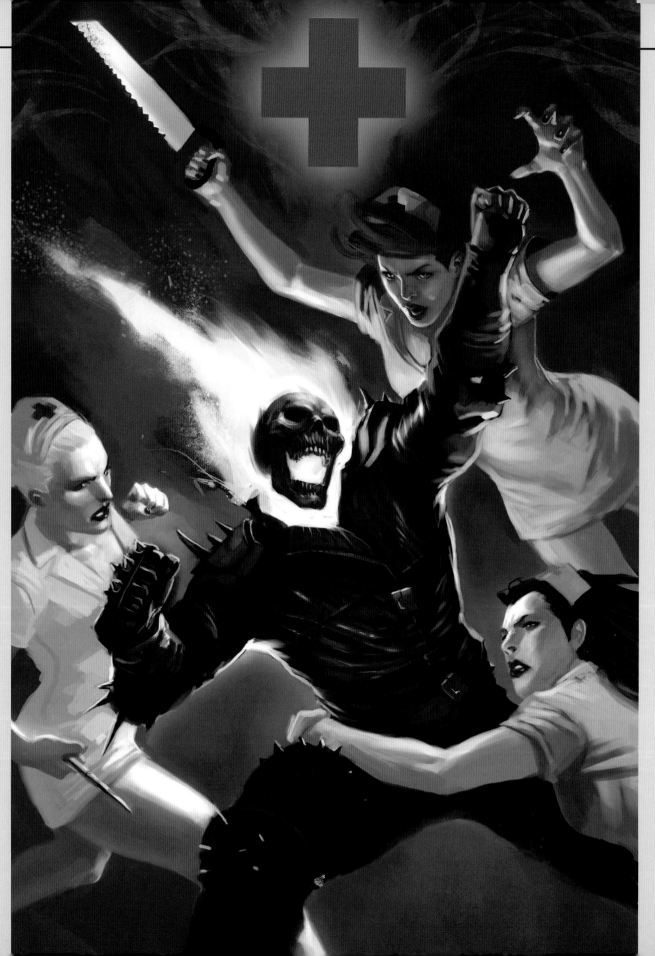

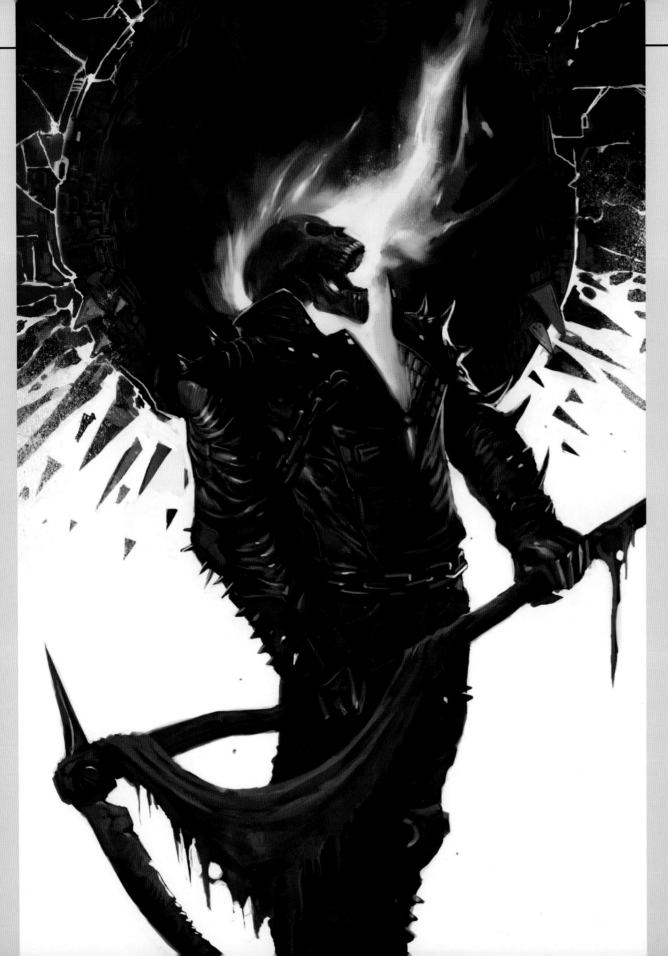

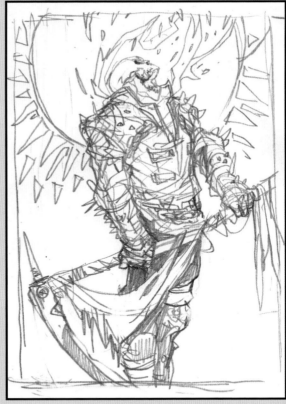

"I like this design, which brings to the fore Ghost Rider's very iconic stature; it has a lot of strength. It has him screaming and laughing towards the sky, which I interpreted as a form of mocking God and religion itself. He is a demonic herald walking the earth. The graphic design in the background represents a huge Mayan black sun, which is just a method for me to show how dark the character is. It's definitely not a 'hero' shot, not the typical iconic pose where you have the character standing in repose surrounded by a bright, shining halo. This one mocks, laughs, spits toward heaven."

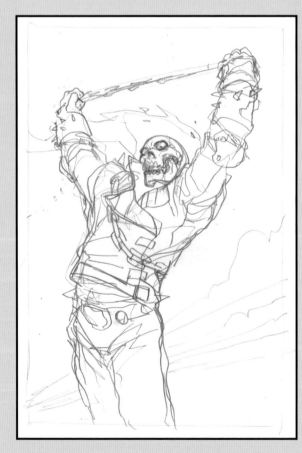

"For this mugshot, I really went in there and layered many intimate details around the skull, so on a painterly level it really has great appeal to me. It's one of those images where I could really go into the subject matter and try to make it as beautiful as possible – as beautiful as you can make a flaming skull, that is."

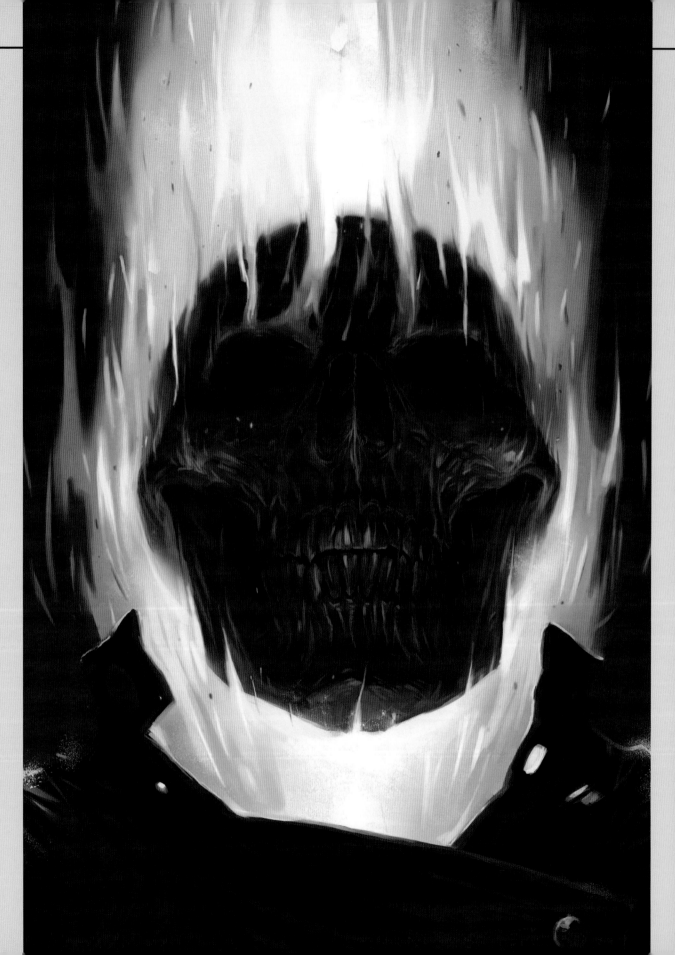

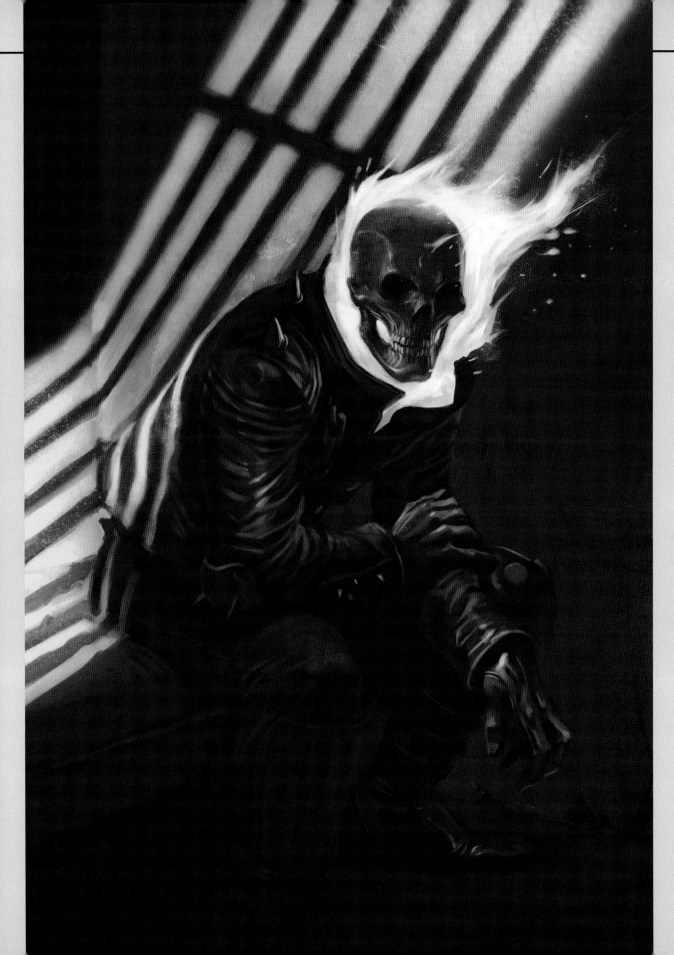

"If you focus in really tightly on the right side, there's some writing on the wall: 'Molly dyed my hair/She threw me through the air/I landed in despair.'

"Before I started working at Marvel, I would routinely do small sketches at coffee shops, and I would always have fun making rhymes and hiding them within the detail of my work. In this particular picture, it didn't turn out to be readable in print because the color values were so close together and it printed a lot darker. But I love hiding little Easter eggs."

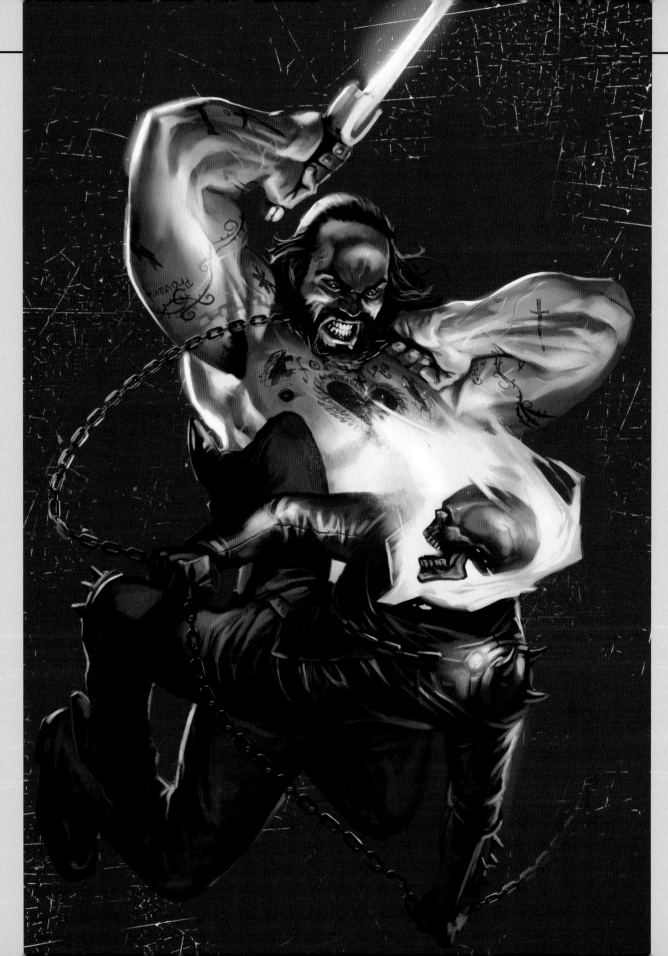

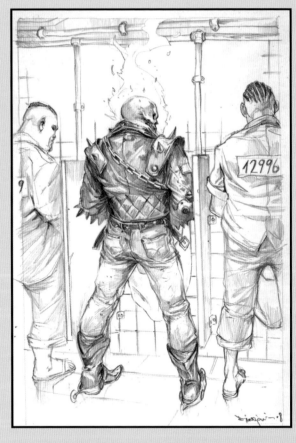

"By this time, I knew the direction they wanted the covers to be in was all about portraying the irreverent, humorous side of the character. This particular story was about Ghost Rider being in prison, so I thought I'd deliver one of the most obvious prison scenes ever – something like an inmate taking a leak and not having any privacy at all. Unfortunately, the editors thought that it was too politically incorrect and they didn't let me do it."

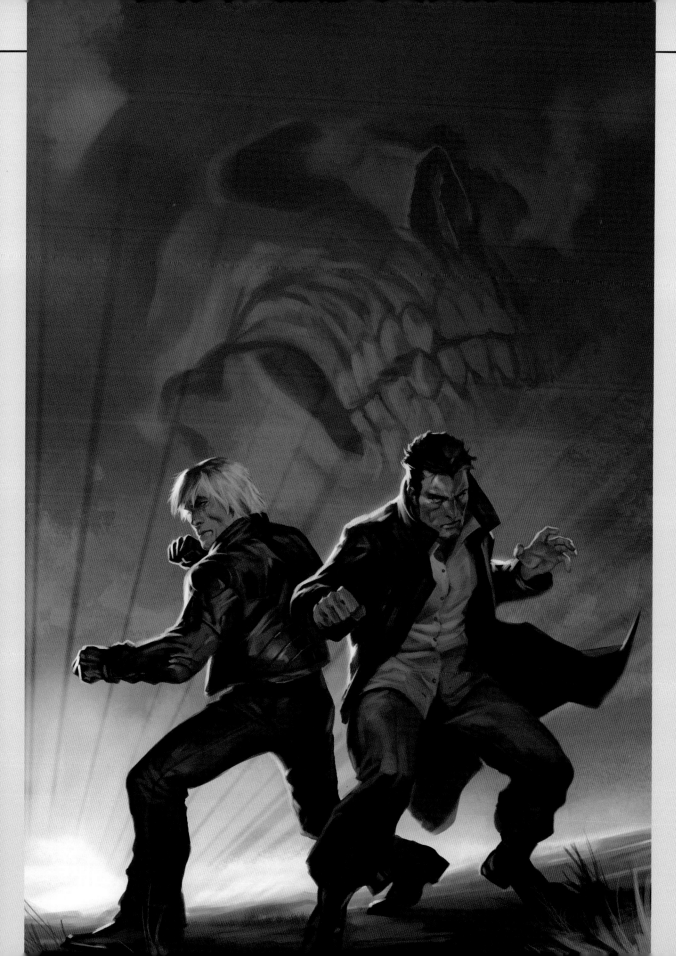

"They asked me to do another round of sketches, and I gave them the one with the bar of soap on the shower floor, the blood draining along with the bathwater. That one didn't get approved either. I thought it was a really funny idea, but they thought it was even crazier than the previous sketch. I ended up painting the scene of Ghost Rider sitting in his cell."

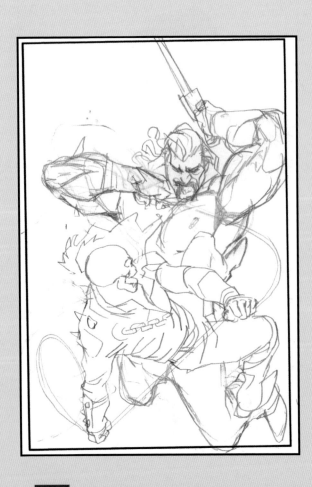

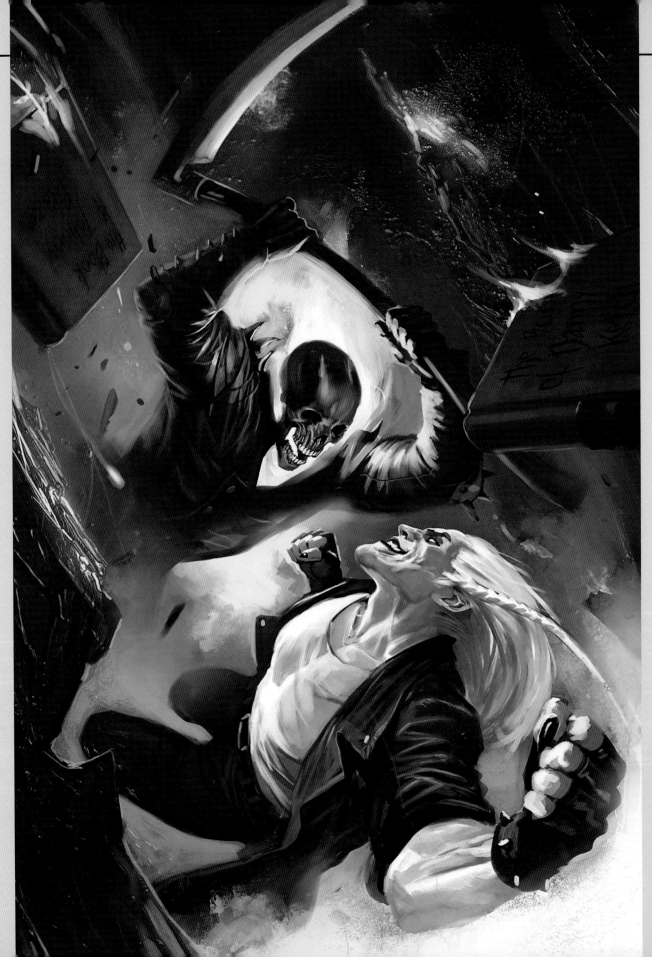

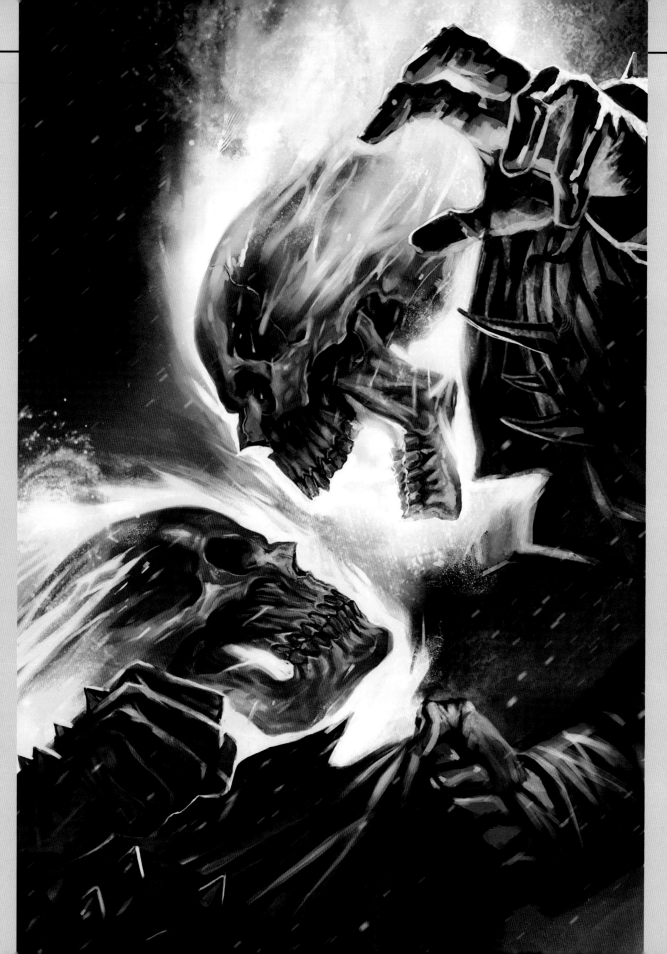

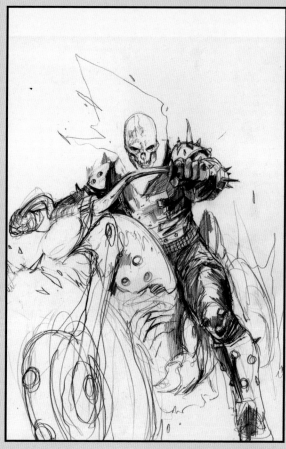

"This cover was unbelievably easy money for me. It was my last cover for the title, and I took a really simple approach. The issue featured Ghost Rider dopplegangers pitted against each other, so I just painted a red skull, a blue skull, and made it confrontational. This is not one of my 'high art' pieces, but it fit the needs of the story."

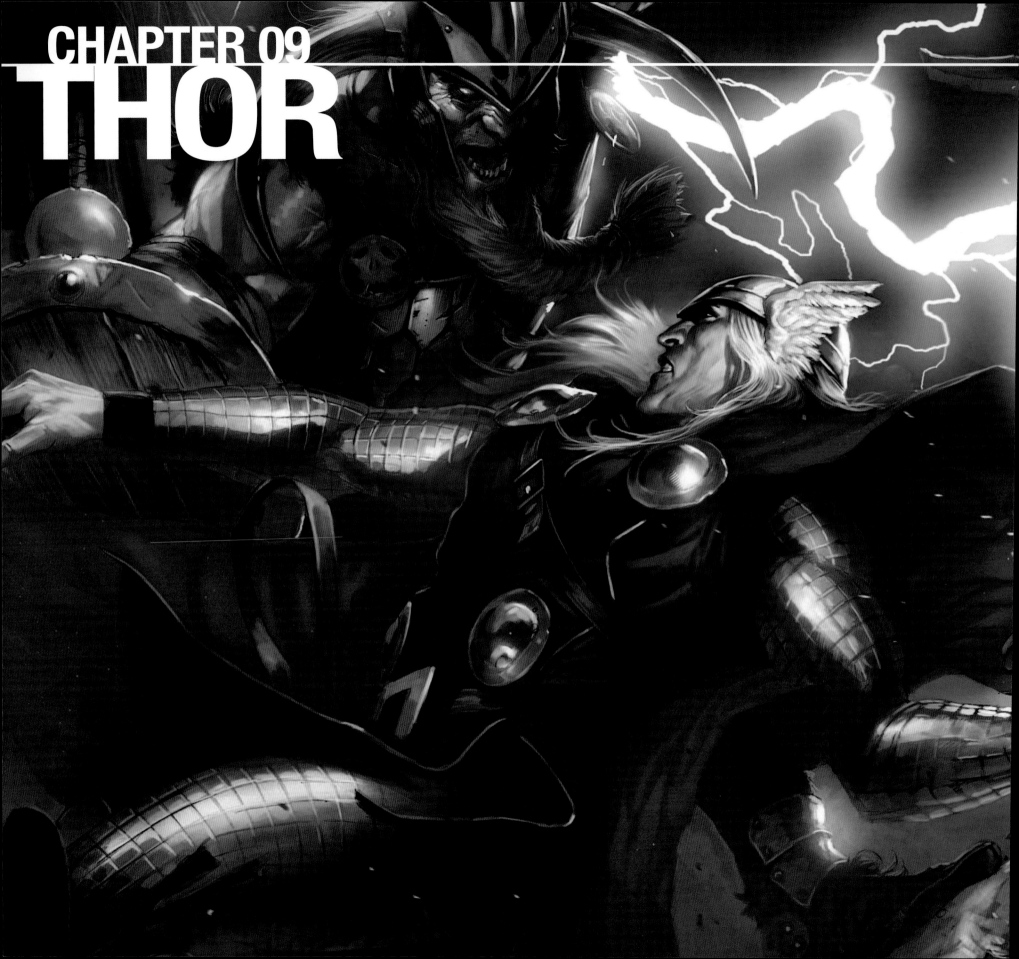

CHAPTER 09
THOR

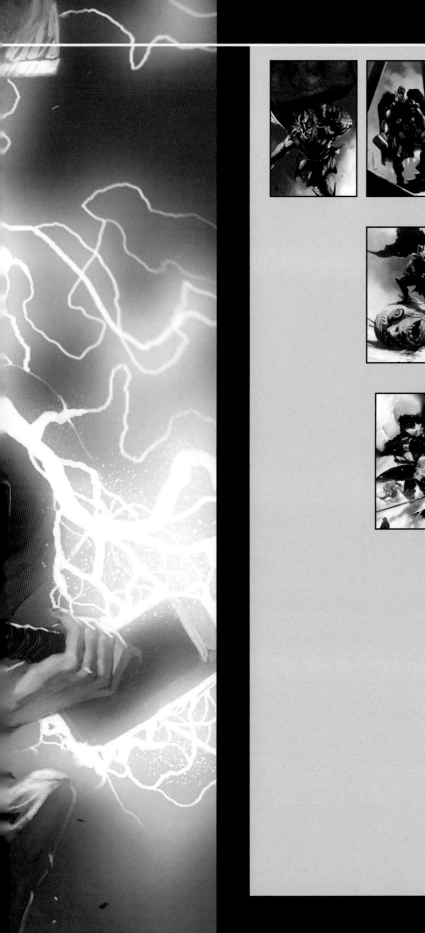

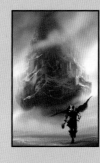

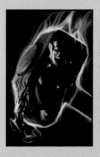

When Stan Lee and Jack Kirby extricated the God of Thunder from Norse legend and placed him amongst the contemporary pantheon of Marvel heroes, they did so in part because they needed a heavy that could – at least in the imaginations of their fans – go toe-to-toe with a certain Kryptonite-fearing, red-caped, do-gooder from their very "Distinguished Competition." Thor was power. Lots of power, all focused through the form of a noble, sometimes stoic, always dutiful son of Asgard wielding a wicked hammer with a funny name. If his deeds and pop art design cast him squarely as a contemporary super hero – indeed that "Superman" Marvel was looking for – the Shakespearean syntax of the words pouring out of his mouth, courtesy of scripter Lee, at least gave a nod to the godly grandeur of Thor's origins. Much of that conceit – though in a thoroughly modern context – remains in J. Michael Straczynski and Olivier Coipel's current revamp of the character.

But much of it is different. Specifically, whenever Marko gets his hands on Thor, a bit of that stoic nobility ebbs into elemental savagery, some of that discipline and duty gives way to the unexpected wrath of the heavens. And why suffer through stilted syntax when a brooding god of thunderous vengeance has a job to do that is best done without words? Marko's Thor lets the thunder do the talking.

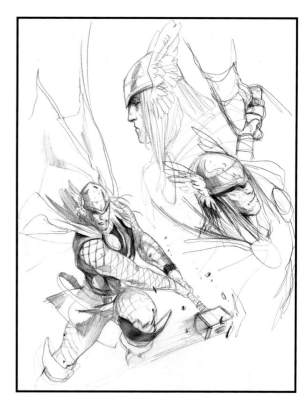

MARKO "I understand Thor through the Norse fables that I used to read as a child, from the early days when I was fascinated by mythology and spent a lot of time studying it, really getting into the gods and their stories. There, Thor was always a raging and spiteful god, and to this day I associate those emotions with the sound of thunder. He's not a god of the sun or moon or some part of the animal kingdom. He's not like the classical Zeus or the Egyptian Horus. He's a god that goes around causing a lot of noise, generating a lot of anger and devastation – all that behavior is very fearsome. And I want to capture some of that elemental fear when I draw him."

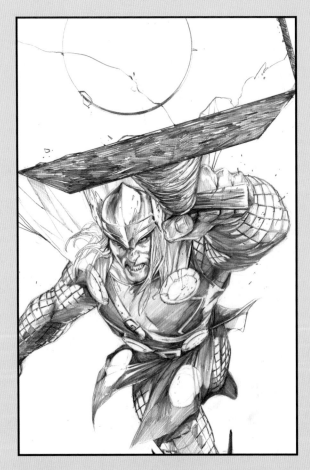

"Being associated with thunder is, I think, much more scary than being associated with the sun. A storm is largely unpredictable, especially in the distant past when the Norse fables were first being constructed; people must have thought storms represented something beyond mere changes in weather. They didn't have the scientific knowledge to know how it was that the clouds began appearing, or why the storm was coming and the thunder rolling. They must have considered these events to be the powerful anger of the gods."

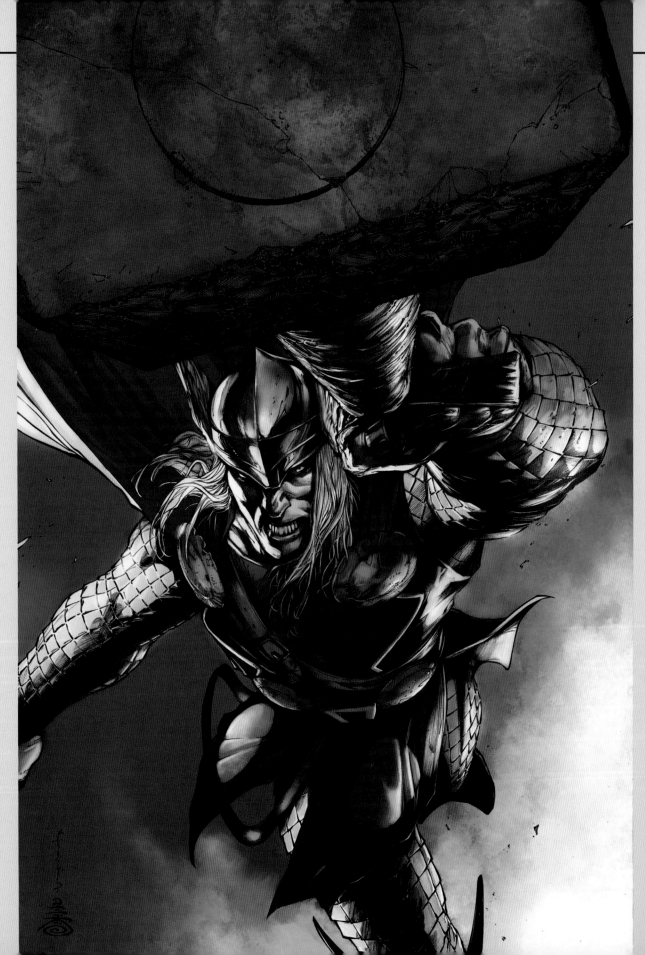

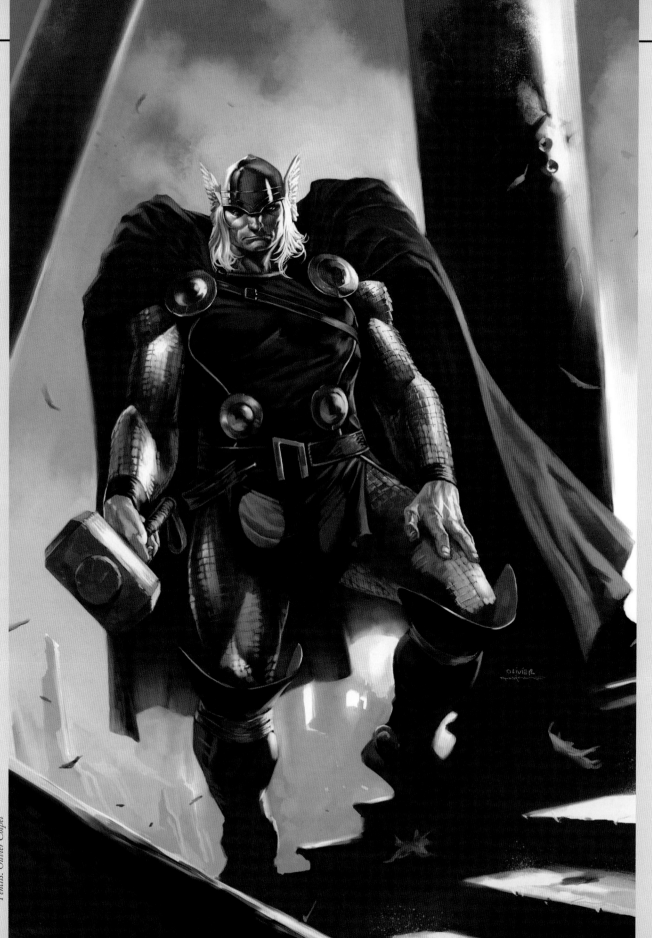

Pencils: Olivier Coipel

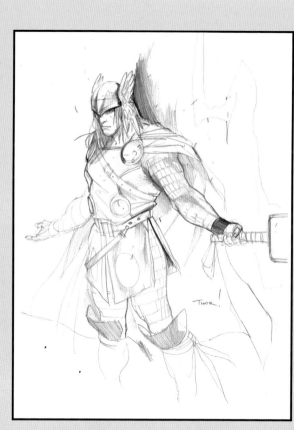

"Painting over Olivier Coipel's pencils on this variant cover was definitely a fun project, and I was able to do it three more times over other artists' work as well. I didn't have to think about drawing at all. I received their already completed pencils and could spend all my time with a sharp focus on the quality of the painting and how to make it as expressive as possible. I enlarged the initial figure, switched the perspective a bit, moved stuff around, and I laid in elements of the background and the foreground. I still wanted to keep Olivier's pencils visible through the painting process and not destroy the design sense he created, but really make it an amalgamation of both of our talents."

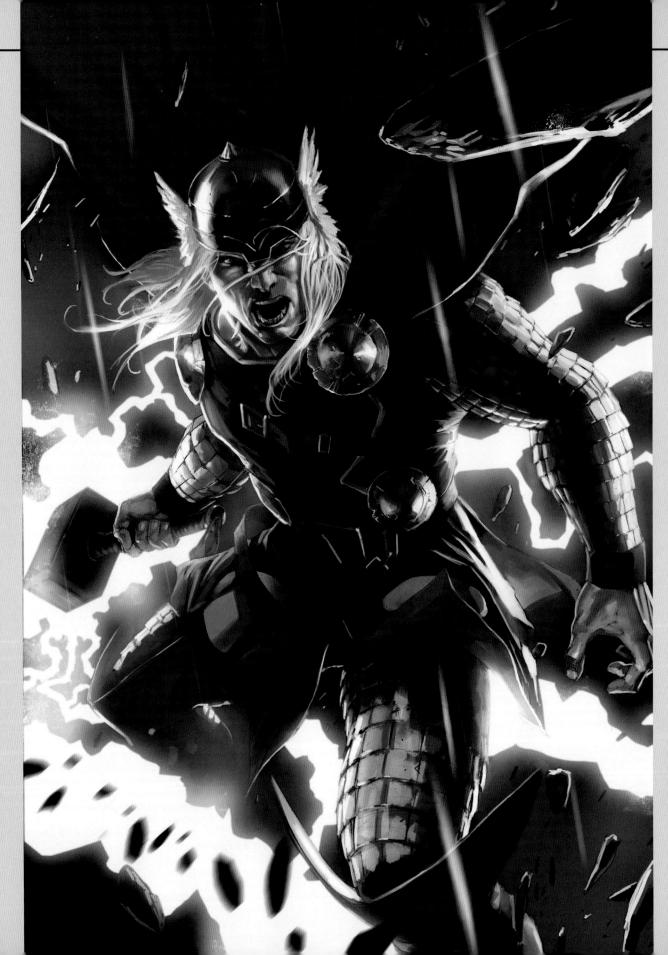

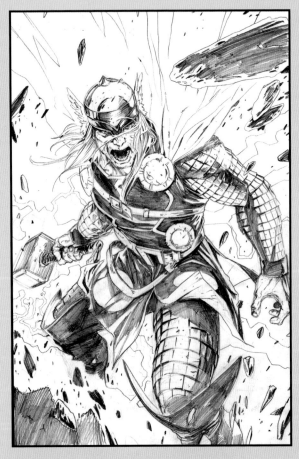

"From an artistic standpoint, it was a really cheap trick to get this cover done, because there's nothing easier to paint than lightning. It's just flat, white color with a little bit of airbrush on top, and you've got instant lighting. You add your jagged lines and the cover is practically done."

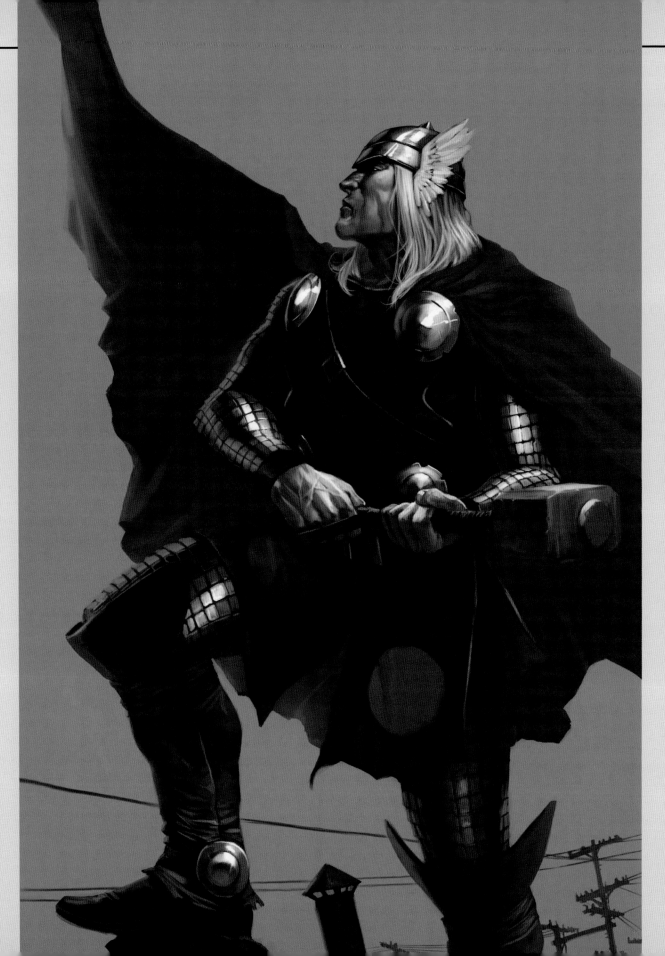

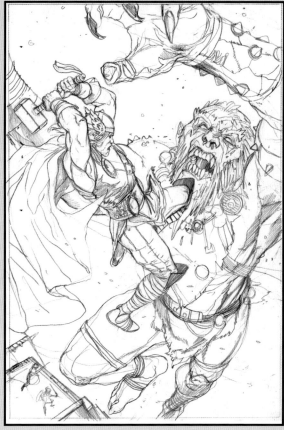

"This was initially planned to be the cover of the *Ages of Thunder* one-shot, but at the time I was painting it, nobody was fully aware of the plot details of that story. As it happened, it wound up being unusable for *Ages of Thunder*, which was set in a completely different time outside of the current series and didn't have Thor wearing his contemporary costume. Just as I found out this information, I had finished the piece! It has never been used for anything, but we may see it used as a cover for something down the line."

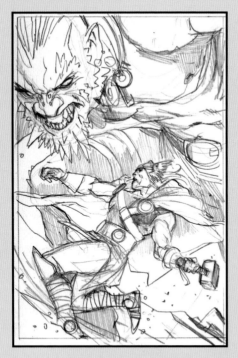

"I really liked the covers of the one-shots: *Ages of Thunder, Reign of Blood*, and *Man of War*. In them, Thor is a bit more removed from continuity and the costume shows it, as it is more oriented toward the classical stories of Thor that I grew up with. You can see it also in the nature of his foes: These aren't the typical 'super hero' Thor covers. With this picture, he's standing on top of a Frost Giant that was just slain, evoking the classical David versus Goliath theme, except in a Norse context."

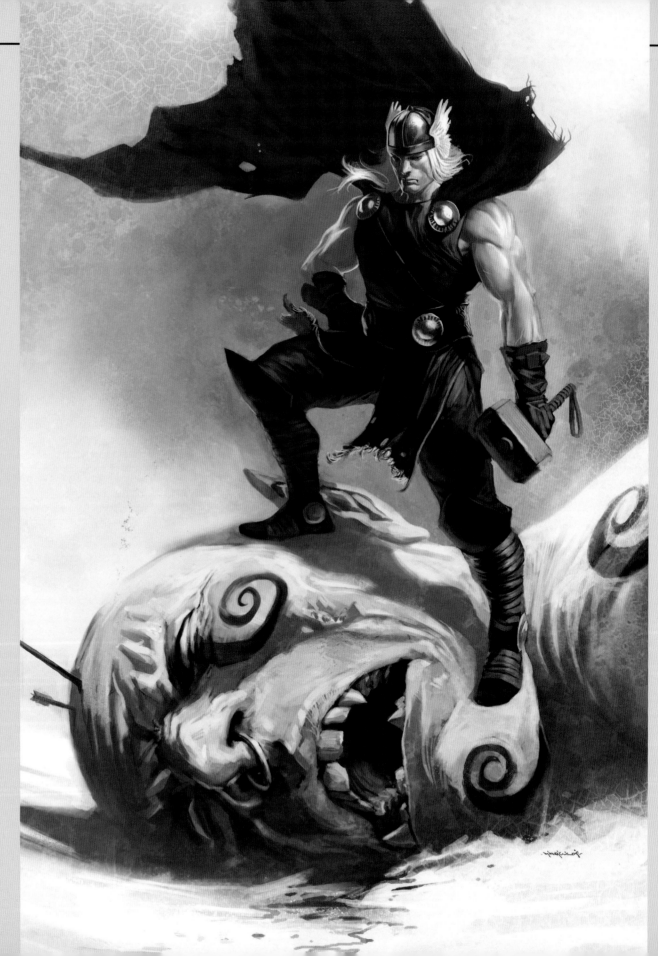

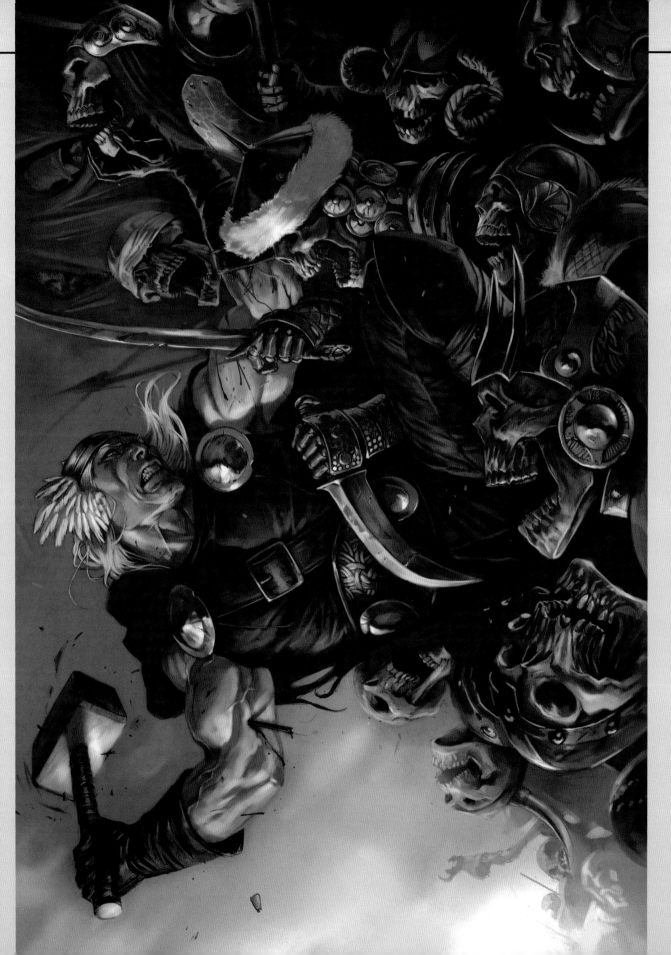

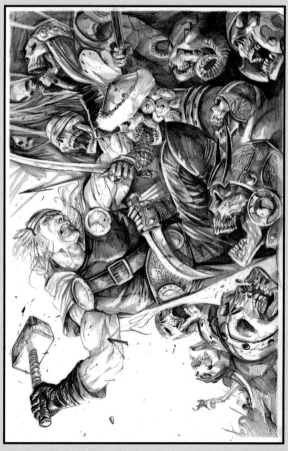

"The Reign of Blood cover grabs me because of the flood of
skeleton warriors that are raining down over Thor, and it seems
like he's fighting a wall that is collapsing on top of him. I like the
composition in that one a lot."

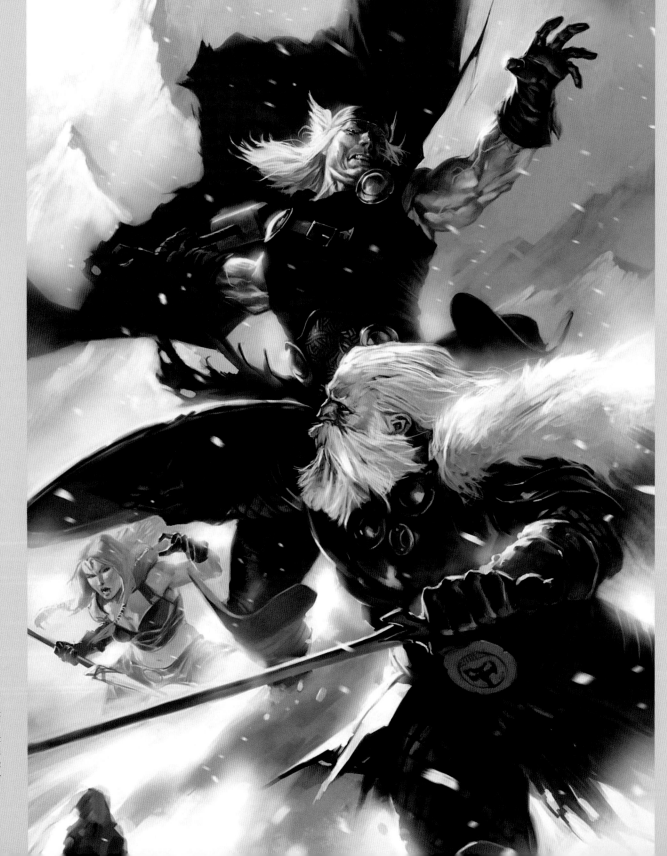

"My favorite of the series is *Man of War*, which was the last of the one-shots that I did. In particular I love the effect of sunlight reflecting off the snow. I just imagined what it would look like if they were really fighting on top of a mountain in broad daylight with snowdrifts all around them, with the light reflecting back on their white fur, their pale skin and blonde hair. I really had a lot of fun with my painting on this cover in terms of how I used my strokes and how fluidly it all came together as an overall image."

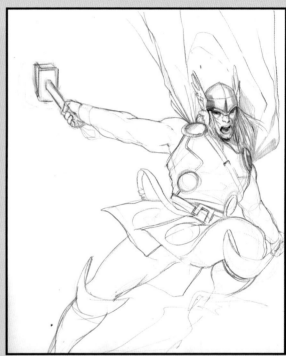

"(Editor) Warren Simons had a particular scene in mind that he wanted shown on the cover, which was based on a Walter Simonson Thor story from 20 years ago. [*"Like a Bat Out of Hel!"* from Thor #362.]

"You can just imagine this as the cover art to some '80s heavy metal album. Everything about this cover is cheesy to me; I really feel it speaks for itself. But I know a *lot* of fans loved it. I guess there are a lot of people that are into cheesiness!

"When I was growing up in a rural part of Germany, I didn't have a lot of art books to collect because there was not a comic book store where I lived until I was 14, so the only fantasy influences that I got early on were from heavy metal album covers. And because my brother was listening to that crap, I would sit in his room and just stare at those covers full of overladen Viking warriors fighting each other with lightning crashing down around them. Pretty much every cliché that you could possibly imagine about Norse mythology always seemed to make it onto those covers. I really wanted to recreate something that had the same kind of feel to it, so that was my inspiration."

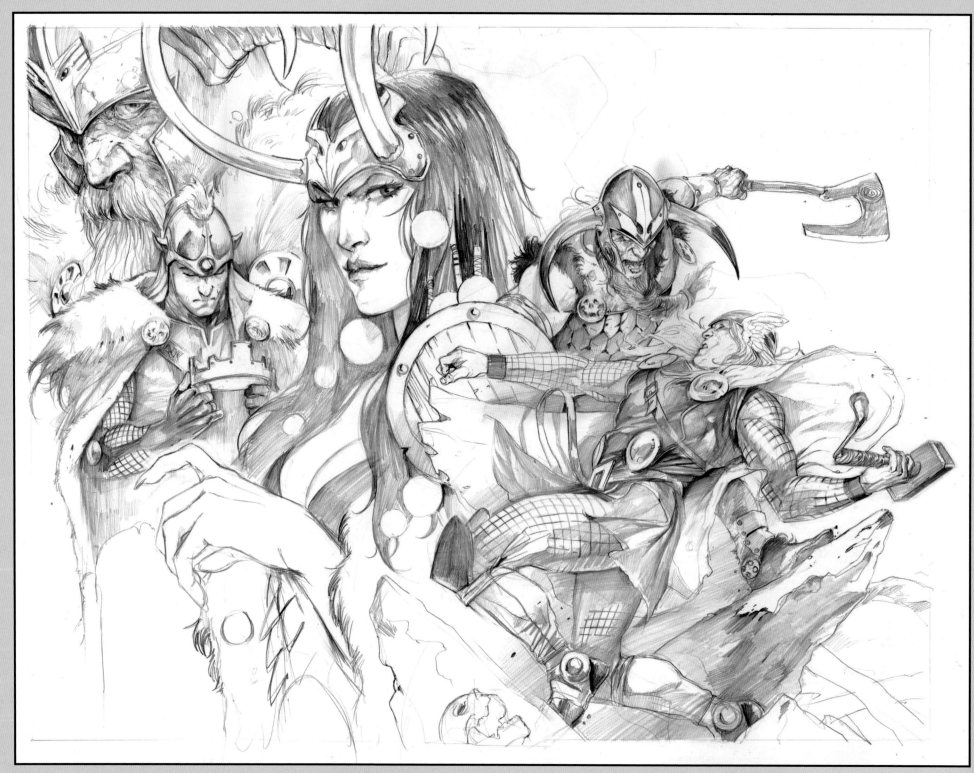

"What can I say, this truly is a work of art. It has all the drama and grandeur worthy of the Asgardians. Marko's rendering on everything from the flesh and hair to the metal and fur is just astounding! His light sourcing is so luminous that it looks lit from within – not to mention dead on. One of his best works to date." – **Chris Allo**

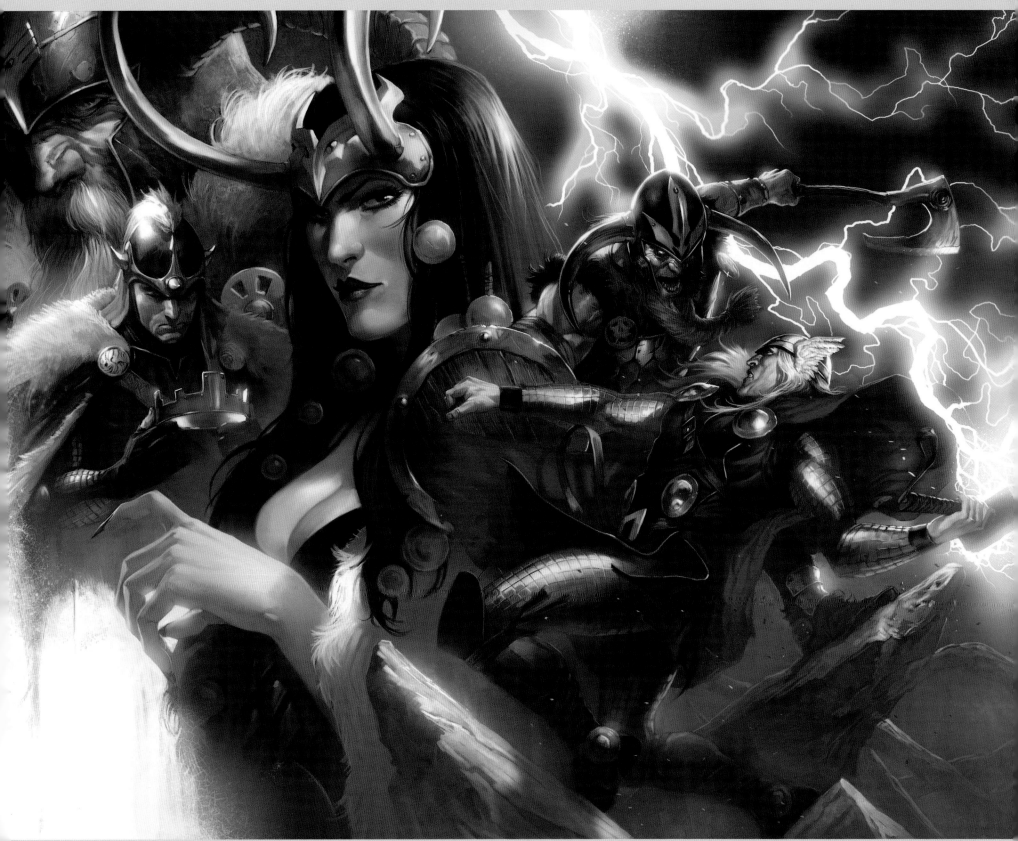

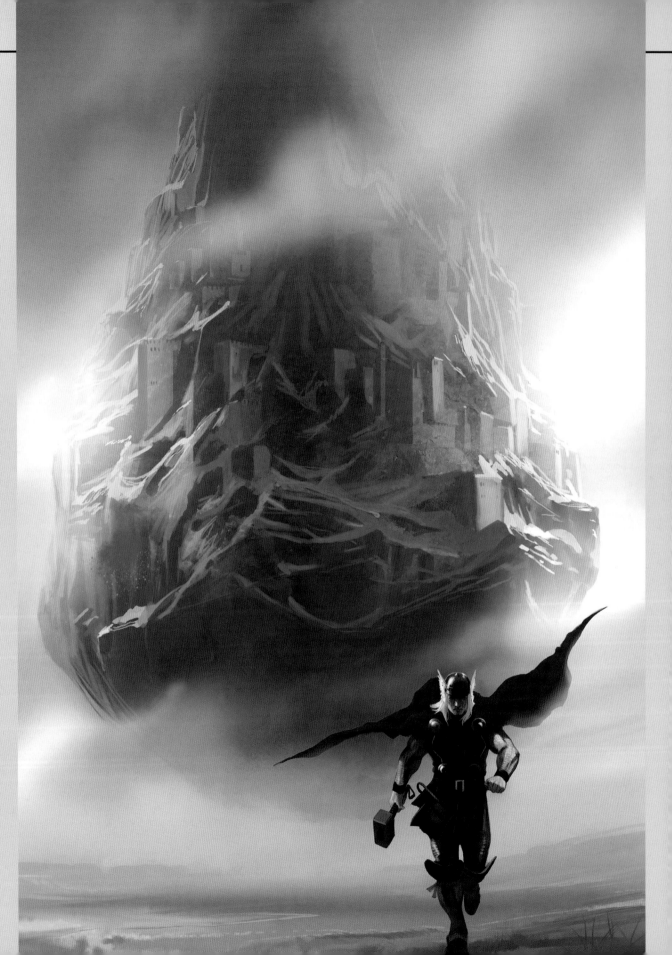

"This was a real pain to paint because Thor is so unbelievably small in the picture. It was such a struggle to give him form and volume in the limited amount of space that I had to work with and still not over-render it. From a painting standpoint, it was a really tough assignment to do."

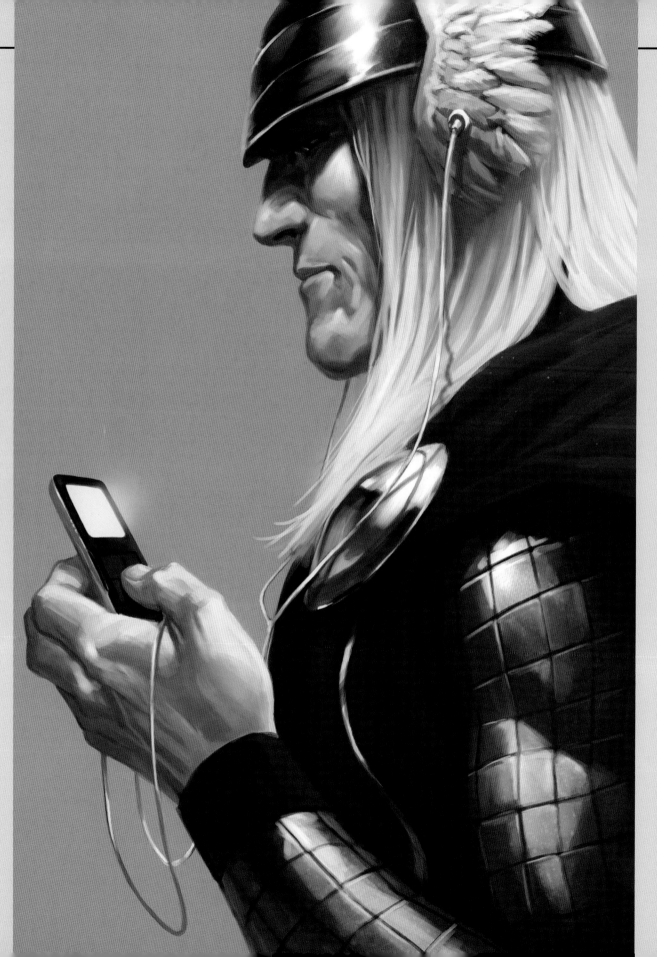

"I must give credit to my friend Andrew Jones for this because he's actually the one who came up with the idea. He was visiting over at my apartment just after I got the assignment for the cover of #601, which came with the request to illustrate something which played upon the idea of Thor leaving Asgard and becoming more a part of the mortal world. I sketched out the cover that was eventually used on the regular edition of the issue, but I wasn't really happy with it.

"So I turned to Andrew. Since we used to closely work together for so long, I asked him what he would do if he were in charge, and he said, 'Why don't you draw Thor listening to an iPod?' And I cracked up so hard! I didn't believe anybody at Marvel would buy it — I was sure they would think I was going crazy, but I still thought it would be good to at least give them a laugh, so I drew it. They loved it so much that they actually asked me to do a variant of it. By the end of the process, it really drove home the point that Thor was leaving Asgard!"

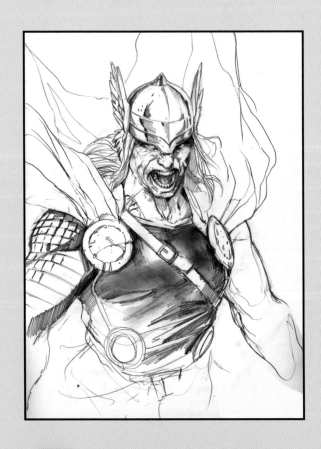

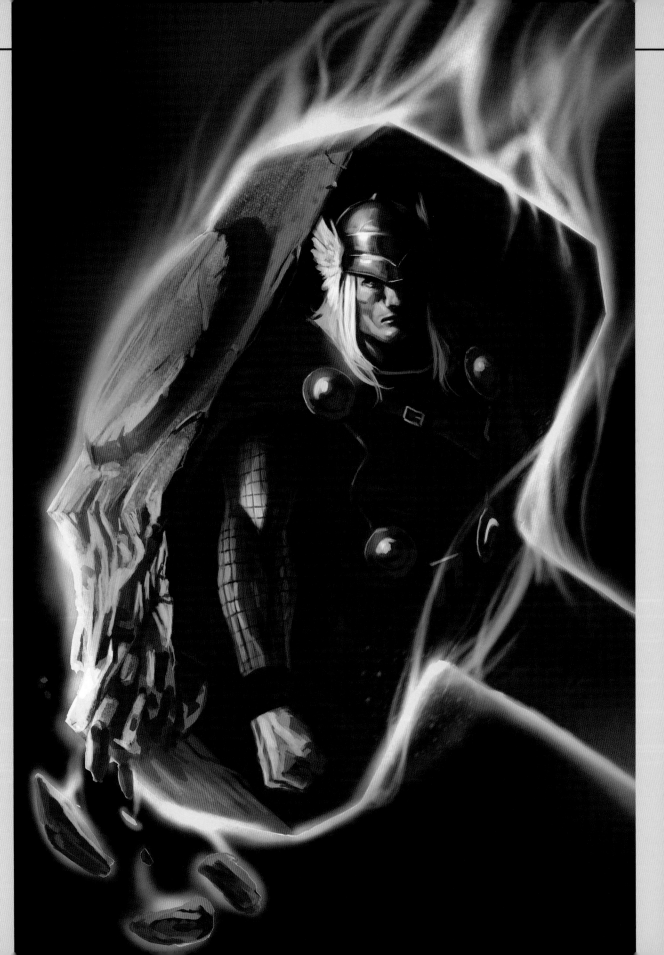

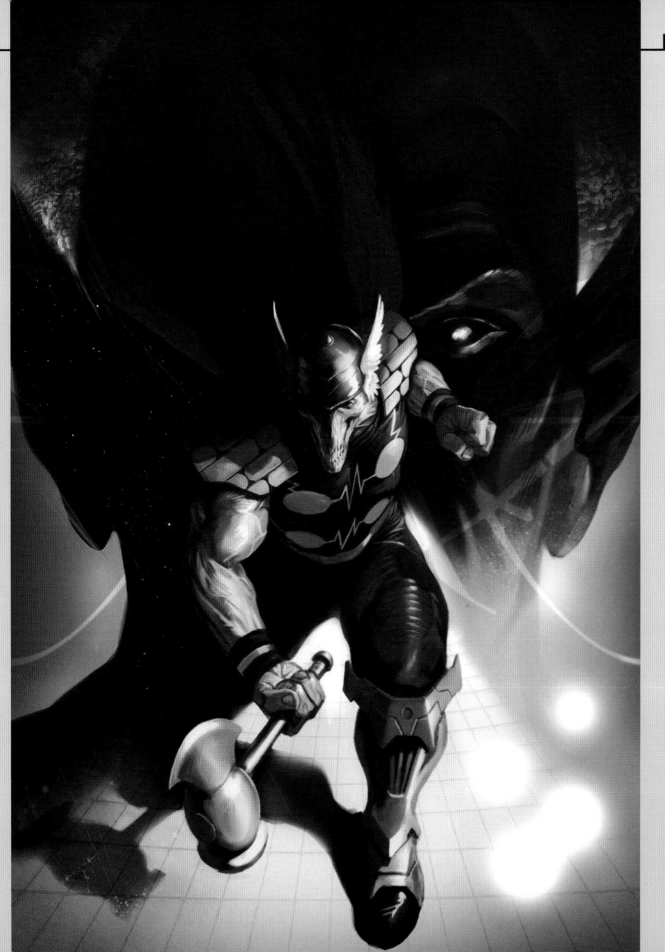

"Beta Ray Bill is such a *weird* character. Everything about him is odd: He looks like a horse demon with three fingers, a hammer and a helmet. I've never in my life had a connection with the character. On the other hand, from an artistic standpoint I always love tackling characters that I have no previous exposure to. It's exciting because of the challenge."

AVENGERS

By the time of Marvel's 2008 event, Secret Invasion, *the heroes of the Marvel Universe either had been replaced by Skrull doppelgangers – or thought to have been replaced. It was a time of great disorder and paranoia, with the Avengers at the crucible of it all, but it wasn't just a concern for the comic book good guys! Marko must have thought he had been kidnapped by Skrulls as well, as his desire to create new designs and concepts was temporarily hijacked by a series of homages to classic Marvel covers – all adorned with Skrullish new textures – that topped eight issues of* Mighty Avengers. *(The original cover art by Messrs. Kirby, Buscema, Miller and more are set next to Marko's contemporary renditions in the back of this chapter.) Still, one gets a sense of Marko's approach to characters like Captain America, Iron Man, and writer Brian Michael Bendis' multiple cadres of* Avengers *in the assemblage of variant and one-off covers gathered here. His work is moving, innovative, and ultimately, heroic – at a perfect narrative pitch with the life and times of a team that has always been at the soul of what Marvel does best: tell stories.*

MARKO: "I was really stoked about being able to paint the roster of the Mighty Avengers. I think as a group they had the most perfect color scheme of all groups, ever. They're all either black and yellow, or red and black, or red and yellow. Those are their three colors throughout the entire book."

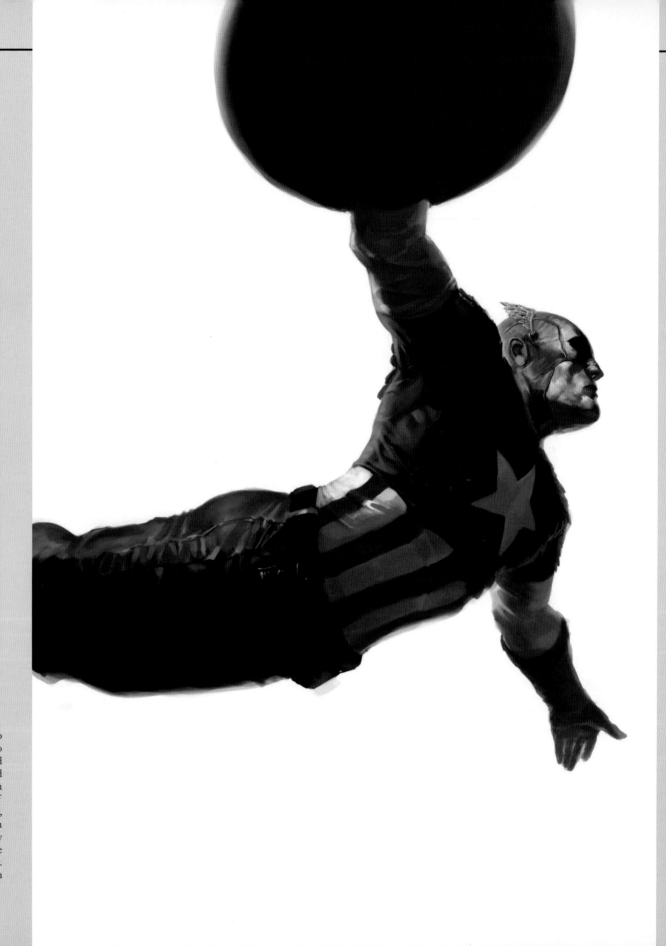

"I painted that shortly before Captain America died. And I had no clue – *no clue* – about the story line at that point. I just wanted to paint my interpretation of Captain America. I was sitting around with the weekend off, and I felt like playing around with colors and forms, and I came out of that with *my* personal vision of a Captain America cover. I shared the cover with Chris Allo and a couple of other guys, offering it in case they wanted to use it for anything, and they came back to me and asked me if I knew about the death of Captain America, or if anyone had told me about it. Everybody was surprised that my coincidental painting had captured the theme that they would be able to be use on the *Captain America #25* cover. They offered it to the British market as a variant and so it went from a weekend experiment to a published cover almost overnight."

"In contrast with the UK variant, I knew all the details of Captain America's death by the time I developed this cover. Panini, the German licenser of Marvel, was doing a collected edition of all the Captain America stories leading up to his death, and they asked me if I could do a striking image of him dying. That's what I gave them: a close-up of him lying on the stairs bleeding out of his nose and his mouth, his eyes fixed on the viewer. It's the death stare of the hero. The perspective in the shot was something very complicated to do, especially with the foreshortening of his hand reaching forward. I added traces of paper falling in the background to add some more dynamics, and I wanted to keep the figure mostly shadowed with just a little rim of light shining on him.

"I use white here because it's a clean color, it gave me the opportunity to make an image read completely differently than if I was just putting black in the background. Black would have just killed the entire image; it would have been such an obvious choice."

"To represent the breakup of Luke Cage and Jessica Jones, I designed a split image. The reason I layered in all these graphs and stats is because I wanted to show the mathematics of a relationship, how most of the time it's bloody and splits apart after a while because it doesn't add up, so to speak. It was more of a symbolic way to describe the breakup, showing all the different calculations in which they could possibly be separated from each other."

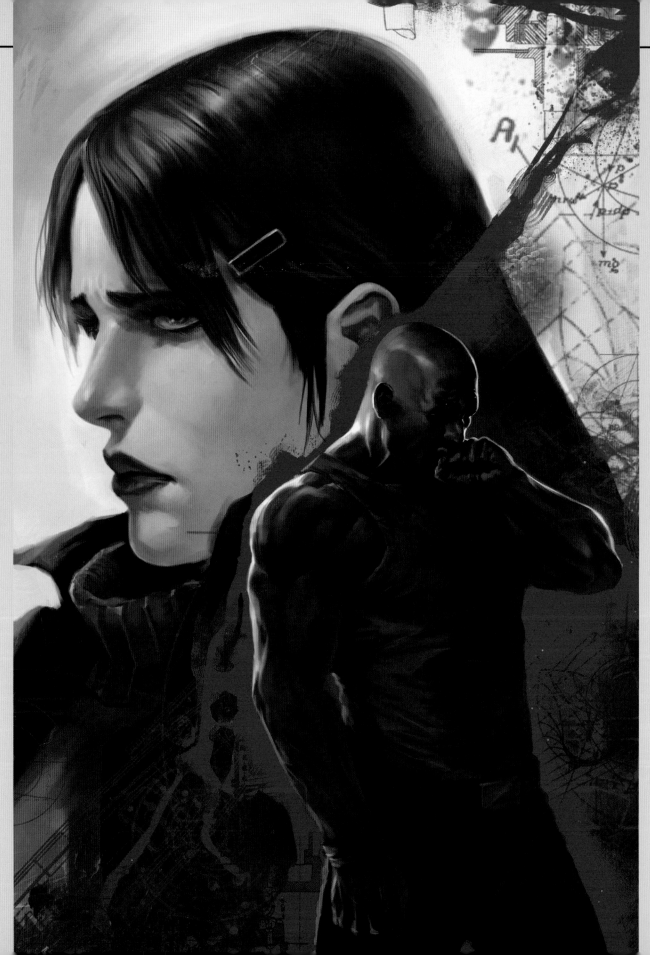

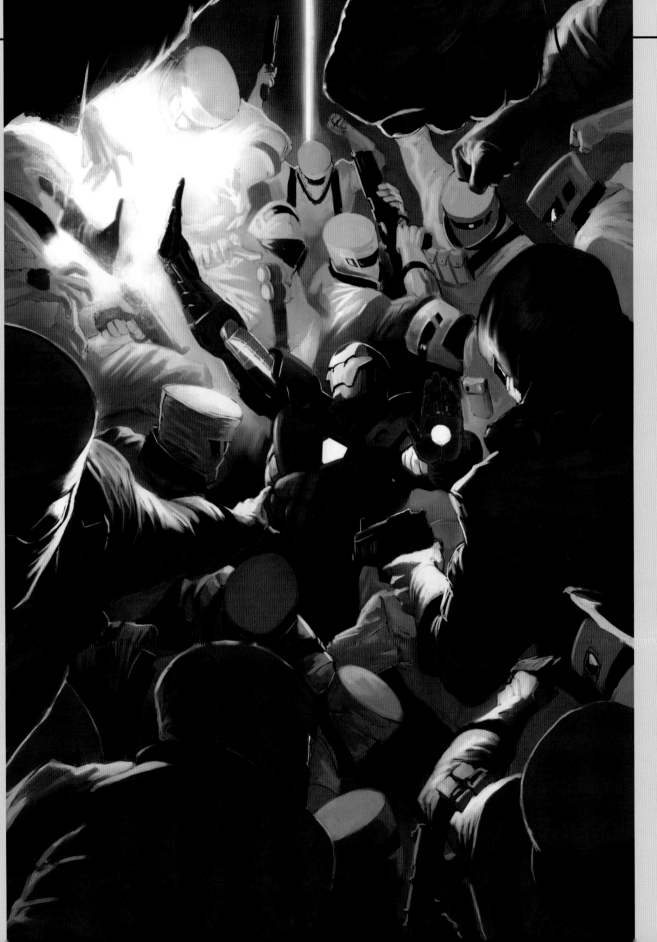

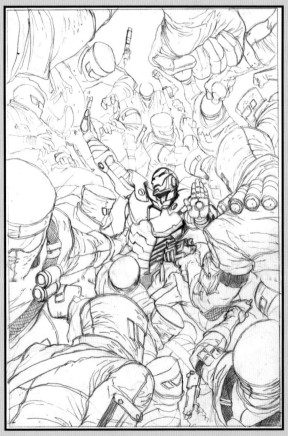

"This cover is a classic Warren Simons cover. He was the editor on this new Iron Man title, and every time he launches a book he asks me to draw the main character fighting hundreds of other characters. Ever since I delivered the *Daredevil #100* wraparound, he thinks I have the most fun with drawing ridiculous amounts of bodies on a cover!"

"I really love this cover for its fury and intensity. Ares: God of War, Unleashed! This piece is so visceral and raw, it's fantastic. He make the hero's flesh textures sort of like stone as if he's one of those grand Greek statues come to life. I love how Marko lit him from underneath. Ares looks like he's rising from the pits of the underworld to take on demons from another world. He's not taking any prisoners..." – **Chris Allo**

"Originally, the story in this issue was to feature Ares, but they changed it up at the last minute and they couldn't use the cover I had generated; it wouldn't have made sense to put Ares on a cover of a book he wasn't in. I had to replace it with another classic cover homage, which was disappointing because I liked the Ares cover a lot. He is a great character – one I have a lot of fun painting. I cannot get enough of Greek mythology. *The Odyssey* was a favorite book when I was growing up and I was *completely* lost in the worlds of Greek mythology. Everything about it, from the gods to the heroes to the mythical creatures, is a trove of interesting things to reflect upon and then work into my art.

"I am not so crazy about certain details in his costume, like the skull and bones design, but I cannot be redesigning every character that is out there. I definitely like the action in the picture, its energy, and the entire flow of the image really gives me a good feeling when I look at it. I consider this to be a successful painting."

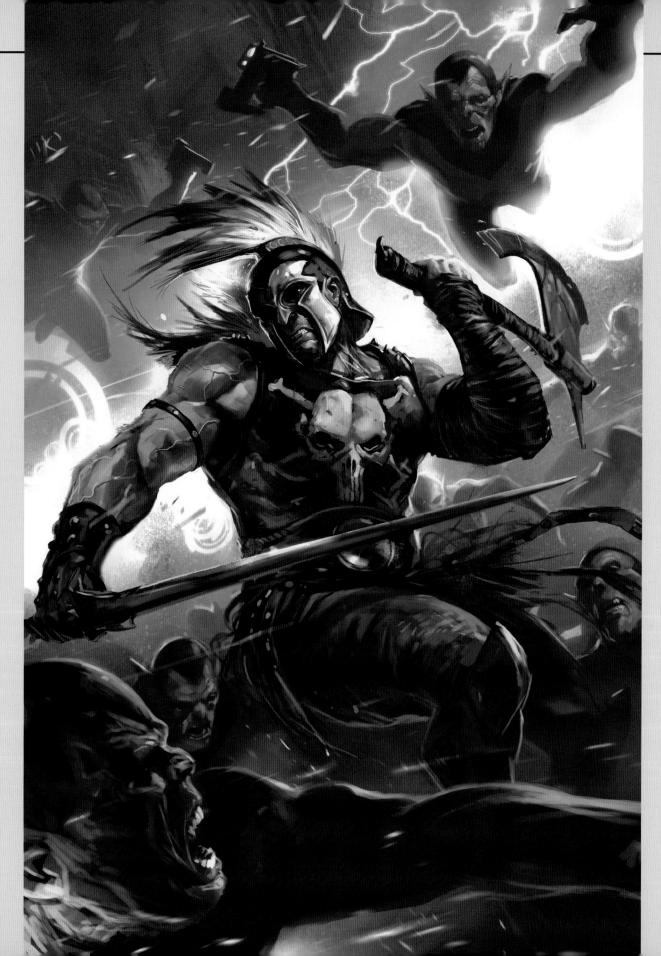

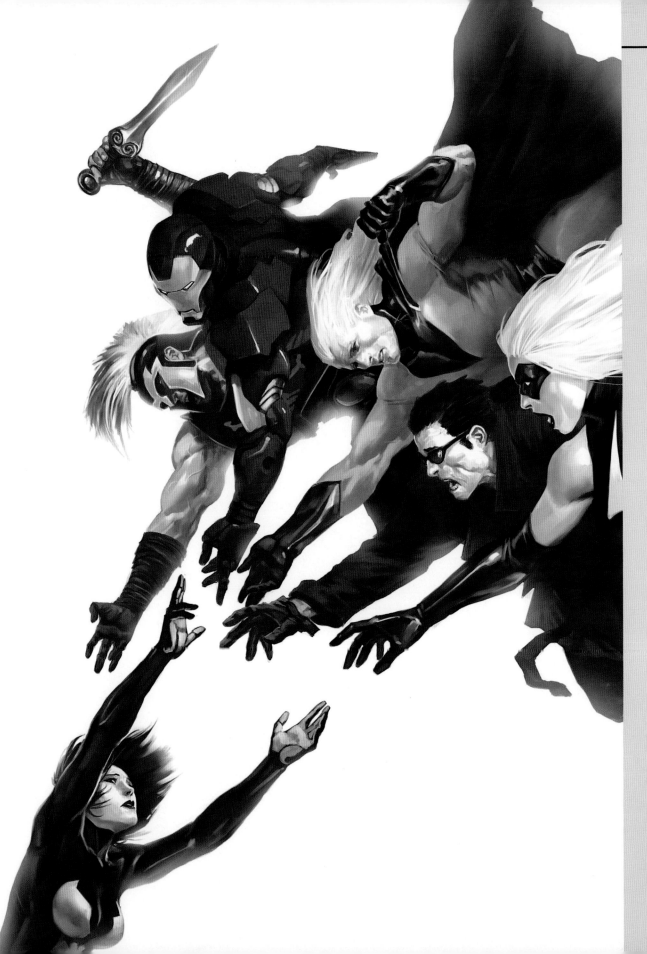

"The Wasp here is very soft and very vulnerable, which was the entire concept of the image. I wanted to show her passing away, with a kind of mellow resignation to her figure. She's accepting what's happening to her, accepting that she's dying. I think you see far more frustration and trauma in the heroes that are reaching out for her than you see in her face."

"Again, I though the color combination of this group of Mighty Avengers was *so* amazing, because it allowed me to mute the colors and just let the red speak for itself. Artistically, it was a lot of fun – but then they switched the entire roster around, which really bummed me out because I would have loved to continue working with that set of characters."

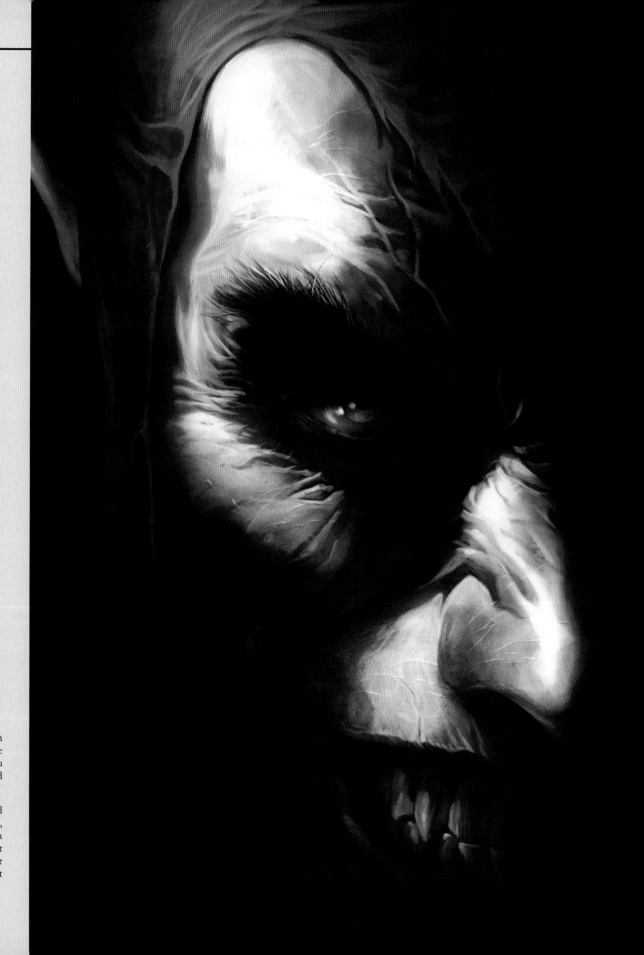

"If anybody would ever let me, I think I would set up a gallery with super heroes that are all covered in shadow. I think a simple image like this is far more striking than an overly complicated one. You can take this image and blow it up to ten times the size and it would make a perfect movie poster.

"I like creating impact through close-ups, really going in there and showing all the veins and the skin textures and the facial structure, giving the viewer some details to appreciate. I think from a promotional standpoint it was very successful, because that's what they're looking for: it has to have the impact. You want the reader to stop, enjoy the image for a second, and then read the text that accompanies it."

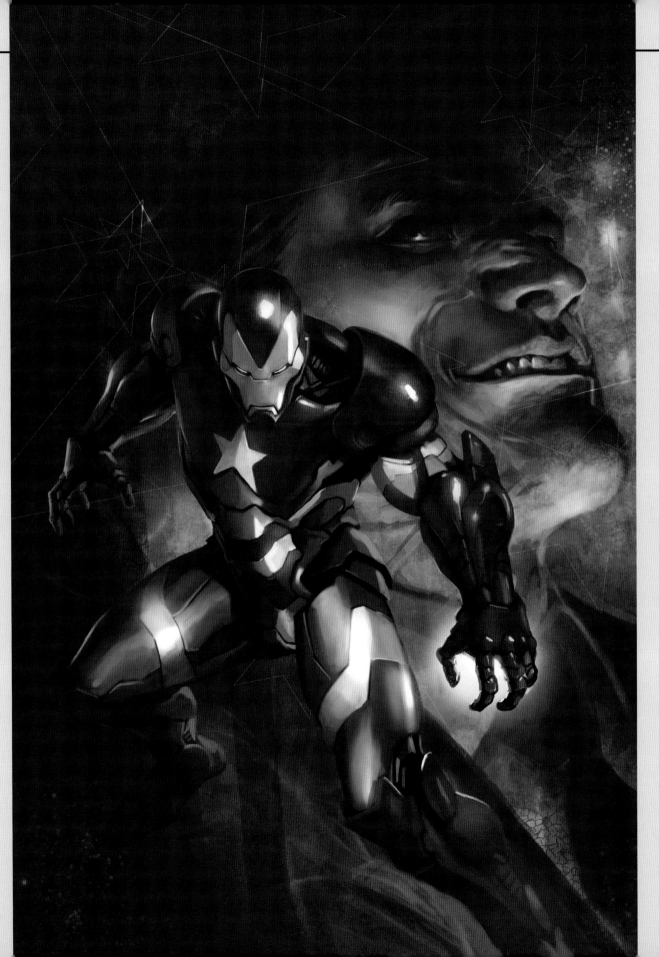

"I had so much fun doing this cover, because I did it while I was delivering an art lecture. I had ninety students in front of me, and they asked me to explain the entire cover-building process to them. I started from scratch in the morning, and finished in the late afternoon, and I was able to present the entire process to the crowd. Everybody clapped and cheered when I completed it.

"I created two layers: the new Iron Patriot armor designed by Norman Osborn and, behind him, a shot of Osborn himself. I gave the background design a sheen that resembled an old, grainy film that clearly contrasted the shiny, bright, new super hero – the leader of the Dark Avengers who is appearing in public and showing off his armor for the first time. It just showed the thin line between those two characters: the shining knight out front and the mad mind behind it, power hungry and covered in shadows."

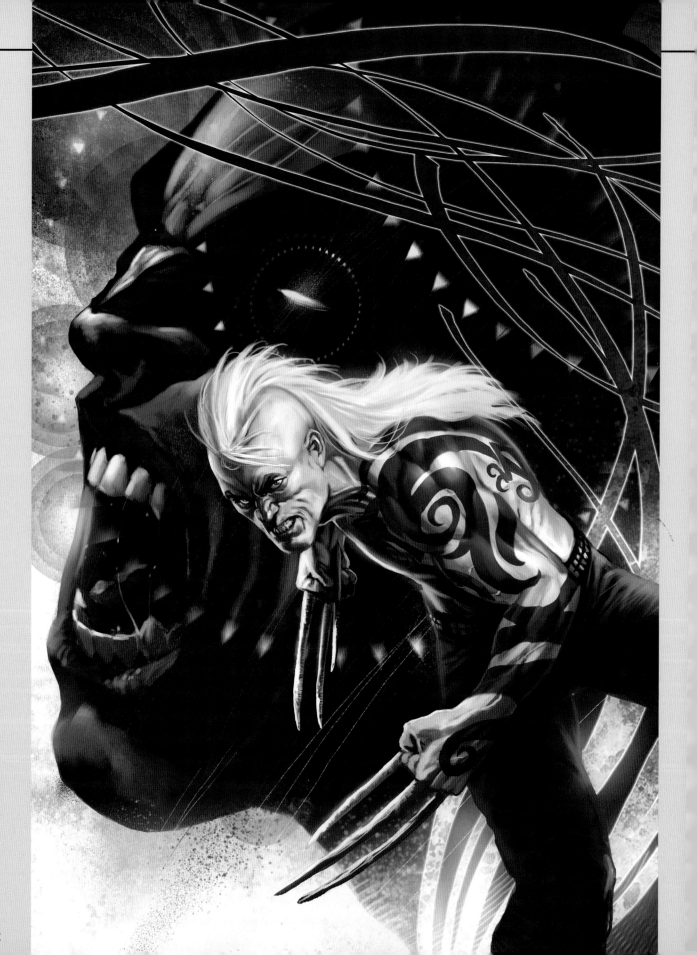

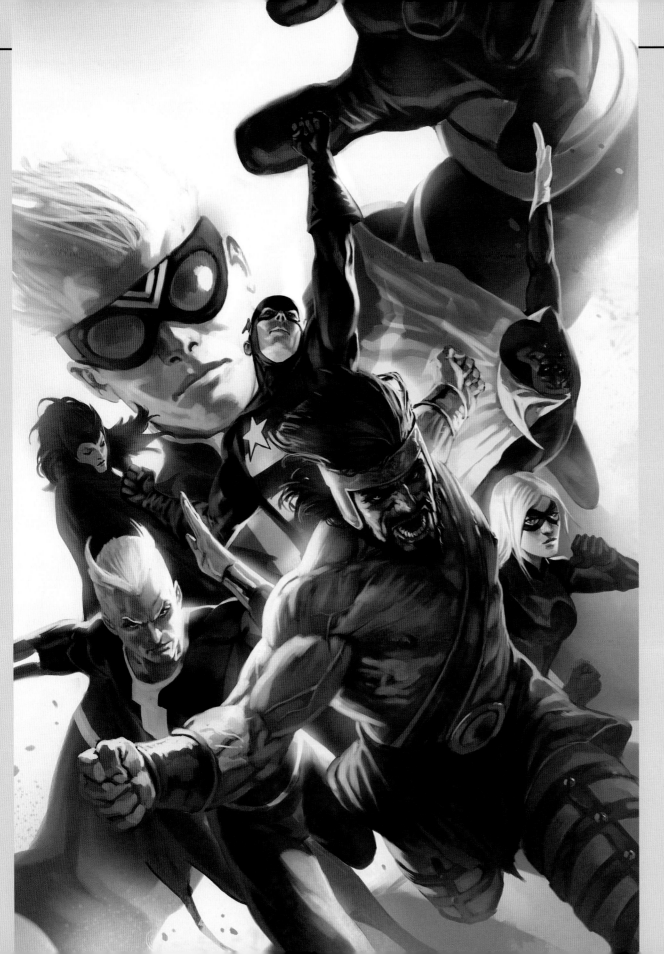

"The previous Mighty Avengers line-up was very complementary. But now this new lineup includes pretty much every color from the entire spectrum, which makes it a little more difficult for me to work with."

Original cover art to *Avengers #4* by Jack Kirby.

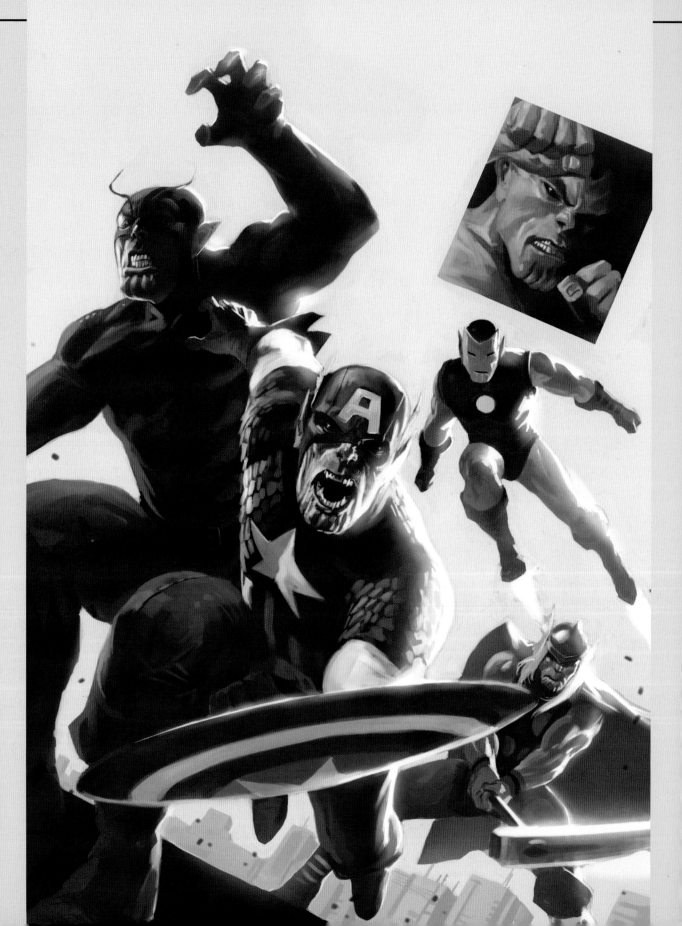

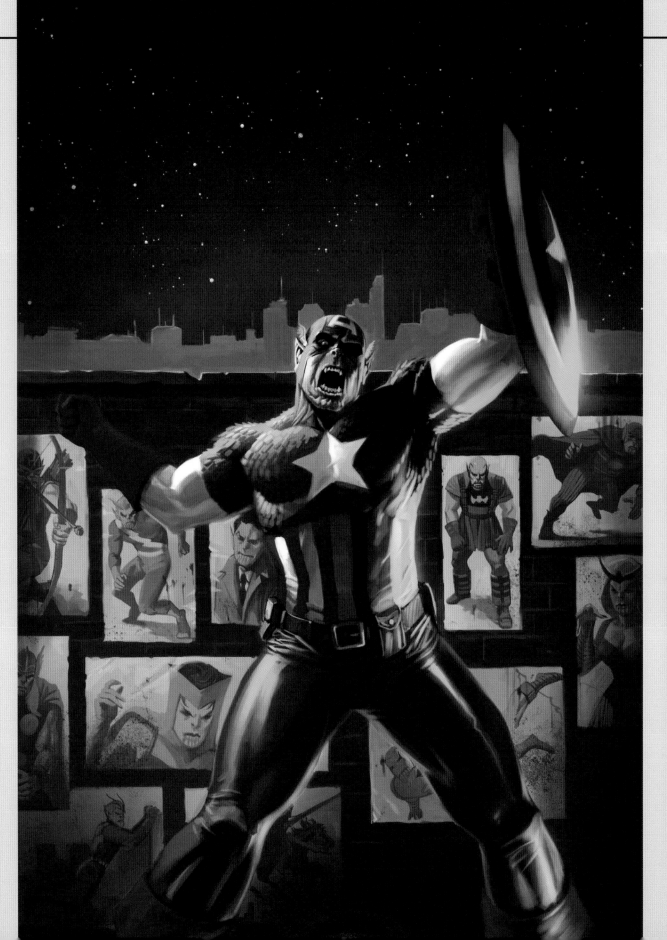

Original cover art to *Avengers #16* by Jack Kirby.

Original cover art to *Avengers* #57 by John Buscema.

Original cover art to *Avengers #213* by Bob Hall.

Original cover art to *Daredevil #168* by Frank Miller.

Original cover art to *Avengers #89* by Sal Buscema.

Original cover art to *Strange Tales #135* by Jack Kirby.

Original cover art to *Tales to Astonish #27* by Jack Kirby.

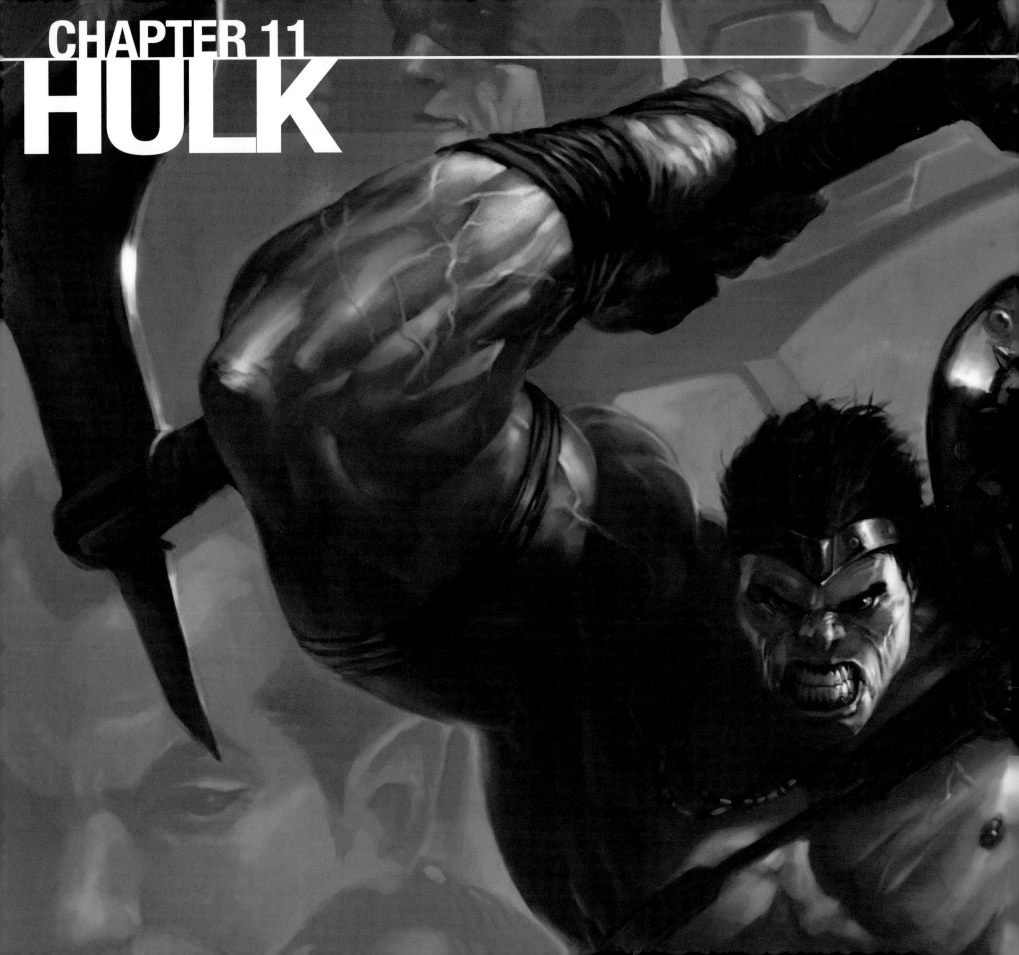

HULK

In 2009, the Hulk is not a character Marko is known for drawing. Assembled in this chapter are the small handful of covers in which he's been able to delineate the massive form of Marvel's most misunderstood monster, a hodgepodge of one-shots, variants and magazine covers. Despite the small body of work, it is some of the artist's most heartfelt work. Finding a deep connection with this iconic character was the easy part for Marko; all he had to do was crack open his first Hulk comic when he was a kid to feel an abiding empathy for the pathos inside the monster. To this day, it's a dimension of the Hulk the artist uses to channel his drawings, a dimension easily missed by all those who stick with their notions of the Hulk who merely plays the bumbling, dumb, idiot savant of overwhelming violence. Maybe one day Marko will get his shot at a regular Hulk run. Until then, the Hulk isn't a character Marko is known for drawing. Yet…

MARKO "The Hulk is a creature of raw power. So when I draw the Hulk, the question is raised to me about how I portray that raw power. But I ask the question a different way: What is that raw power good for? It has never given the Hulk peace. The power that I show in Hulk's figure is just an estimation of that raw power being worth absolutely nothing. Power alone is not a means to an end. It's not going to make the world a better place, but it makes it a lot more sad for those who have to live with it."

"I thrilled at reading the Hulk when I was a child, so totally connecting to his character. It's such a beautiful paradox when you think about how he is so strong – the strongest there is, so strong you cannot stop him – while at the same time he is unable to find a friend. The lesson underpinning his character seemed to be that no matter how mighty you are, it doesn't automatically make for a better life. The Hulk is such an unbelievably tortured character: he's never given his rest, he's always on the run, he's constantly traveling the world. He searches forever always trying to find a place of peace for himself, always trying to find a cure for his condition."

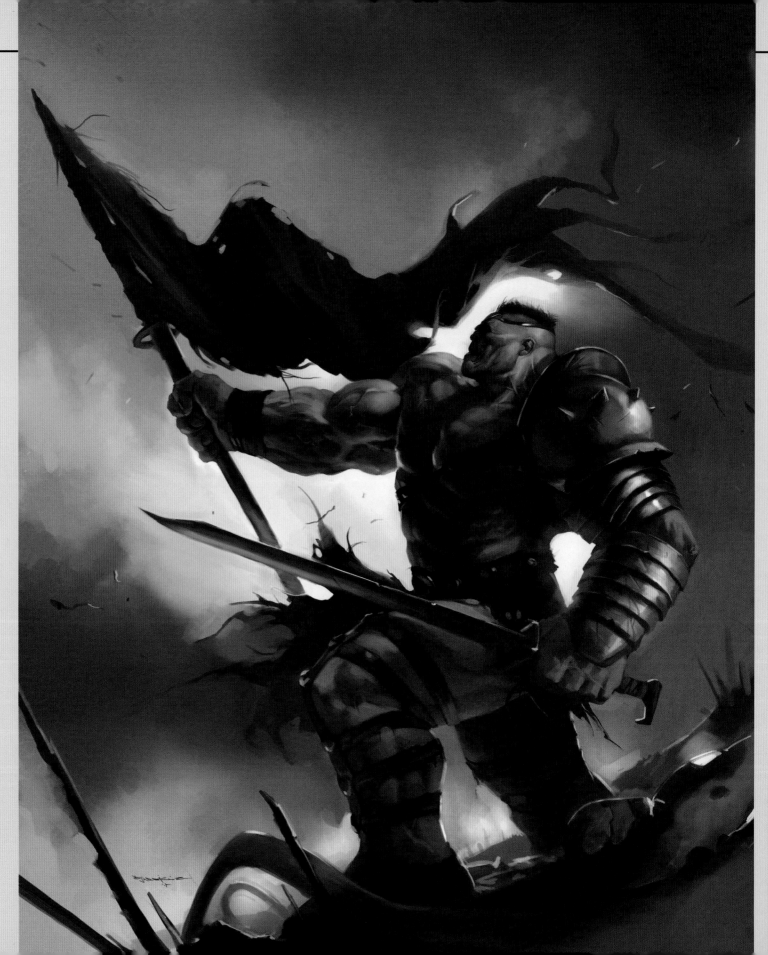

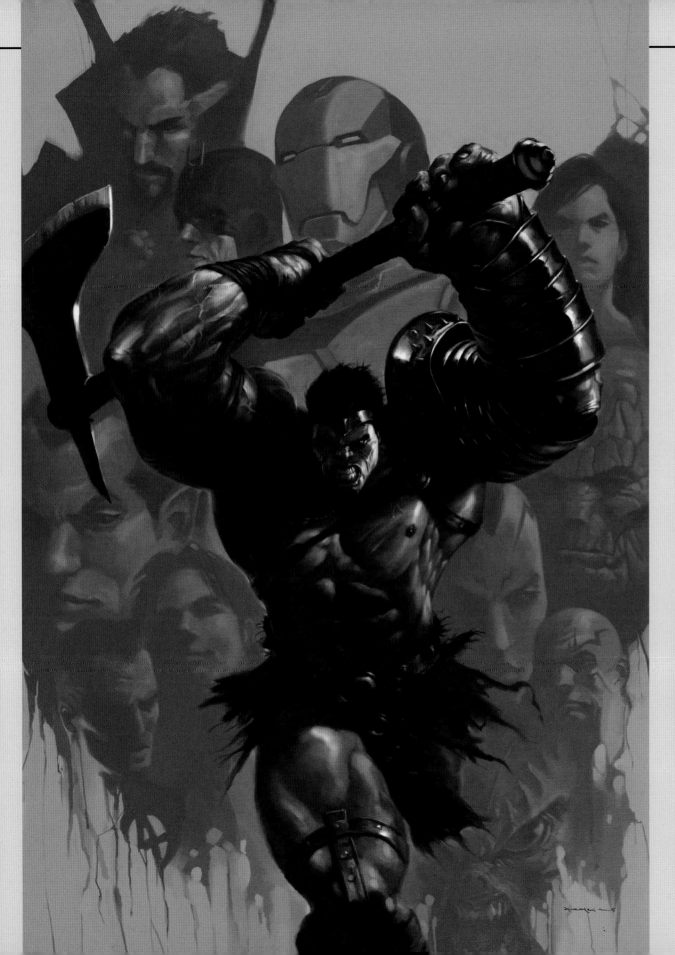

"When you compare Iron Man to Hulk, for example – Tony Stark has got his tower, his billions in the bank, and all the hot chicks. Or if you look at Captain America, he is one who is loved and respected by everyone. They have their own flaws, but largely what they represent is what is most desired by others in real life – they have a respite from what makes them flawed. They are not perfectly flawed like the Hulk, who has always represented the greatness of a hero far better than other characters: the imperfect god that is constantly striving for his own betterment. This is the essence of the character that always kept me engaged with him. I would draw and paint the Hulk all day long."

"It's a pleasure painting him as realistically as possible. If you look at my version of the Hulk, it's a little different from a lot of other artists who are either trying to make him more primitive – sometimes a lot more primitive – or a lot more exaggerated. Even when having to contend with depicting his massive size, I work to give him some sort of realism – depicting him as a huge human being on steroids, perhaps, or giving his face a wide variety of expressions."

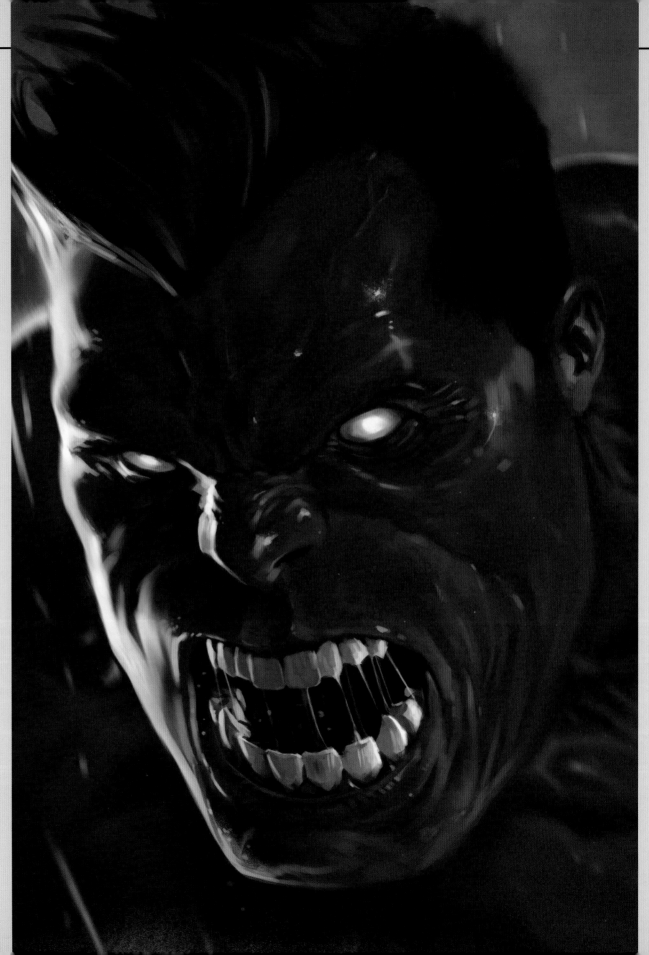

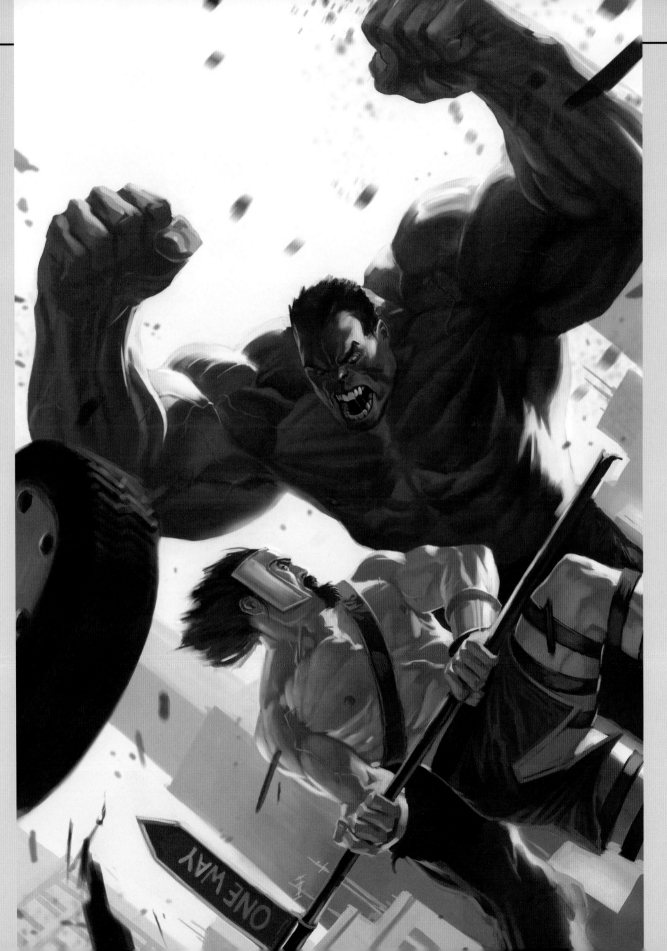

"His larger-than-life nature always works best when you put him into context with something else. For example, on the Wizard cover I painted him holding up a black flag with all the fallen heroes around him. Or the cover where he's going up against Hercules, it gives you a chance to take in all that sheer mass and realize there's nobody bigger than him."

"The character definitely translates so many essential human conditions on so many different levels; it's one of the few characters where I could easily see him venture into literature. He has all the aspects of Frankenstein buried inside, he's got the Jekyll and Hyde complex going on, his story narrative includes the classical Buddhist search for a place of peace and meaning. Those buttons aren't pushed in comics enough.

"But it goes even further – it goes into the back story of Bruce Banner having been witness to his father murdering his mother and having to bury that trauma deep inside. With that in mind, the Hulk is merely a manifestation of the rage that he felt when he was a child, and the gamma radiation wasthe trigger that releases the rage. I really think that it's one of the deepest franchises Marvel has."

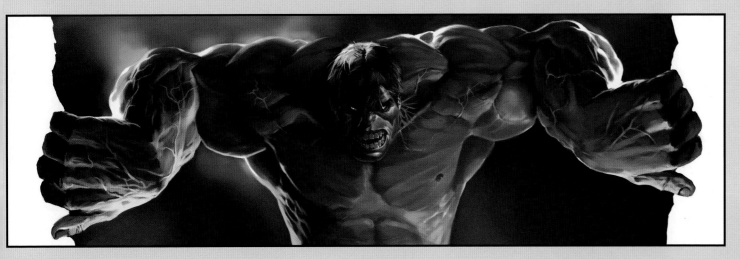

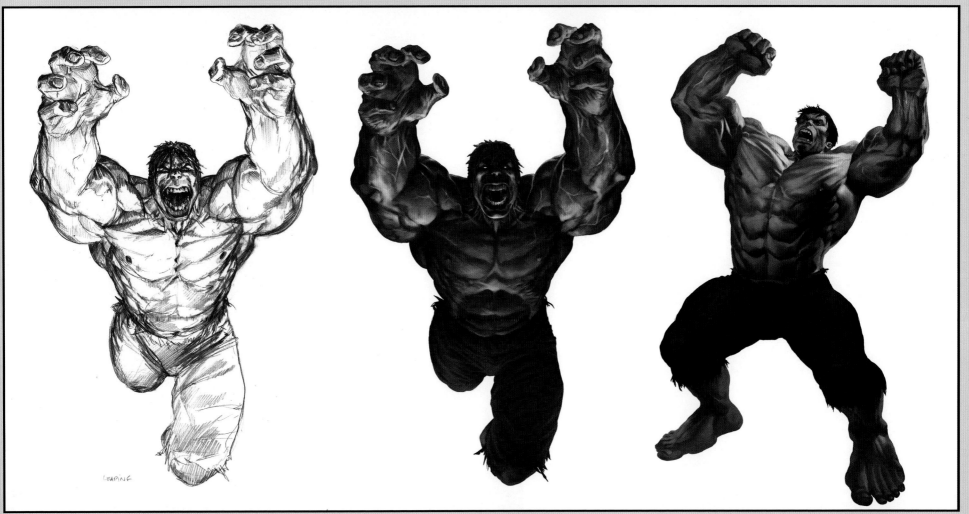

"These are my concept designs for the *Incredible Hulk* film, my
complete vision before the process took over and changed them."

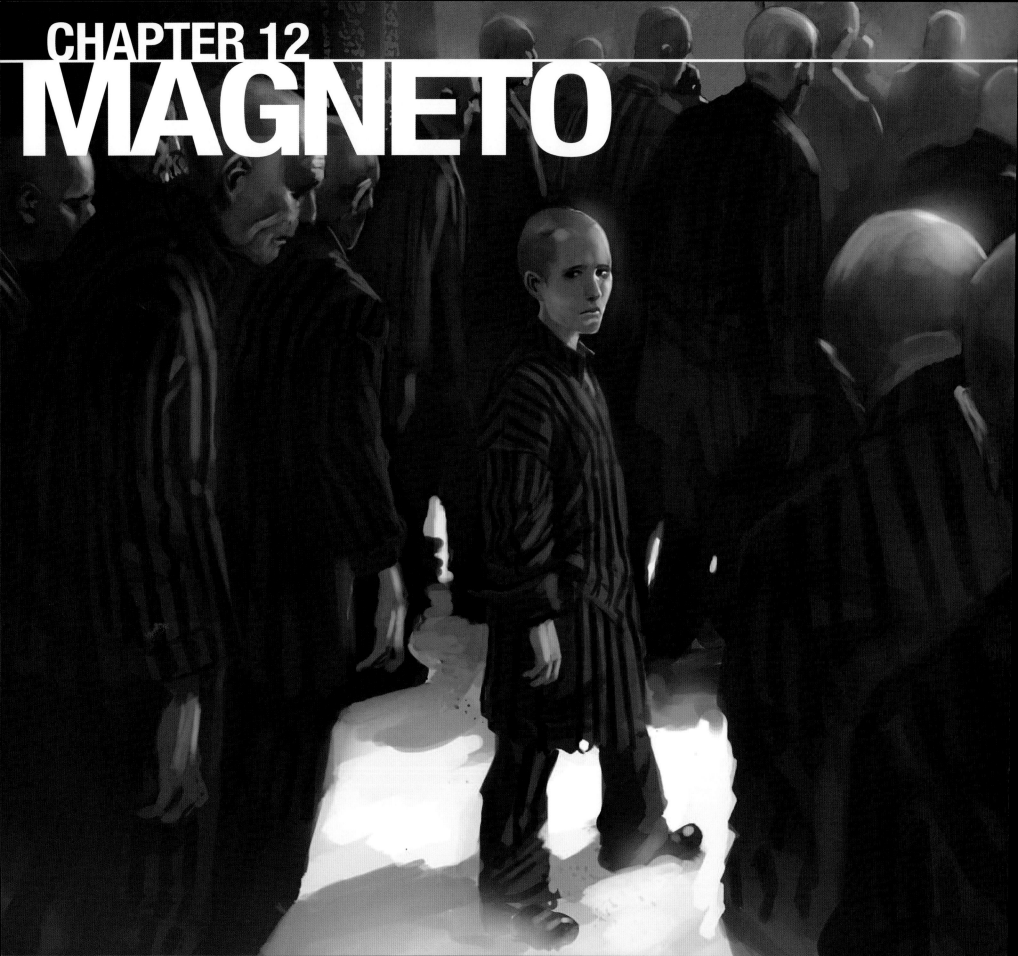

There's nothing simple about Magneto. In the decades since his first appearance in X-Men #1, he has emerged as one of the Marvel Universe's most complex characters. First cast by Stan Lee as the cackling, evil overlord of Homo superior rising, his persona evolved under the stewardship of writer Chris Claremont into a more multidimensional portrayal. The first glimpse inside this character's depth was courtesy of a newly introduced origin: Born a Jew in Germany during Hitler's rise to power, Magneto's early life was filled with the creeping carnage of the Nazi takeover of Europe – with the mind-bending cruelty of the Holocaust lying just around the corner. For a character whose raison d'etre had always been as no-nonsense protector of his persecuted minority of mutants, these nuances led to many probing new stories about Marvel's elite bad guy. Drawing the covers to Greg Pak and Carmine Di Giandomenico's X-Men: Magneto – Testament limited series gave Marko a chance to explore those nuances. To place the travails of the young Auschwitz prisoner into context, Marko relied on a restricted color palette and total reverence for the epic story, and in the process, gave testament to what were the daily, harrowing trials of a young boy just trying to stay alive.

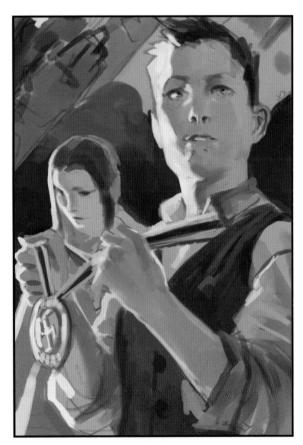

MARKO: "It is artistically liberating to be able to do covers that have only subtle connections to super heroes. In addition to that, I'm a huge sucker for learning about history, particularly about the First and Second World Wars. The amount of world-changing events that happened during these two wars is very inspiring to me from an artistic standpoint – the Second World War especially has been the most gruesome war ever led in human history. Never has the destruction of human life been perfected in a more perverted way than how the Nazis acted out genocide against the Jews. This was a great opportunity to be able to tackle something that is grounded in the real world in which we actually live. For me, this was very much a personal story, one where I really had the feeling that I was doing something with a lasting value to it."

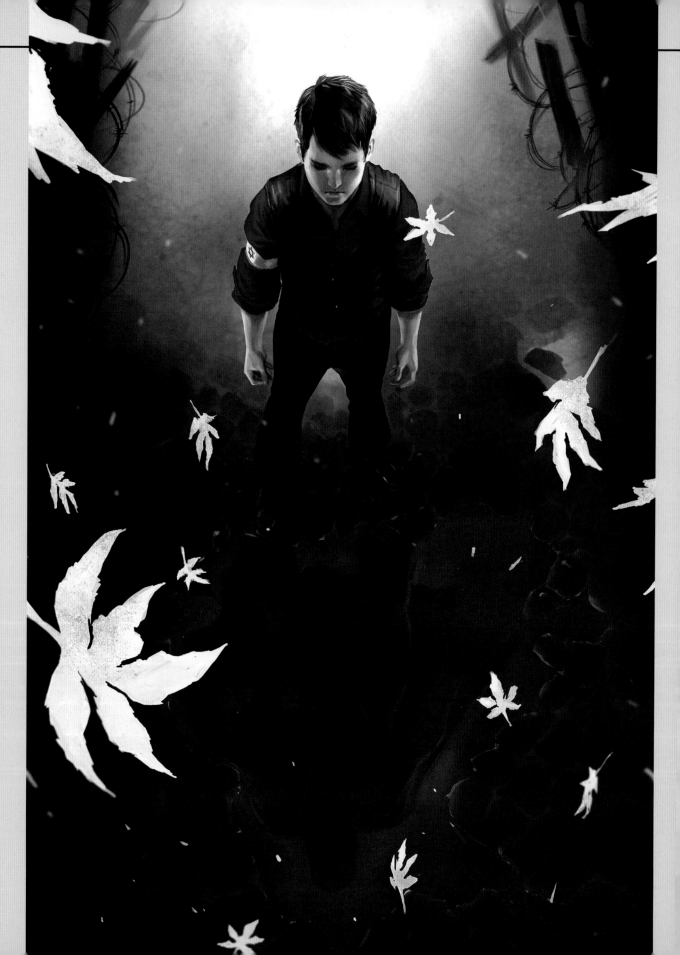

"To be assigned a more mature series such as *Magneto – Testament* was very satisfying; it's so much more centered around the history of the world that I'm living in. I grew up in Germany, grew up with German history, and I get to experience living in this nation every day, so for me it's very easy to become absorbed in the process of drawing covers for a Jewish boy growing up in Nazi Germany."

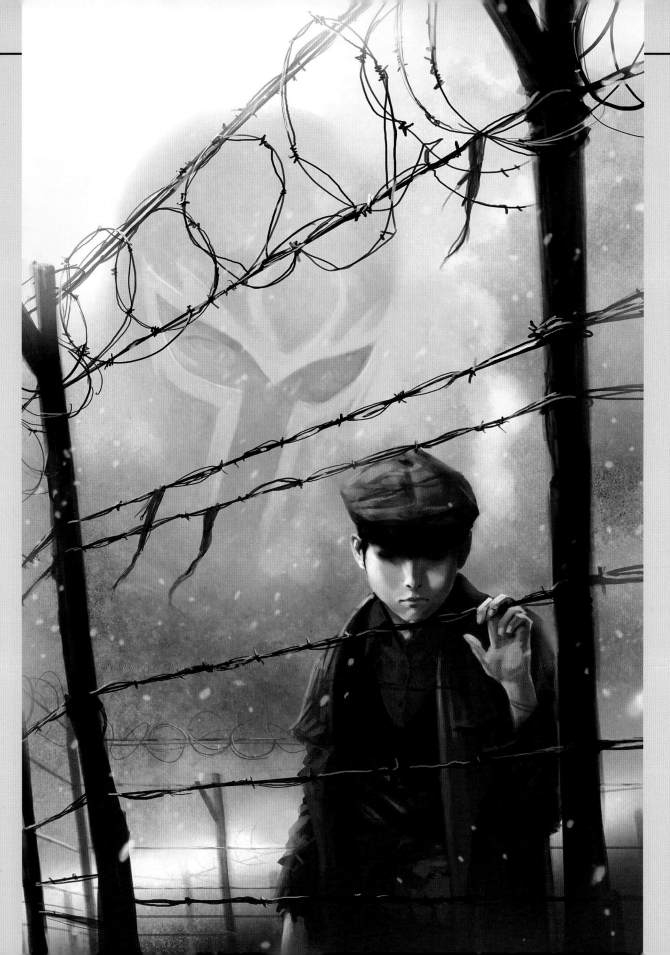

"And I use the term 'mature' because no matter what you do with super hero comics, the illustrations will never translate reality in a fully developed way. No matter how nicely you paint your Thor covers, it's always going to be an out-of-this-world, brawny dude that wears chainmail and a huge cape."

"The color concepts themselves were pretty simple; it's merely the Nazi color scheme that was ubiquitous under Hitler – white, grey, red, and black. Those colors were used by the Nazis for all their propaganda posters, for their flags, for their banners, for everything. If you illustrate a story featuring Nazis, you want to give it the feel of the times, and colors can do so much for you in that regard. If you reduce your colors to a certain palette, you can tell the story a lot easier than if you were trying to labor a more diverse amount of colors into it. Doing that from the start insured I'd keep the right tonality for the series. All the covers were built on the same idea, to use splashes of red to enhance the drama inherent in the story."

"The swastika is illegal to be reproduced in Germany, so I try to avoid that as much as possible. There are no swastikas on these covers. But as established, the color textures used make the pointed symbolism of the swastika largely irrelevant."

"This is a very stark image, very strong. It's just a close-up of Magneto's face as a child, with a shaven head, and there's fire reflected in his eyes. He is witnessing the burning of bodies in the camp furnaces. Its power comes from a combination of this expression and the intimacy with the viewer. Using proximity to this extent, you can bring out more emotion than if you removed the character to the background and visually referenced what he was looking at. You don't have to show everything literally: Sometimes hiding the information – like the fire in his eyes that represents his parents and all of his friends being burned to cinders – tells the story more effectively because it inspires questions. What is that reflecting in his eyes? Why is he crying? It engages your audience to take part in finding the answers."

"We talked back and forth for a bit about the cover idea for the last issue and then he went off to start work on the sketch. Normally the way the cover process works is, he'll send in a sketch, I'll run the sketch around and bounce it off a couple of people and see what they think. But this time, he did the complete painting over the weekend. He turned it in, saying, 'Listen, this was so beautiful I just had to finish it.' It's just a very simple shot of Magneto; it's just a gorgeous cover – a simple headshot but there's so much energy and compassion and heart put into that particular shot." – **Warren Simons**

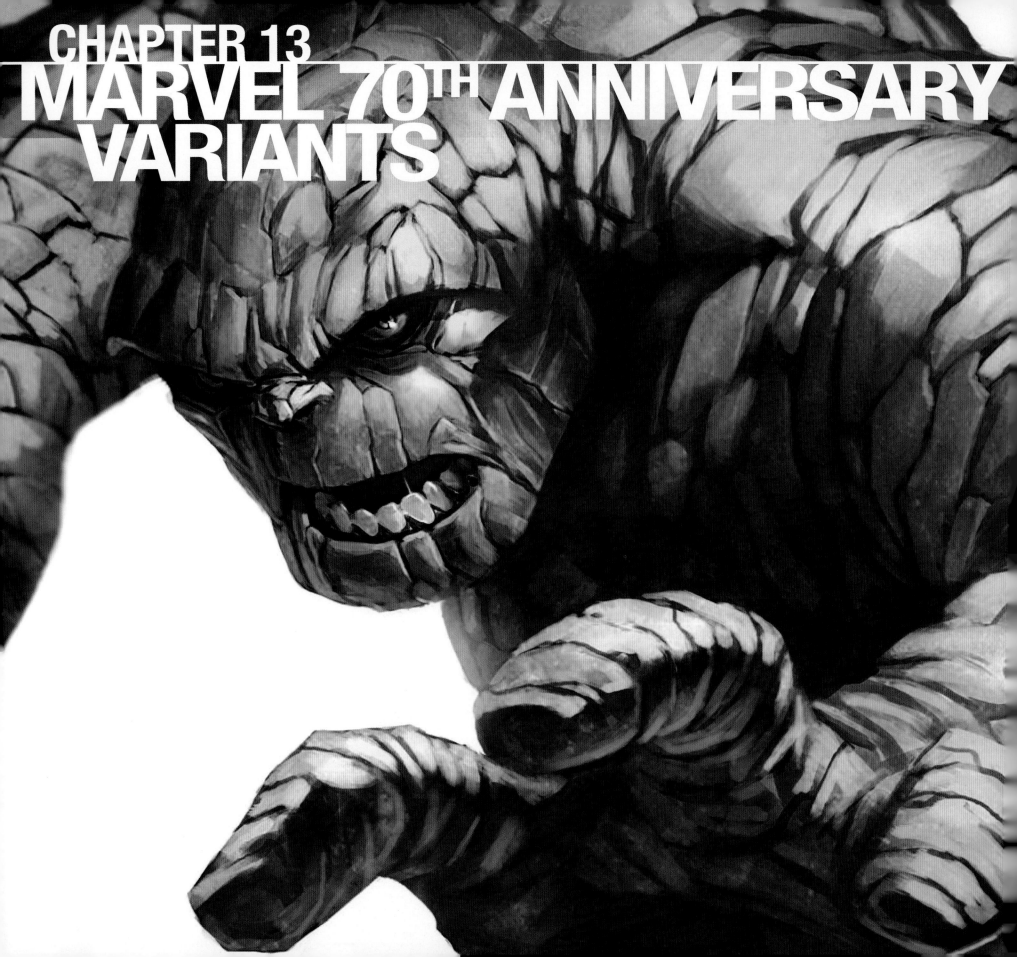

In September 2009, Marvel will turn the calendar on a full 70 years of history. Debuting to none of the fanfare with which it is feted now, Marvel Comics #1 *introduced in its pages a random collection of adventure, Western and super heroes. There were similar books on the shelves around it, but what those books didn't have was two dramatically different characters like Human Torch and Sub-Mariner, nor did they have as explosive a cover. Sales boomed for this Timely book and a pop culture legacy was born. Since then, there's been a seven decade record of Marvel employing some of the greatest art talent in comics history to tell stories with its deep catalogue of trend-setting characters.*

Part of the reason this art book is in your hands is that artists like Marko Djurdjevic are ably taking up the reins of the old guard, not by aping the successes of the past, but by pushing the boundaries of the artform and finding new ways to express the Marvel Universe of characters. That alone is nothing new: It is the way Marvel, at its best, has always done it. In keeping with that idea, a series of variant covers was commissioned to adorn a different Marvel title each month in 2009, in which Marko gave his own modern rendition of classic Marvel characters. As you will see, his approach to characters like Spider-Man, Sub-Mariner, and Captain America is as unique and stylish as any of the masters. If the next 70 years starts out like this, Marvel is in good hands…

MARKO: "I did these variant covers for Chris Allo. He's my earliest contact and also my closest friend over at Marvel. He's a wonderful person who is really excited about my work, and I've spent so many hours on the phone with him throughout the past three years. You can definitely feel it every time he talks about something that I did that he is really into it. When he approached me for this job, I knew it would be a really easy gig for me – all he wanted was just a simple version of each of the Marvel characters on a white background with a little touch of Marko in it.

"Everything else was my cup of tea to finish. He gave me a list of the twelve characters and away I went; it's actually the fastest gig I've ever done. I painted all twelve characters in only ten days, so it's been a fantastic cover gig for me to do. I sat down and did all the sketches in one day while I was still in my first inspiration for the job, and then I just painted them one by one. I had such a feeling of completion after they were done, that I turned them all in as a group instead of sending them out in batches. I just wanted to see what impact it would make if Chris were to see them all at once. He was blown away and, of course, really happy about the turnaround."

"Each character design is predicated on what the character was about when he was first created. The Human Torch is an android that can set himself on fire. That design is pretty in-your-face, and I felt an excellent way to start off the series: the first ever Marvel character just dashing towards the viewer, in flames, igniting himself into a state of life…"

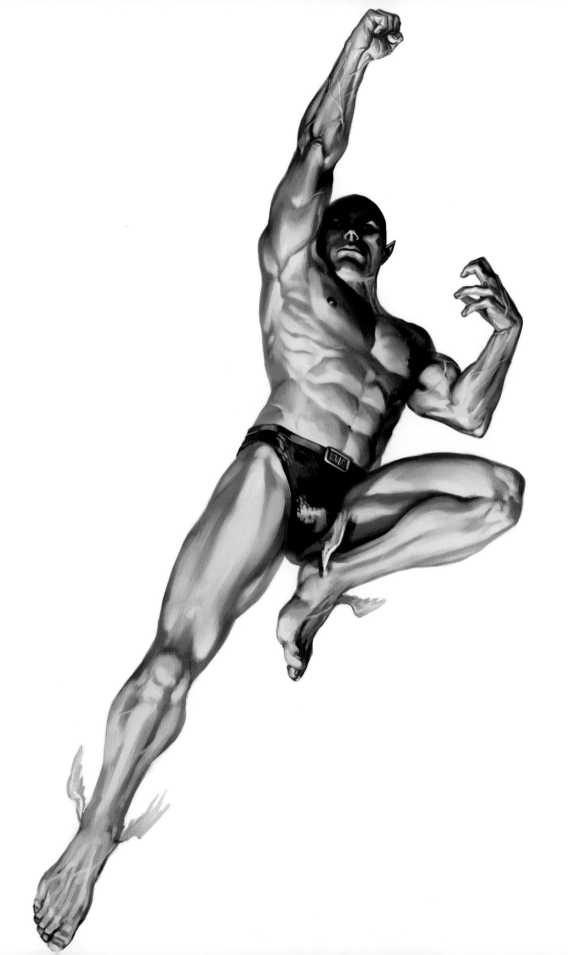

"Namor, in all his exaggerated, royal splendor. His arrogance is what keeps him aloft…"

"Thing, in his classic, beat 'em up pose…"

"Marvel Girl, in an almost mystical, shamanistic pose, only showing a small glimpse of her true power…"

"An amazingly beautiful iconic shot of Marvel Girl. He made her hair seem like fire without rendering flame. You can feel the power emanating from her — it's subtle and ominous at the same time. I love that he gave her alabaster skin to further enforce the fact that she truly is, as they wrote in the first appearance of the Phoenix, 'FIRE! and LIFE INCARNATE! Now and forever... She is PHOENIX!'" – **Chris Allo**

"Wolverine, who is like the Rock of Gibraltar. He's taken his stance
and will not be moved…"

"Iron Fist, the kung fu master: that's what he was invented for and that's what I wanted to do with him. To show him being athletic, lighting up his 'iron fists' and making awesome kicks. To show him at his absolute best…"

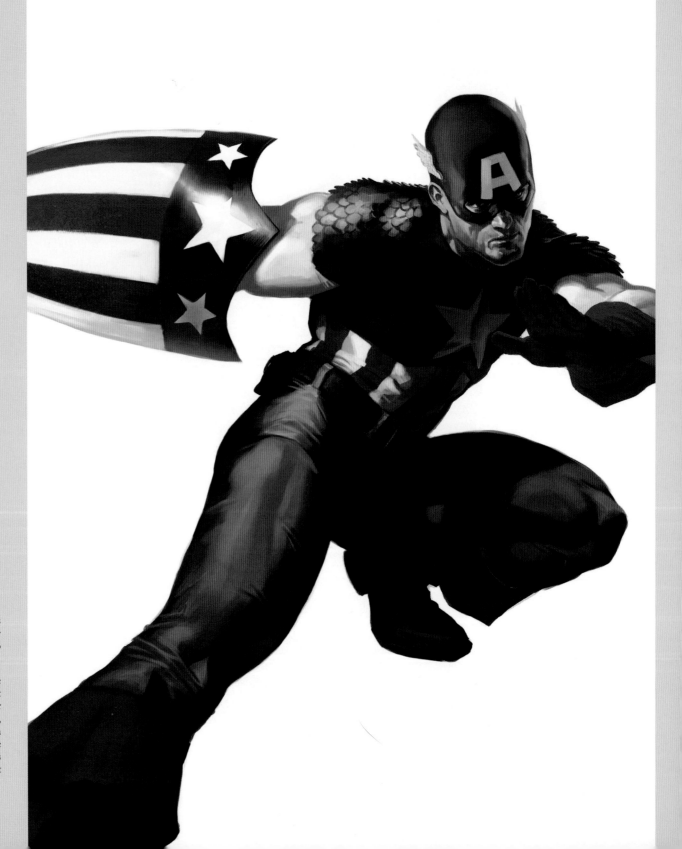

"There's a certain peacefulness about Captain America; he exudes total confidence, total control. I still think his movement and body posture is trying to either calm the viewer, or warn them not to mess around with him.

"What I really appreciated about this painting was I was able to recreate the lighting of dusk on a white background without including any other background information with it. Just the color textures of a sunset hitting the shield, giving light to the character, though if you look at him, he's not the famous Captain America blue at all. He's actually orange – there's not even a little bit of blue in there, but our eye tells us it must be blue by the way the light is hitting the costume. As a painter, that was quite an achievement for me."

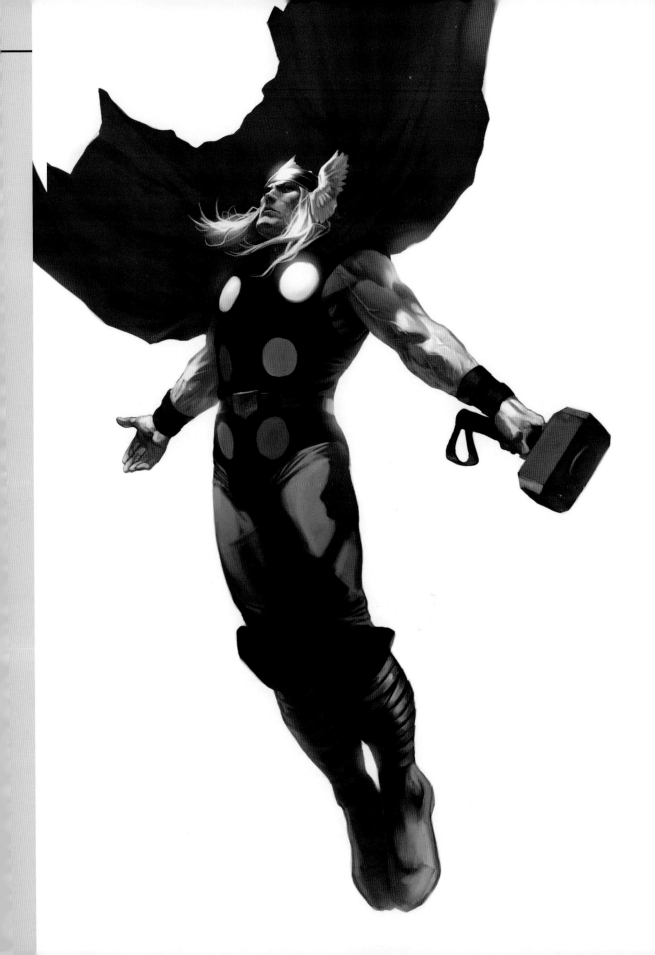

"Thor carries himself in a godlike pose; he's floating above it all. That's where the classically minded, almost Shakespearean way he is written comes into play – where you just show him as a more grand being than anybody else around him. It's almost Christ-like in the way he spreads his arms and looks into the sky."

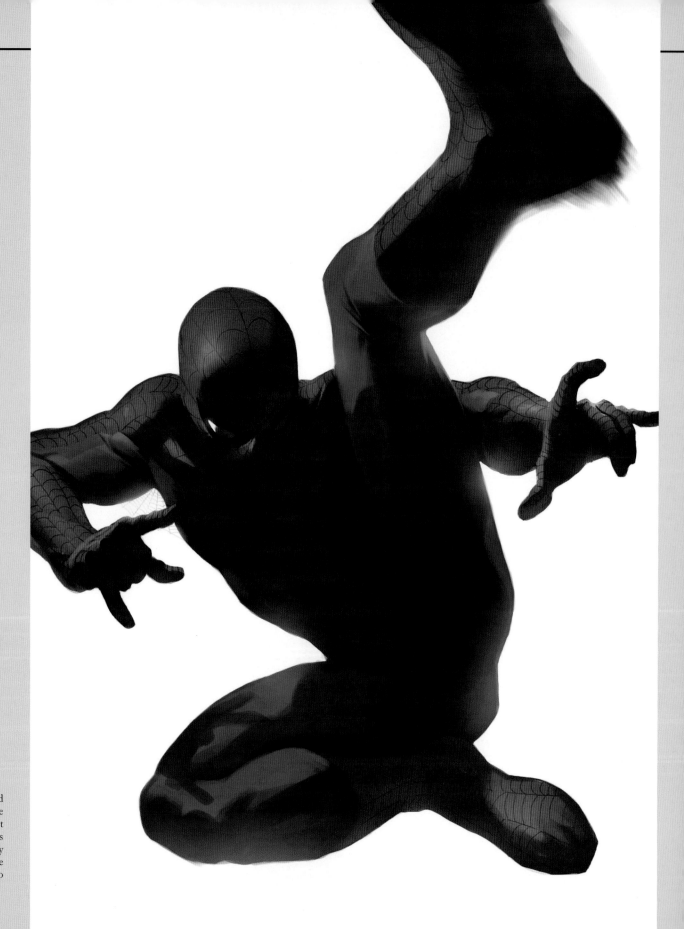

"I don't know why, but I really think this would make a good poster. I like the way the image is breaking outside the border, the full figure clipped at the edges. It's as if somebody was taking a lot of photos with a camera, Spider-Man was swinging by, and this was the only sharp snapshot in the entire batch. It's a composition very much about aesthetics; not too much story behind it, but a pure focus on the figure and how it is capable of cutting the page into different parts."

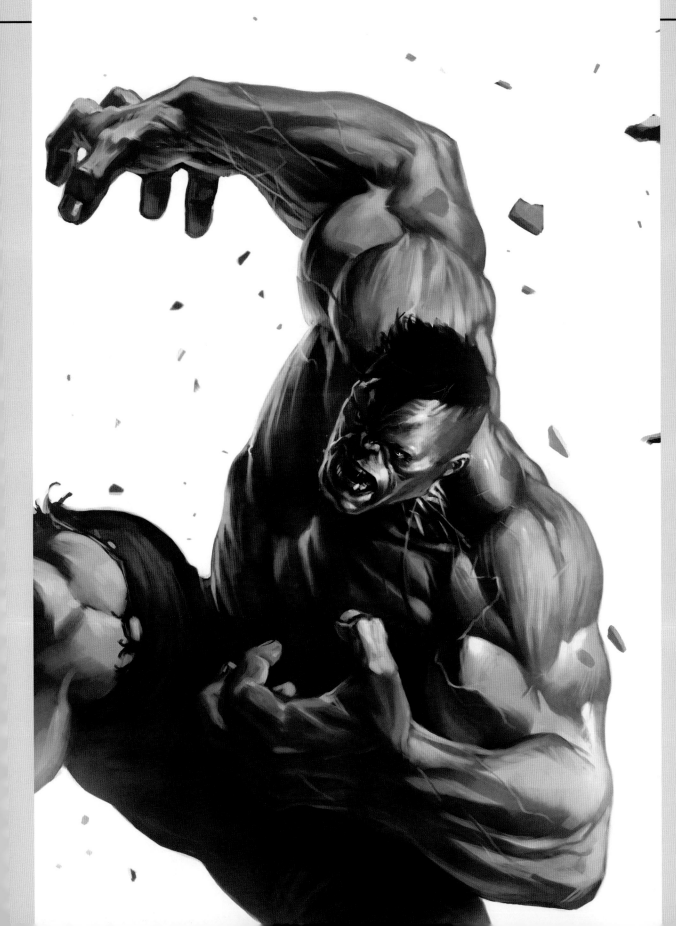

"As I said earlier, he's one of my favorite characters to paint, and this was actually the job I was looking forward to the most. I saved it until the very end so that I could enjoy working on him the longest. I like the angle in this picture, as if the horizon were tipping over as the Hulk stomps straight towards us, stirring up rocks and debris. This has all the action, all the fire and anger – everything's that's good about the Hulk."

"I don't know anything about Ms. Marvel. I never read the old stories about her origins, and I also have a beef with that old school costume of hers. I really think it's a little bit dated, but from a painter's standpoint I can never have enough experience. I can never paint enough covers to really be satisfied. I'm my own sharpest critic anyway, so I will constantly strive for new assignments just to improve myself, and I like drawing characters, as I said, that I haven't touched before, because it always gives me the opportunity to discover something new."

"And we end the year with Iron Man. For all these anniversary images, I reverted back to my white backgrounds. White is one of my favorite colors for covers, and it is so underused in the medium of comics. If you look at most covers that are on the stands today, they're just *screaming* from all the colors used. Most colorists go wild putting more and more colors on there, which makes it seem like it's all about saturation. Most often, I think that really takes away from a lot of work. For me, white is a color of innocence, a color of thought, a color of reflection…it implies so many meanings. That was one of my big goals when I first started with Marvel: to use white more, to let the image breathe on a different level. You can see that idea in a lot of the covers I did for *One More Day* or *X-Men First Class*; the white is what is supporting the symbolism that I use over and over again."

"Most of the characters in this series, if not all of them, have highlights that are off-white. The only real white part is the background – even the white in the reflection is not a real white; it's more of a milky, greyish white. They really work well together as a group because each and every one of them has a certain flair to them, capturing the essence of what the character is about."

The final covers in this art book cover random series, specials, or one-shots that don't fit easily into standard character or title themes. It includes a handful of dynamic covers for What If? – Marvel's title of alternate ending tales – including an astounding gatefold for the Civil War issue; Marko's irreverent take on Steve Gerber's already more-than-irreverent Howard the Duck; a gallery of illustrations for Roy Thomas' adaptation of Alexandre Dumas classic The Man In The Iron Mask; rare cover art for a French comic book magazine; some rarely seen test paintings; and more interesting artifacts from his covers career – particularly a piece of Sub-Mariner art that has to be seen to be believed.

But that's the trick with Marko: In many ways, seeing is believing. For someone who toils in an industry that tells fantastic stories, his lust for portraying realism through painting has brought the Marvel cast of characters to vivid life in exciting new ways. Many would say that in order to tell stories featuring super-powered beings with extra-human abilities, an artist would need to be a master at creating "the suspension of disbelief." Marko takes a different route. He finds something in his subject matter to believe in. It's called art. And Marvel has been honored to have it as a standard-bearer of their fiction for three years…and for many more to come.

MARKO: "I expose myself on a daily basis to the best artists in the industry. My learning process is connected to these artists. You never want to be satisfied with anything you do – always look out for the best and be challenged by them. You don't necessarily need to know and work with them on a daily basis but if you surround yourself with their artwork you it will become a real influence in making you want to be better. It's an ego thing: Use it to push yourself further and further."

"This test piece was painted right after I started on Blade, so it was from the very beginning of my Marvel career. My main purpose with it was to show painting's superiority over simple drawing and coloring when translating detail and realism.

"Drawing is inherently about placing lines, but we as real people aren't covered in outlines. There's no visible line that forms around our physical beings. It's when you lose those outlines in painting that you are able to render your art more realistically. That is because everything in life is defined by light; it is the only definition of volume that we have. You have to be able to understand lighting and how to use it as a tool. This particular cover was an exercise in many ways of just how realistic with detail I could get with the Spider-Man costume.

"It's also the first time I came up with the particular style of webbing that I used, because I always thought that Peter Parker – the kid that stitches his costume by himself – is not going to be so diligent about how nice the stitches are arranged, or how far they are apart from each other. His costume would be a rough interpretation of a spider web on his costume. Through painting and the placement of light, I was able to render the webbing with a very handmade look, like something that came from his bedroom instead of a big fashion house."

"After painting the variant cover for the Death of Captain America issue, I wanted to explore painting his nemesis Baron Zemo just to see if I could make something of the character. The costume was never to my liking, so I never really had a connection with the character, so I tried to touch him up a little, to reinterpret him with my sense of design aesthetics. I went for a less garish tone than you typically see with him, and I think it turned out pretty well. Normally he's wearing a crown, but I took that off because I always thought it didn't mesh well with his mask. The mask was really cool by itself: it allowed for a clear facial structure, but without eyes or face to be seen. That was an interesting facet of his design I wanted to play with."

"The way Namor is placed in perspective, lying there with only a bit of light from above hitting him, and then Venom leaning over him in close quarters – it reminds me a lot of the themes of 16th and 17th century painters, how Caravaggio might interpret the figures.

"I like painting Venom because he's just so easy to paint, which is ironic because he's ten times harder to draw than he is to paint. If I had to draw him with pen and ink, it would be such a tiring process of blacking everything out and making sure that the parts of his anatomy are visible. But when you paint, you just place big blobs of black, and then basically put the light on top – it's a much easier process of creation.

"I loved the fact that Venom has such a schizophrenic personality. Thinking about this huge, hulking creature that talks to himself while eating somebody couldn't help but give me a lot of inspiration – in particular, he lends himself to be illustrated in many humorous ways. In this picture, he's trapped Namor with the gooey, oozy matter of his composition. You see that he himself is hanging from the nasty sinews like a black widow spider. He is putting his tongue around Namor's throat, coming in closer, the better to eat him. But what really set it over-the-top for me was the shadow his maw cast on Namor's face. Before I painted that, it didn't look as menacing, but once I painted that shadow over Namor, I had the feeling it had finally all harmonized."

"It was around the time I was working on Blade that I got assigned to do the *Super-Villain Team-Up* covers. These were fun, irreverent stories. MODOK itself – or *him*self, however he is to be addressed – is such a goofy character. There's no way for me as illustrator to take him seriously. The rest of the cast of characters were, taken altogether, composed to exploit the humor in the comic, so I just simply went for funny themes for the cover art and gave them a light-hearted touch."

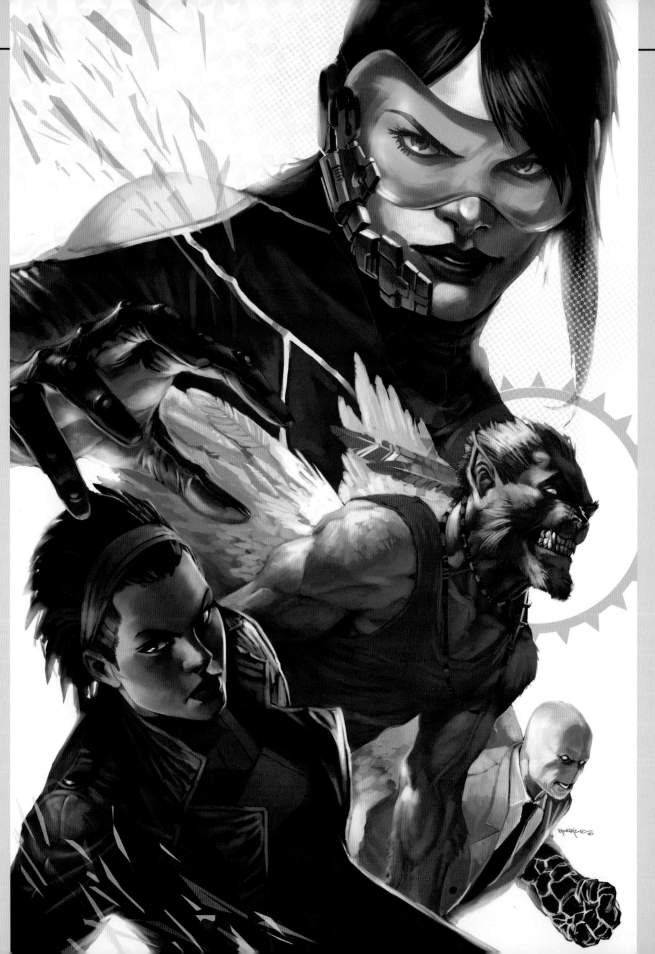

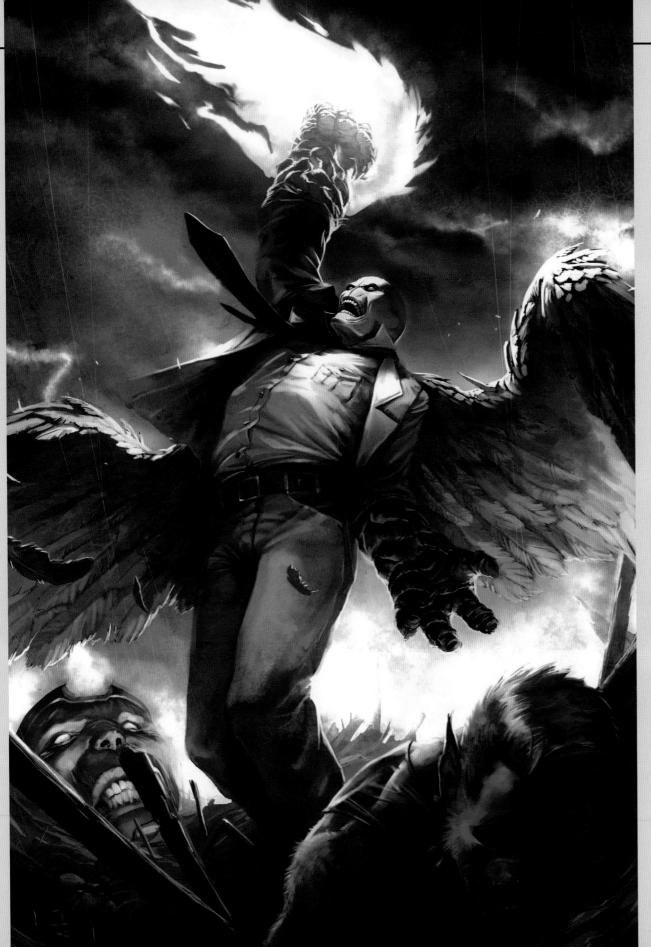

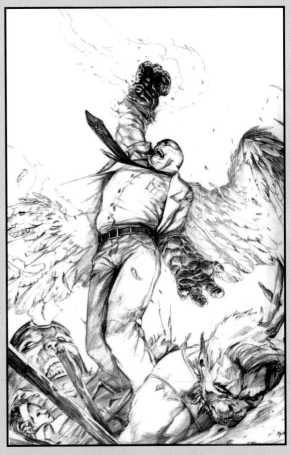

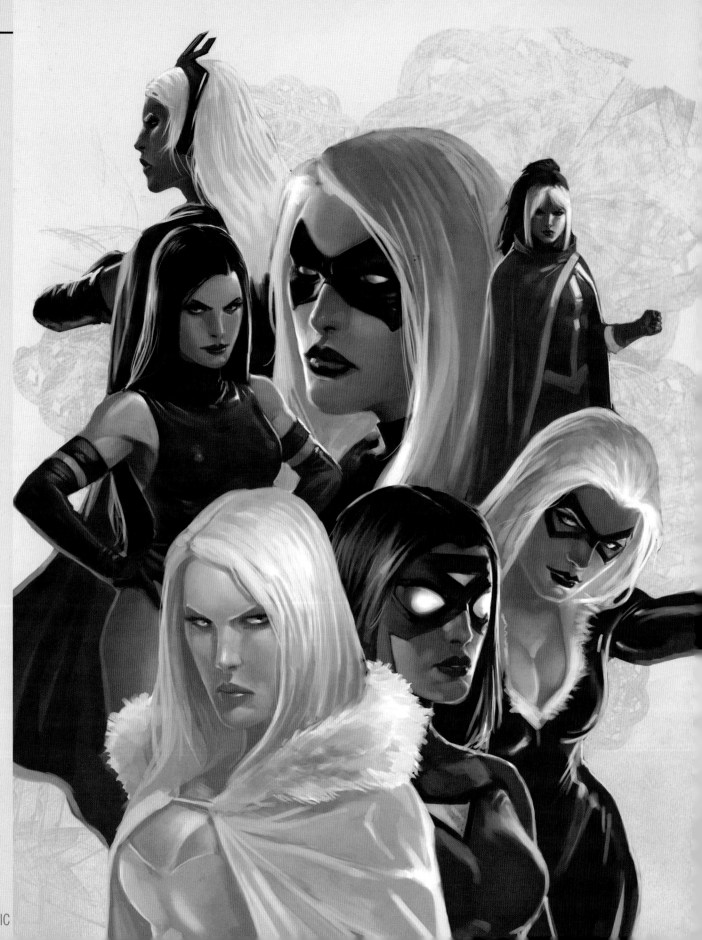

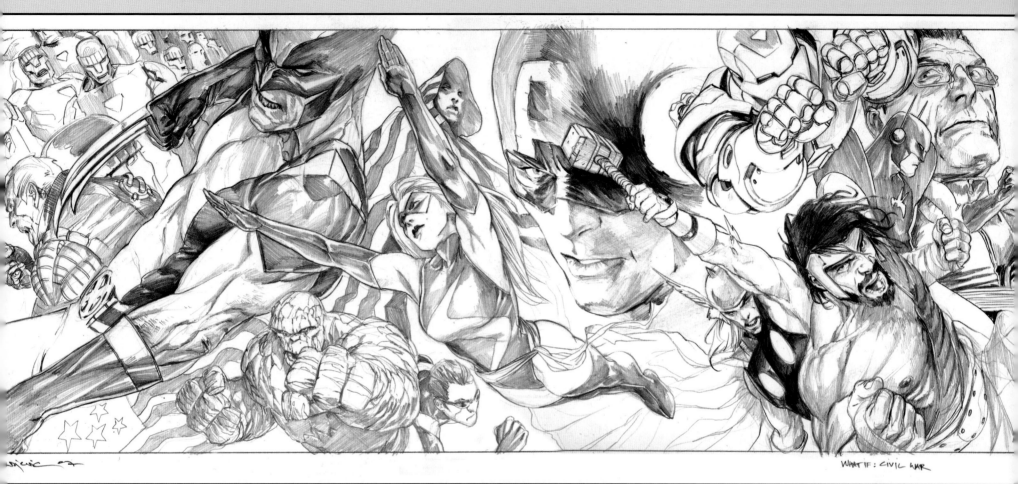

WHAT IF: CIVIL WAR

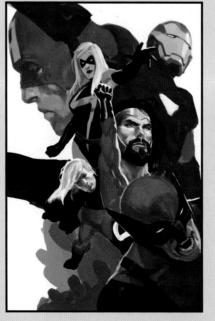

"At the time *Civil War* came out, I had just begun reading comics again after being away for ten or so years. The packaging of the series was startling to me, it was such a beautiful, beautiful design. I loved the fact there was so much white space on each of the covers, the logo was in such a prominent place, and the cover art was presented in the form of a banner across the bottom. Just from an aesthetic standpoint, these were some extremely creative choices.

"When *What If: Civil War* came around, I was really happy because I could finally take part in employing that spread-out panorama for a composition. (*Civil War* artist) Steve McNiven had already done so many nice character montages in the main series, so I decided to do something that was basically channeling that aspect of *Civil War*, pulling in all the major players from the original series and placing them all so you could clearly read the piece from left to right."

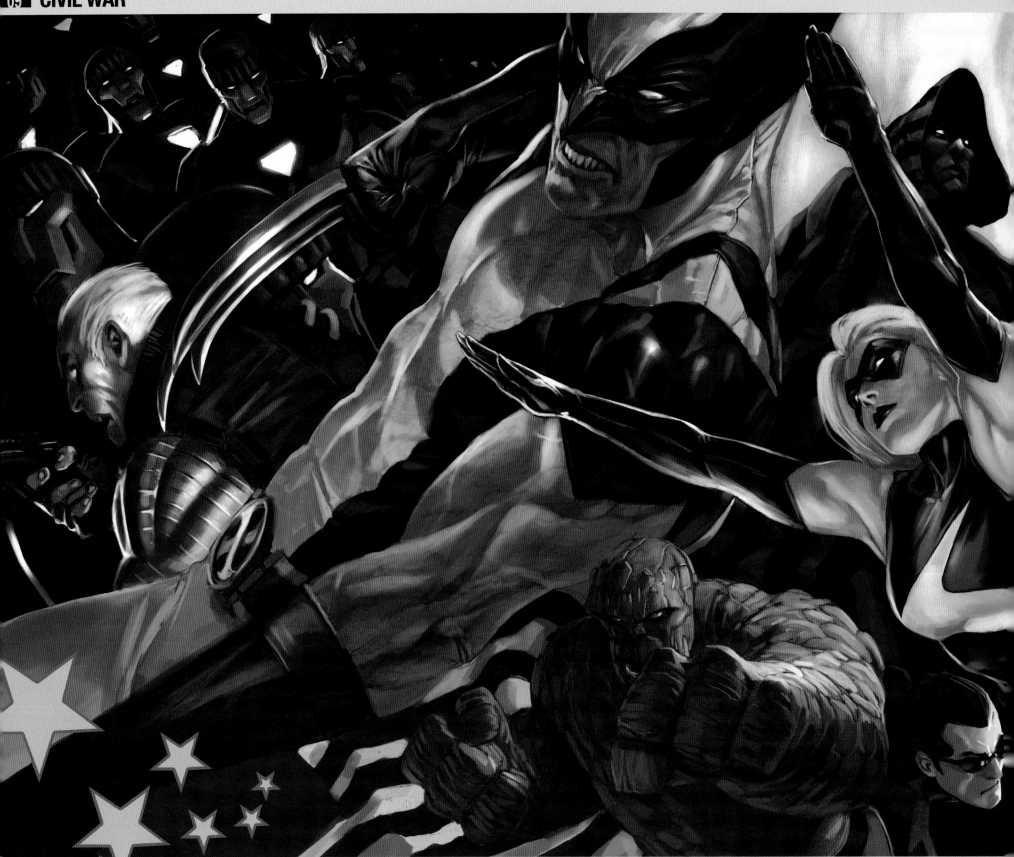

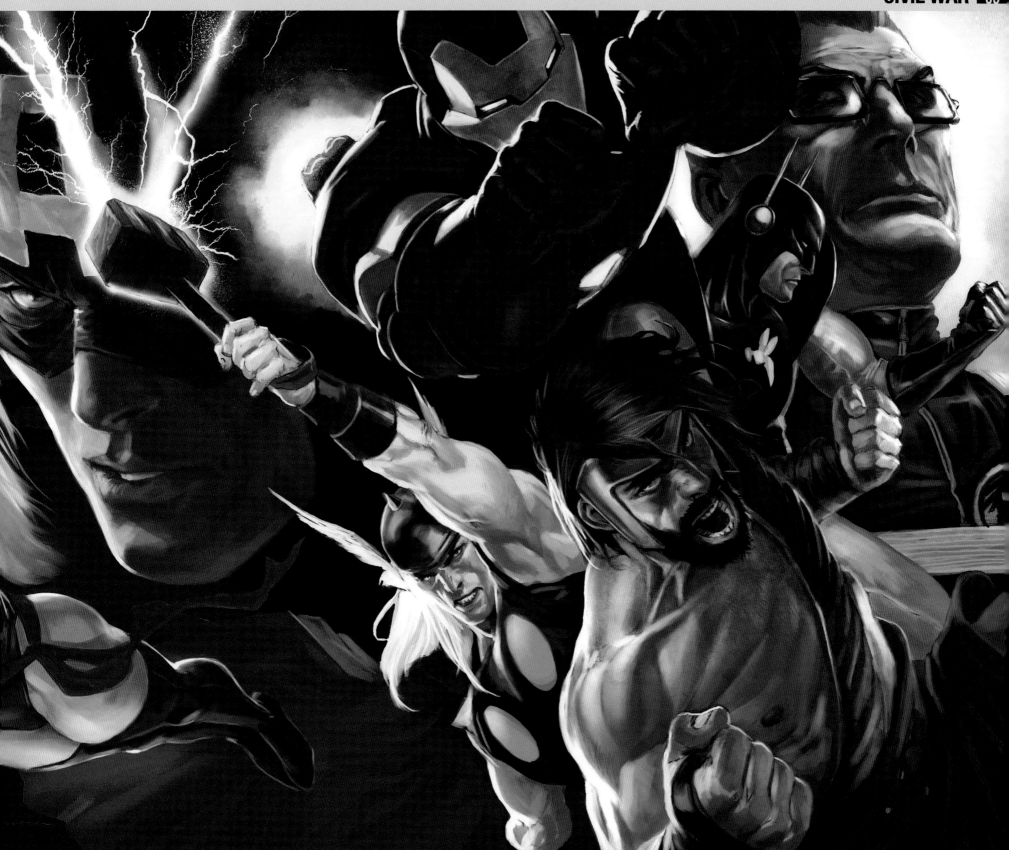

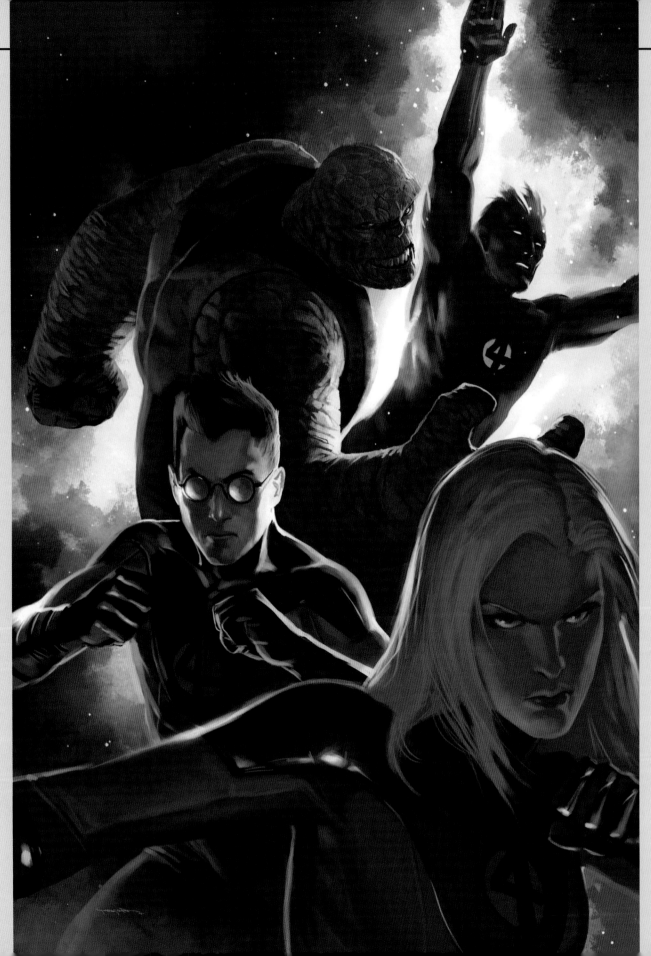

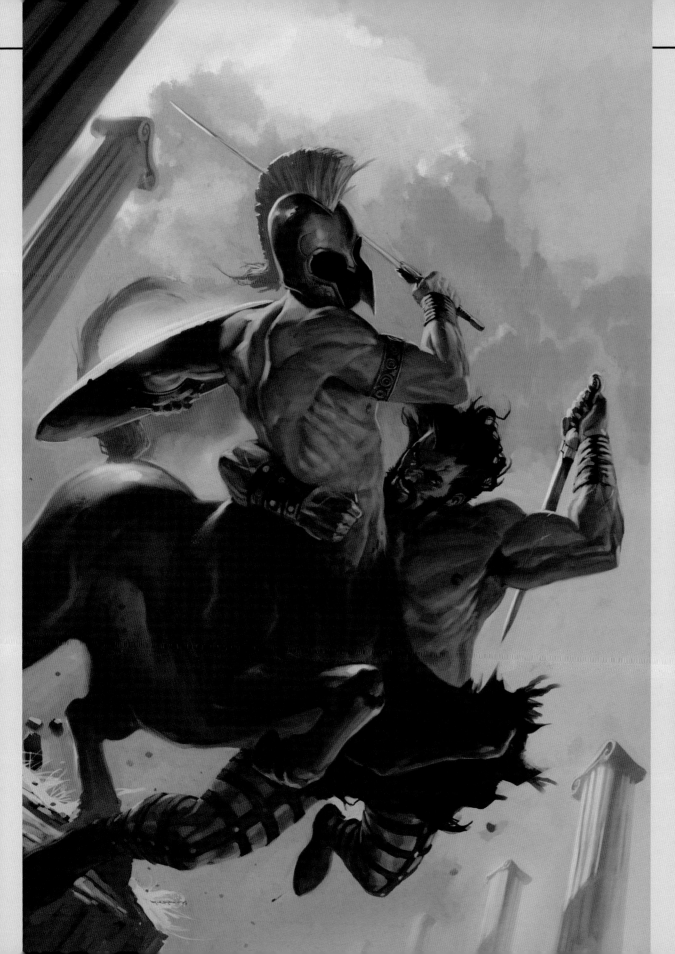

"The mythological Hercules is one of the most amazing characters of legend in mankind's cultural history, but the Marvel version is, of course, a super hero twist on the mythology. My sketch didn't really speak to me on a storytelling level, but the finished cover became one of my biggest accomplishments ever as a painter. The short reason is that it's painted with only two color choices: orange and blue, and black and white. Artistically, it was a very satisfying achievement to push that small set of color values this far and still get such a feel."

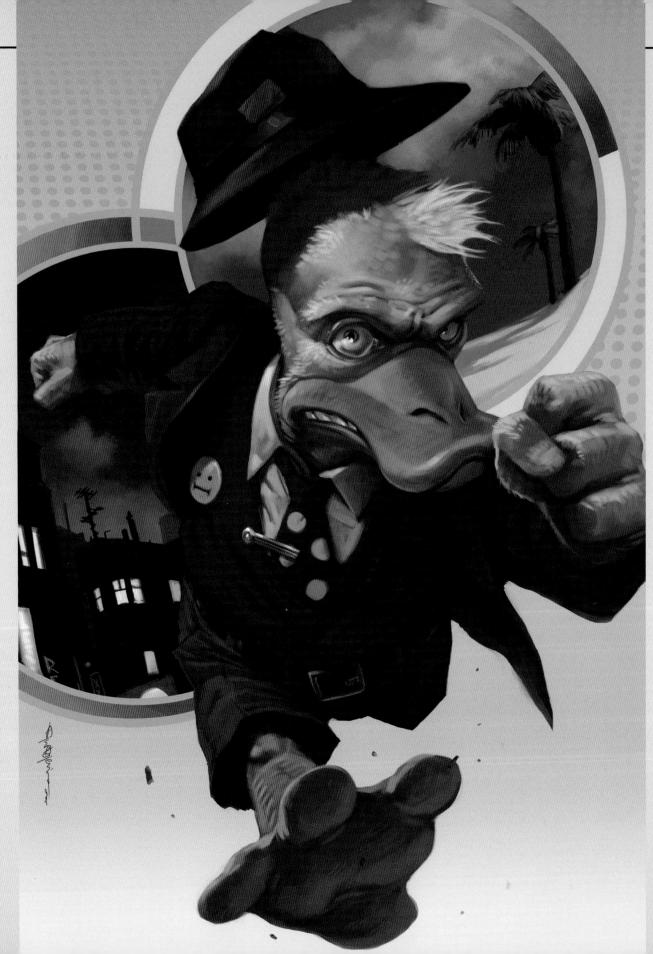

"I never have the chance to draw cartoons except in my free time, and I actually do quite a lot of them just for my own pleasure. So when I got this assignment, it was a great opportunity to let loose and do an image that has absolutely no maturity to it at all. I wanted to go crazy on the design, so I put the Miami Vice-style background in there with those *super garish* colors on top: the purples, the blues, the turquoise. The whole combination really takes it over-the-top."

"The most memorable thing about this cover to me is that it was what I was working on the week my son was born. I was very sleep deprived."

"When I started my professional art career, did I think I'd ever have to draw a flesh-eating, zombie Spider-Man? No!"

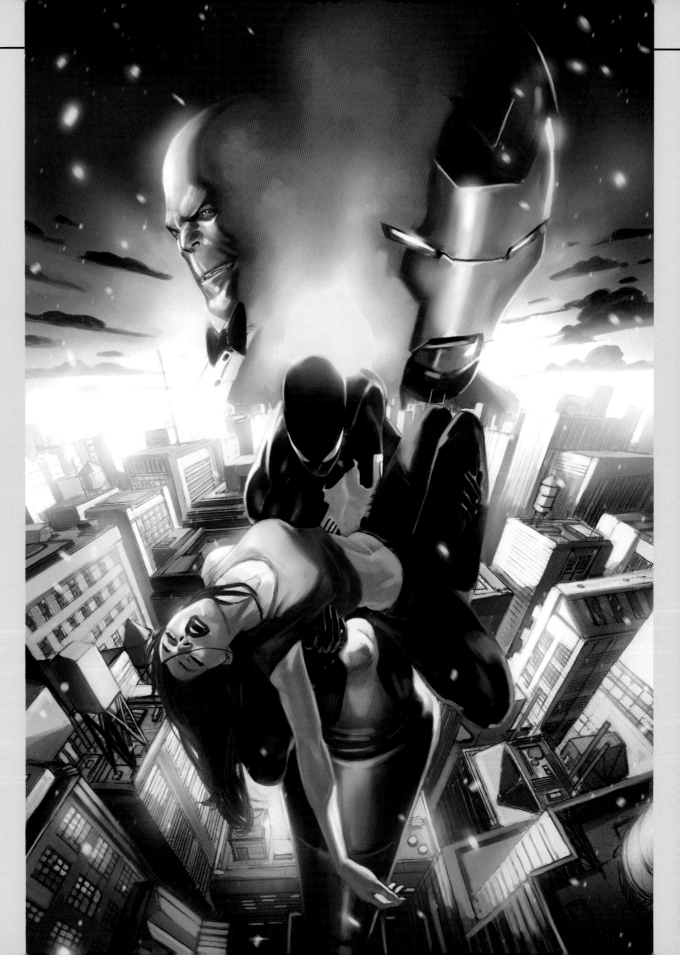

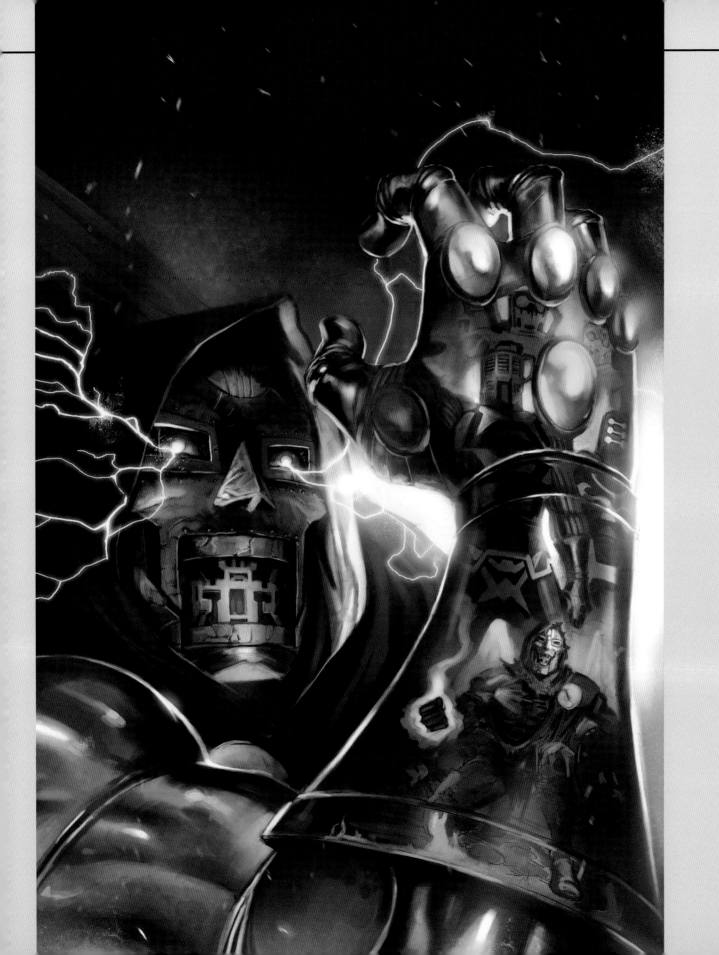

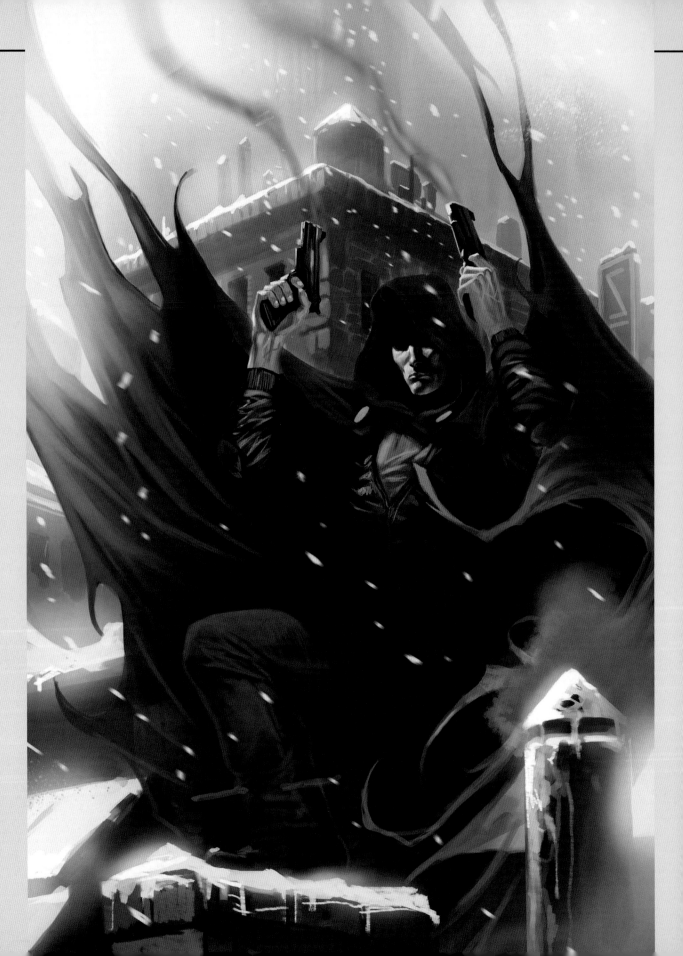

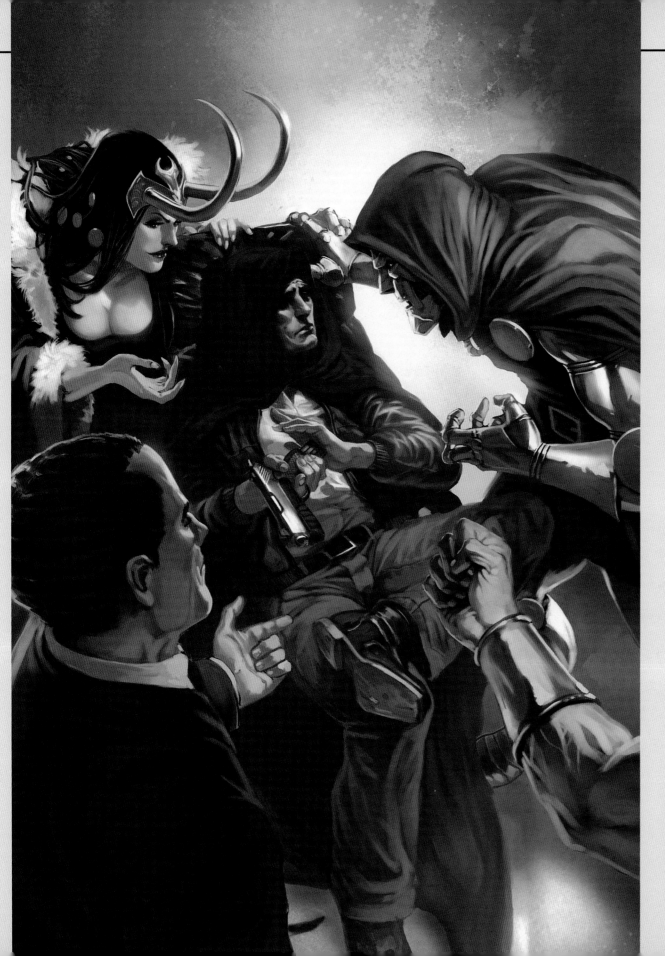

"The previous cover was just an entry level, iconic shot of the Hood, but here, I was able to tell a story through body language. After I completed the work, I really felt excited about being able to pull it off. Looking down on the scene, building up a feeling of tense claustrophobia, you see the Hood sitting on a chair loading his gun. At the same time, Dr. Doom is probably upset about having to take orders from the Hood, while Loki comes in from the other side, perhaps whispering some seductions into his ear. And then you have Norman Osborn pointing his fingers, trying to take charge of the situation. And Namor's hand is reaching in there, defiantly clenching his fist. So there are many different ways each character is trying to persuade the Hood, who is the center of attention."

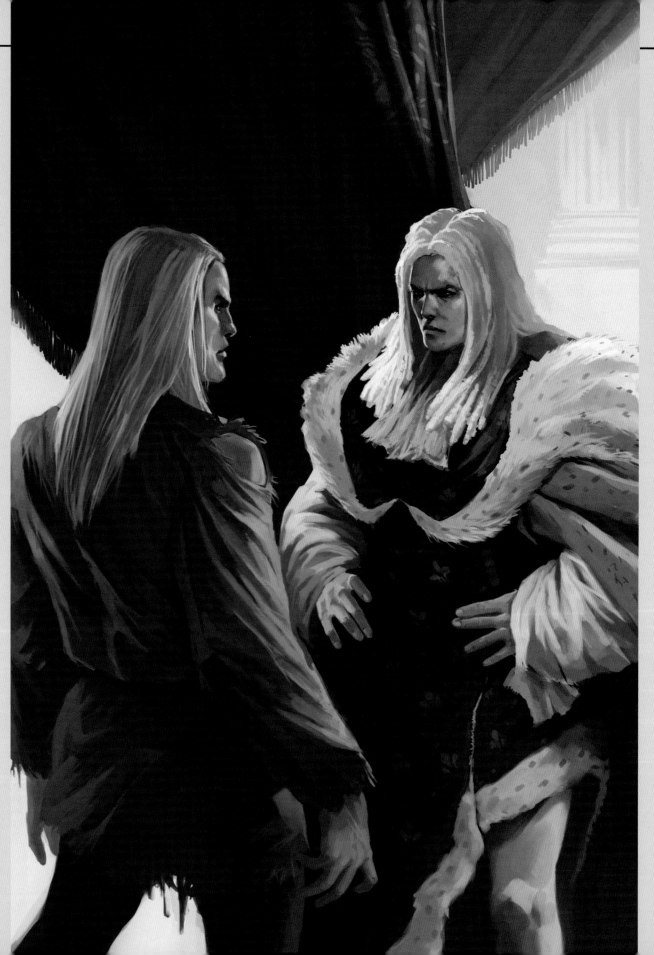

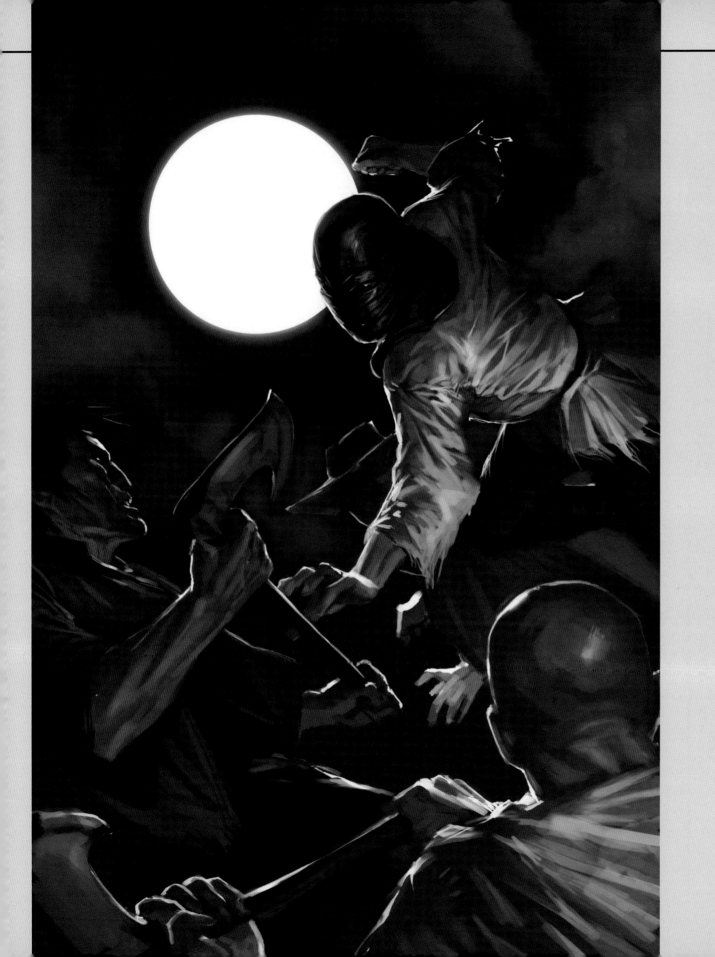

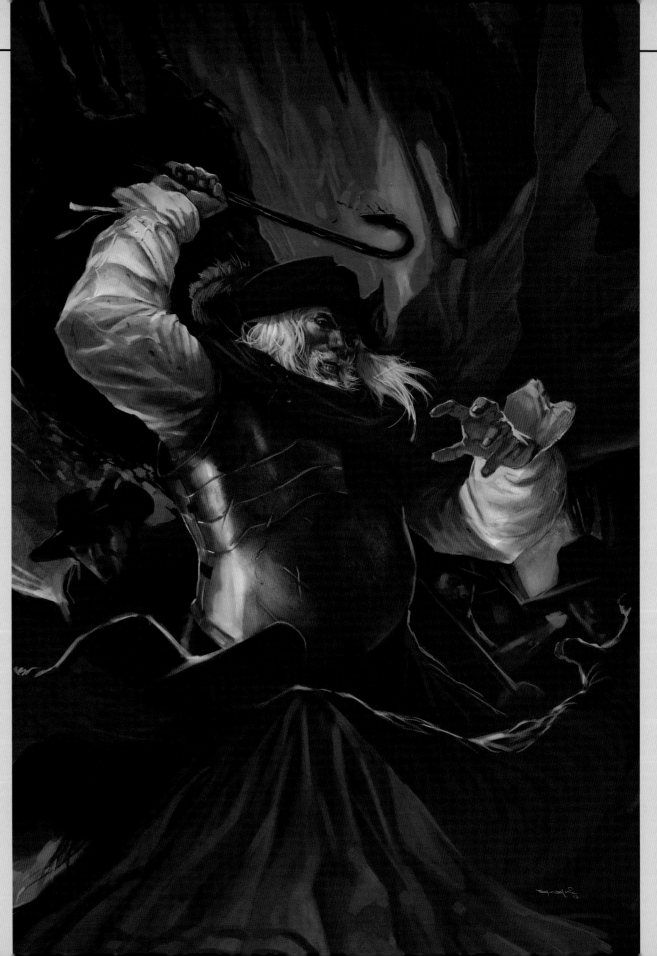

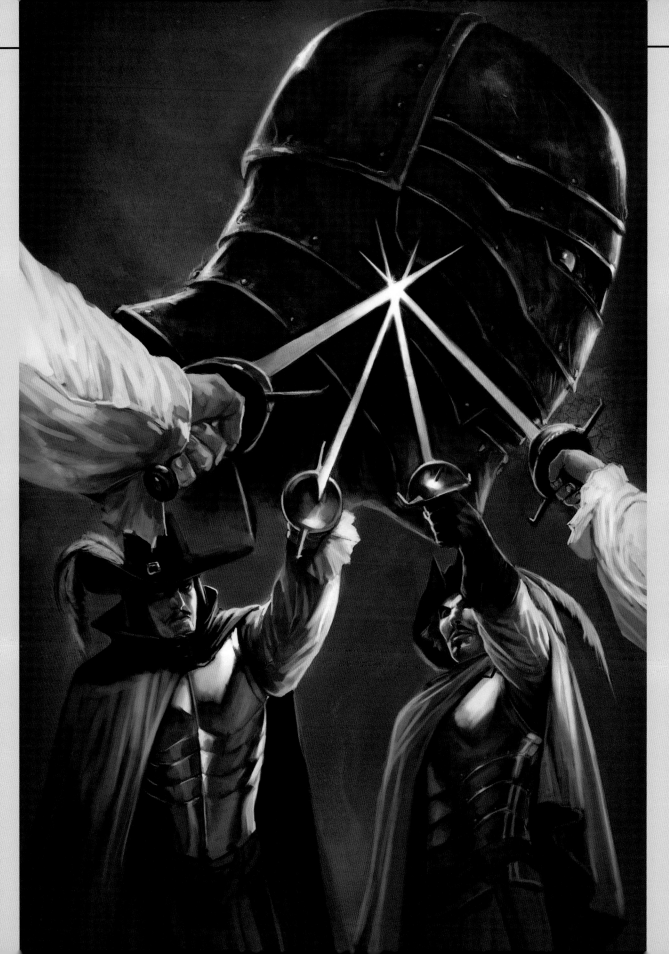

CHARACTER CONCEPTS

Every page of this book has been devoted to the myriad of covers Marko has produced for Marvel over the last three years. But that is not all he's done. Behind the scenes, he has employed his formidable talents as a concept artist to design several characters for a handful of contemporary Marvel titles. Though he's still adding to his resume as a modern master of the comic book cover (not to mention his initial steps into the terrain of interior comic art), it's his design work that has gotten him to where he is today. And he's good. Damned good.

A case in point: His concept work for Dan Abnett and Andy Lanning's space opera *Annihilation* produced a quartet of character designs that were cosmic in scope. Three redesigns of '70s era favorites (Quasar, Star-Lord and Warlock) and one design totally of Marko's making (Wraith) added to the ultra-contemporary feel of the space-faring mini-series. To show his versatility, Marko also recently designed the costume for Spider-Man Noir, a version of Peter Parker set in the 1930s. Further, we cap off this book with a look at a series of X-Men sketches done while Marko was still at Massive Black and any thought of a career at Marvel was pure fancy.

But to actually see Marko in action, his Massive Black instructional DVD *Marko Djurdjevic: Character Ideation* showcases him in the process of designing his own original characters right before your eyes. His insights into the process will augment the understanding of his art that you may have gleaned from this book. Until then, check out the designs on the following pages and enjoy what Marko's partner-in-crime, Jason Manley, described in his foreword as Marko's "virtuoso imagination." Here, then, is the act of creation.

MARKO: "During my days at Massive Black, I must have created thousands of characters that are now rotting away in the drawers of some big companies. They're never going to see the light of day, I'm not allowed to publish them anywhere, and nobody's ever going to know that I did them. It's part of my life that I used to do stuff like that.

"With Marvel, my role in designing a character was actually promoted. It would be mentioned on the Marvel website, or by the editors or writers in interviews. It's nice to get public praise for your creative efforts.

"My approach with design is pretty much always the same. Having just turned 30, I still feel young, and my tastes and cultural references might be completely different than a 30-year-old artist twenty years ago. If such an artist is assigned to draw a concept for a character today, he might not be inspired by the same things that I am inspired by. You see that happening quite a bit, where old school artists are designing modern characters and those modern characters end up looking old school again. That is fine, but personally I want to avoid that with my work. I try to go as much with the pop culture trends as I feel comfortable with, while at the same time push for my own vision."

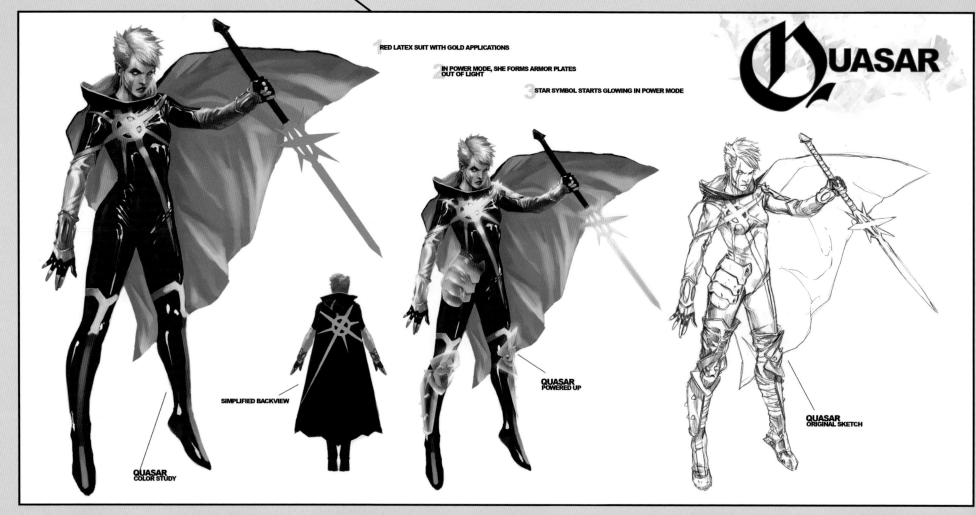

1 RED LATEX SUIT WITH GOLD APPLICATIONS

2 IN POWER MODE, SHE FORMS ARMOR PLATES OUT OF LIGHT

3 STAR SYMBOL STARTS GLOWING IN POWER MODE

QUASAR

SIMPLIFIED BACKVIEW

QUASAR
COLOR STUDY

QUASAR
POWERED UP

QUASAR
ORIGINAL SKETCH

"Marvel's cosmic cast is so full of unexplored territory, and I think what they have been doing with them lately has been so interesting. *Annihilation* was incredible, not the least because of Gabriele Dell'Otto's fantastic covers, and it really pushed boundaries that Marvel should continue to push. One of the entertaining aspects of designing the cosmic characters is they seem to have a sense of pioneer spirit. They are unleashed upon the vastness of space to make their own way, and their potential for innovative character designs should reflect that."

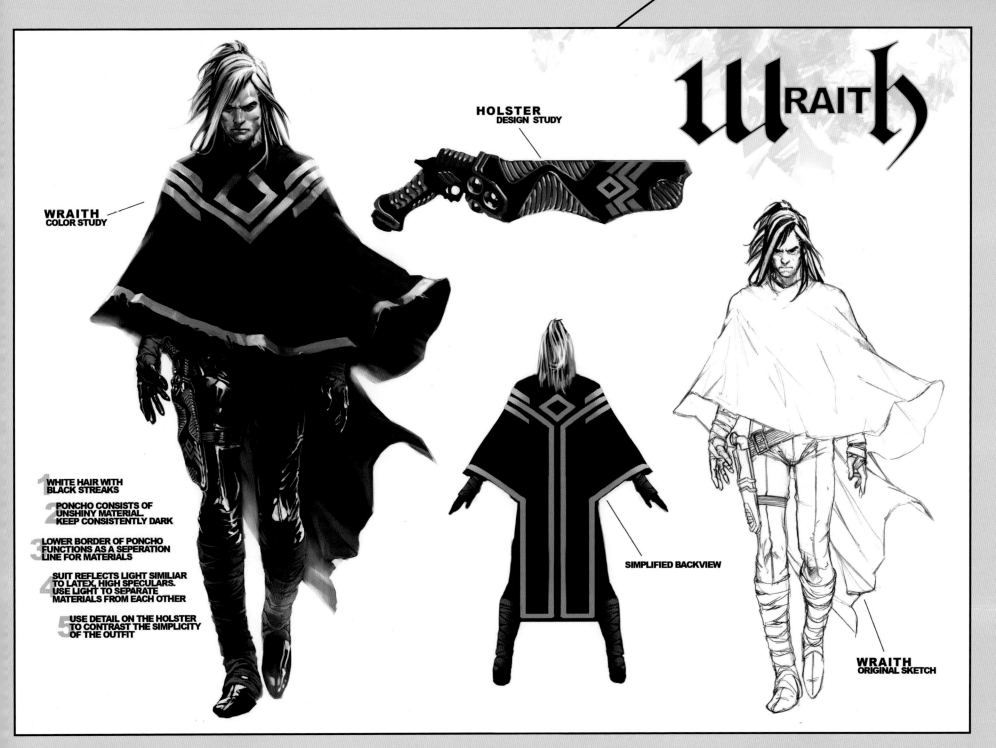

WRAITH
COLOR STUDY

HOLSTER
DESIGN STUDY

WRAITH

1 WHITE HAIR WITH BLACK STREAKS

2 PONCHO CONSISTS OF UNSHINY MATERIAL. KEEP CONSISTENTLY DARK

3 LOWER BORDER OF PONCHO FUNCTIONS AS A SEPERATION LINE FOR MATERIALS

4 SUIT REFLECTS LIGHT SIMILIAR TO LATEX, HIGH SPECULARS. USE LIGHT TO SEPARATE MATERIALS FROM EACH OTHER

5 USE DETAIL ON THE HOLSTER TO CONTRAST THE SIMPLICITY OF THE OUTFIT

SIMPLIFIED BACKVIEW

WRAITH
ORIGINAL SKETCH

"The description given to me for Wraith was 'Clint Eastwood in space,' and I took it from there, wanting to capture that idea of a lone gunman in space. I gave him a poncho, which is something that you wouldn't expect from a guy traveling in outer space, but I still think it's such a unique piece of clothing; it's not the classical super hero cape, but it implies a lot of the same effects. The poncho was emblazoned with Indian-style carvings to give him some iconography in a more naturalistic way than just planting a logo on his chest. I wanted viewers to take away a sense of mystery from the Wraith, to imagine that he can somehow move about unseen by others."

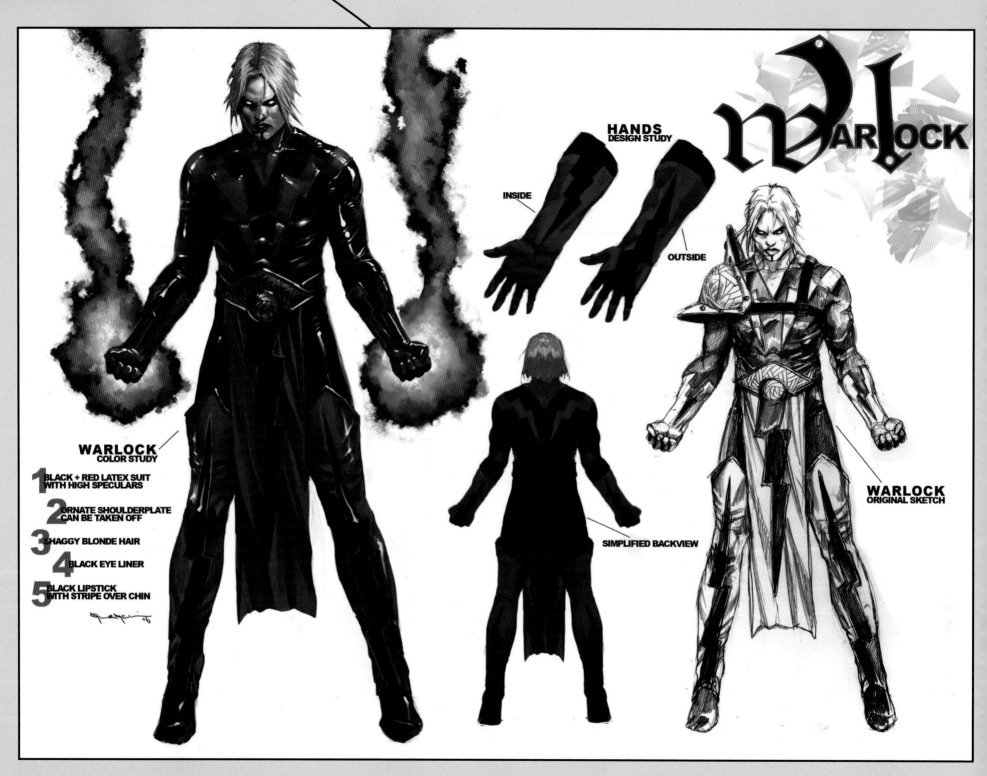

WARLOCK
COLOR STUDY

1 BLACK + RED LATEX SUIT WITH HIGH SPECULARS

2 ORNATE SHOULDERPLATE CAN BE TAKEN OFF

3 SHAGGY BLONDE HAIR

4 BLACK EYE LINER

5 BLACK LIPSTICK WITH STRIPE OVER CHIN

HANDS
DESIGN STUDY

INSIDE

OUTSIDE

SIMPLIFIED BACKVIEW

WARLOCK
ORIGINAL SKETCH

"Warlock was not a character I was familiar with before I got assigned to do the job, and the only reference I had for the character was actually visuals that I found on the internet, all of which were a little too old school for my tastes. Marvel wanted to make sure I kept the lightning bolt as part of his design, but other than that I was pretty free to work with him. The bolt became the main element I built the design around – and I just put it on everything. I put it on his hands, his boots, his long loincloth, on his chest; I really wanted to make it an intricate part of his appearance. I thought I came up with a bit more realistic costume that also set him off as free and new and modern."

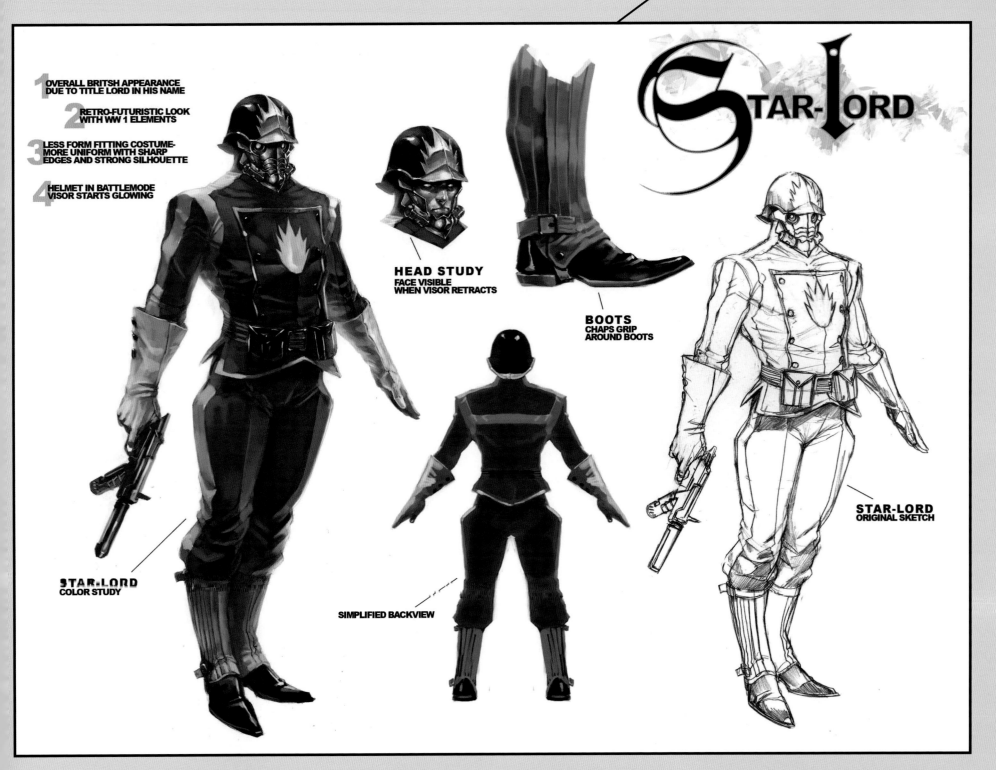

1 OVERALL BRITSH APPEARANCE DUE TO TITLE LORD IN HIS NAME

2 RETRO-FUTURISTIC LOOK WITH WW 1 ELEMENTS

3 LESS FORM FITTING COSTUME-MORE UNIFORM WITH SHARP EDGES AND STRONG SILHOUETTE

4 HELMET IN BATTLEMODE VISOR STARTS GLOWING

STAR-LORD

HEAD STUDY
FACE VISIBLE WHEN VISOR RETRACTS

BOOTS
CHAPS GRIP AROUND BOOTS

STAR-LORD
COLOR STUDY

SIMPLIFIED BACKVIEW

STAR-LORD
ORIGINAL SKETCH

"The main inspiration for that design came out of the name itself. I imagined him to be a sort of cosmic policeman, but I couldn't but be reminded of a British lord when I heard his name. The uniform spoke to those British qualities, especially with the riding boots he's wearing, and mask and helmet, for which I took inspiration from British military garb from the First World War. The gas mask, with the retractable visor, is the only thing ultra-modern about his outfit – all the rest seems to be of antiquity."

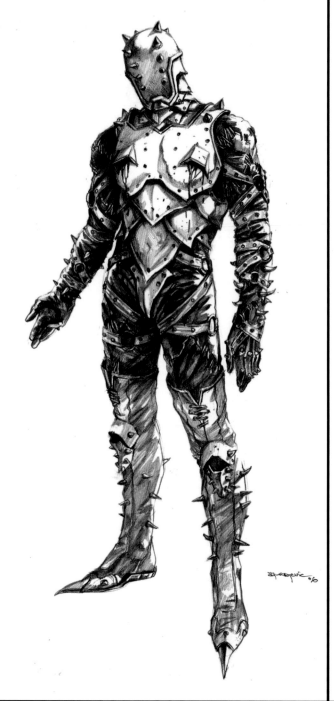

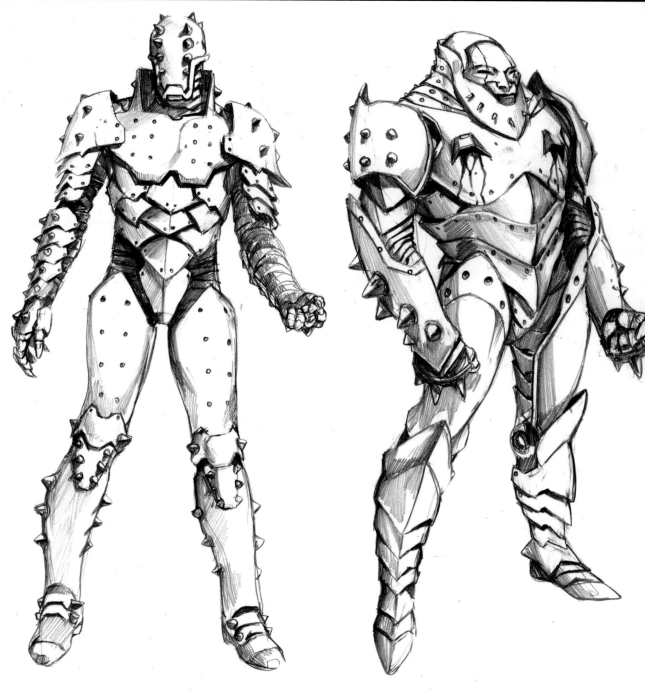

"'Speedball in an Iron Maiden suit' was pretty much the only information I had. I underlined the torture aspects with bolts and spikes coming out of the costume. I designed for him a sewn-together leather suit with an armored chest piece that had spikes protruding out – and possibly inside as well. I placed two bleeding holes on his chest, to showcase the point where the armor is just beginning to pierce his skin.

"I also thought it important to hide his face. I didn't have any idea of how he was actually sensing the environment around him, but at that point, I wasn't even paying attention to that, because somebody wearing a torture costume is not somebody who necessarily needs to see. I was avoiding the logic behind this – I just wanted to come up with a design that was creepy, one that portended to the viewer the agony Penance is going through without being so literal. If I would have left an opening for a face, it might have taken away from the mystery of who was actually behind the costume and where his power comes from."

2.1
AVIATOR GOGGLES
WITH HAT COMBO

1

2 WITH AVIATOR GOGGLES
AND TRENCH COAT (OPEN)
PLUS WEAPON HOLSTER

3 WITH TRENCH COAT (CLOSED)
WEAPON HOLSTER (ON BELT)
PLUS HAT

"The initial design was little more oriented toward the classic Spider-Man costume, which was basically the same cut but made out of leather. I liked that a lot more than the later ones that I did, because it followed my image of what a person in that time might do to make a costume – in taking the leather and seaming it together, the way the seams would be aligned it would, without any intention, resemble a spider web.

"However, they thought it key to remove the design from the contemporary Spider-Man look and really go for a different route, one that didn't involve webbing. Overall, it was a good editorial decision – not everything has to look reminiscent of the current state of things."

magneto

juggernaut

sabretooth

"These X-Men sketches came about while I was in Germany waiting for my visa to be renewed so I could return to the US to work at Massive Black. I was hanging out with an artist friend named Nic Klein, who would later do some covers for Marvel, and we were bored one night because we didn't have anything to do. Go out and drink? Stay home and watch a movie? As we were both artists, it happened that Nic challenged me to a drawing competition. The contest would be to see who could come up with the best redesign of an old-school Marvel villain. He took Green Goblin and I chose Sabretooth. It was such a dumb challenge, especially since Nick is a guy who loses attention very quickly. At half a sketch, he wandered off to do something different, while I sat there and finished my Sabretooth drawing. I liked what I had done so much I kept at it and by the time Nic came back, I had three additional characters drawn…"

professor X

archangel

banshee

"Since I was on vacation and didn't have anything else to do, I kept drawing over the next three days and had sheets of paper devoted to designs of eighteen X-Men, completely redesigned via semi-complicated back stories I had dreamed up for each of them. Further, I grouped them in three to make them compatible with each other. It was all a purely personal pursuit, just to see what I could do with them using all the experience I had gained as a professional concept artist. I hadn't read X-Men comics in years, was completely out of touch with their current comic book reality, and was only drawing on my memories of reading them as a child…"

storm

rogue

jean grey

the treacherous

"I tried to group the agenda of three characters into one over-arching, unifying theme. With the Treacherous, for example, I was thinking of making a group of X-Men women that are only interested in bringing Angel to the fall. In my narrative, they all shared a common agenda in terms of they had all fallen in love with Angel and been spurned by him. And because all three of them have huge egos, and they felt really destroyed by his betrayal, they banded together to plan how to eradicate Angel from their lives.

"I imagined Storm as a voodoo priestess, a weather magician – not a lightning-bolt throwing, flying, super heroine, but more like a

dignified woman with a long line of ancestors going back to the Zulu tribe of Africa. She performs her weather magic on a very personal scale, and would never let a man into her life unless he had really conquered her heart. Angel was so seductive that she let him in, and then he ditched her and moved on.

"Rogue was always infatuated with Angel, but he never gave her a chance. And as it is if you're infatuated with someone, it all turns to rage at the point when you're not getting what you want out of it, if your expectations are too high.

"Jean Grey was tempted by Angel to cheat on her husband, Scott Summers, a relationship that was the first time she actually had been so close with somebody else, but because of Angel she let herself go, and she could never forgive herself afterwards for cheating. And so those three banded together as 'the treacherous,' plotting on how to destroy Angel's life…"

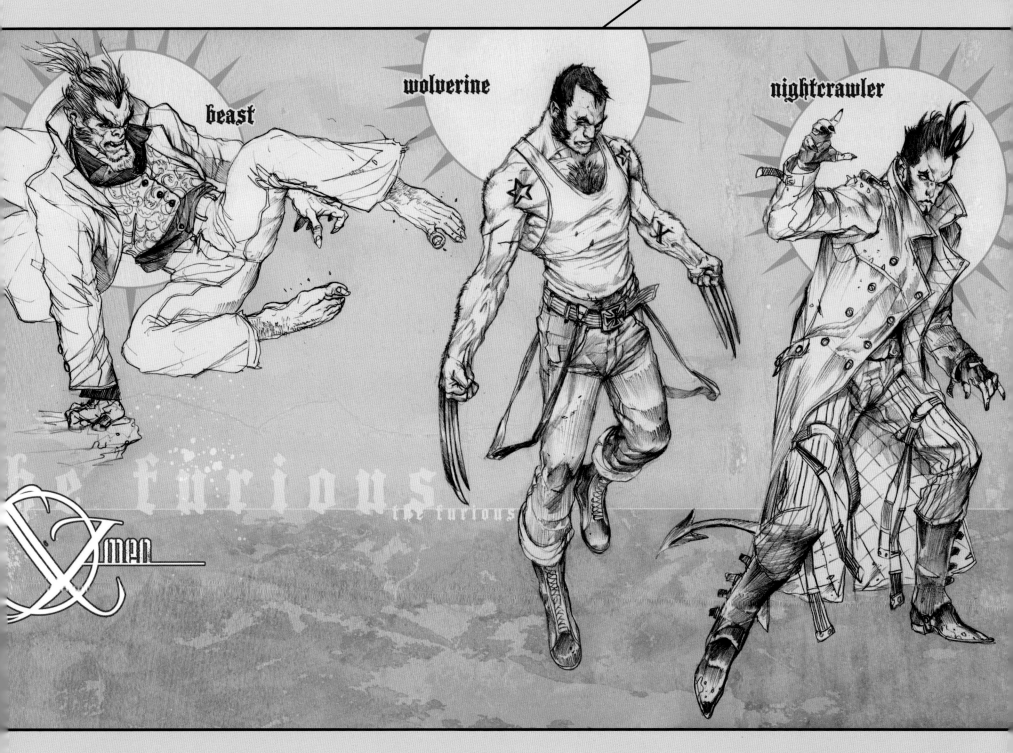

beast

wolverine

nightcrawler

"These are all character motives that I came up with on the fly. My only plan when I started out was just to make the X-Men look more interesting, to take them out of their costumes and their world-saving agendas and give them the problems of everyday people. What would they look like, what would they be doing if there was no common enemy around? If they were just living their lives normally among human beings, with rent to pay, jobs to go to, down to earth relationships, and weren't all living together in a big mansion that was paid for by some millionaire. Reimagining the entire concept of what those characters are about – but still keeping them close to the core of what their powers represent – was what all the fun was about…"

cannonball

iceman

bishop

"At the end of it, I posted them up on conceptart.org. There was a lot of love and praise for them, but there was also a significant amount of hate for them. The typical rants about raping someone's childhood with horrible ideas. I got all kinds of email – positive and negative – and there were people blogging about them, mostly talking about how awful the designs were. It must have been two weeks later, when I returned to San Francisco on a fresh visa, that I found a private message from Chris Allo in my forum inbox. He told me he was the talent manager at Marvel and he wanted to talk to me about the possibility of working with them and to please give him a call. I gave him a call that very day, and he offered me the gig to start working for Marvel…"

cyclops

gambit

colossus

"I was a complete unknown at that time. I had never worked for anything comic related at that point, and I had never provoked such a fury with anything I had drawn before. Comic book message boards like Newsarama and Comic Book Resources were on fire with everybody bashing the designs and going off on how messed up my ideas were, and how they should never give me a job at Marvel, how it's typical for a video game designer to come up with a bunch of crap like that. You name it, I got pretty much any insult you could get. So it was a most profound pleasure for me when Marvel showed their interest in me. I cannot deny that I smiled from ear to ear when they came around and wanted me to work for them."

■ CLOSING THE BOOK

■CLOSING THE BOOK PART I:

INTERVIEW WITH CORO KAUFMAN

*Illustrator, painter, and concept artist, **Coro Kaufman** jumped from a four-year apprenticeship with Shaba Games to found Massive Black, the San Francisco-based concept art studio where he currently toils as art director. It is also where he met Marko Djurdjevic and formed a bond of friendship out of a mutual respect for art.*

You call Marko your own pseudo-adopted son. How come that defines your relationship with him?

Marko came out to San Francisco a few years ago, back in '04 or '05, and he was one of the first guys that we brought into the fold at Massive Black as we were building the studio up. He lived right about a block away from us here in downtown SF. My better half actually rented him the apartment in her name, and he became very much a part of our lives.

So he would rummage around in her refrigerator and hang out on your couch?

Everyone kind of does that. We're mom and dad's house around here. So yeah, it was definitely one of those situations where he would come over and raid the fridge and grab a few things he might need. We definitely play into that role.

So, what was your first impression of him?

Well, the first thing you notice is his amazing drawing talent. But also it's his demeanor. I haven't met many people with as powerful a personality as him. He's definitely of the more outspoken people I've met.

What was your feeling about how he'd adjust to leaving Germany and taking a risk in coming to the United States to be an artist?

You remember that show *Perfect Strangers* with Balki Bartokomous? There a lot of moments like that, where he had come to the States and experienced our country for the first time. For instance, for the first couple of months, he kept saying, "Man, I don't know what's wrong with the food out here. I'm gaining so much weight!" And I didn't really know what to tell him until one day I caught him drinking a glass of half-and-half, and I was like, "What are you doing that for?" And he's like, "Because it's half the fat of milk." And I'm like, "No dude, you're drinking like half *milk*, half *cream*!" He had no idea that drinking all that half-and-half was gaining him all this weight. It was those kinds of things that were pretty funny. And at that point, he was still trying to figure out what he wanted out of life, what he was after. It was a fun time to watch him come into his own a little bit, as an artist and as a man, and to start reaping the benefits of the skills he'd spent his life developing.

When did you see that risk start paying off for him?

Well, I saw him as someone who had the world in the palm of his hand. I told him, "You can do whatever you want." He was hindered by neither laziness nor lack of ability. In fact, for a long time his biggest enemy was merely himself. And it seemed like as he got older, and kind of experienced a little more, he started to really take his potential seriously.

I think meeting his wife was a huge, huge thing for him in that direction. It really seemed to turn him around from being a wildly talented, very heavy drinking, very "hardcore" guy. At the time, he slept amidst a two or three foot circle of beer bottles filled with cigarette butts around his bed. He was one of those guys who was a really hard livin' dude. But then he met his wife and all that changed. He really cleaned himself up. I talk to him now, and he's so happy, and so thrilled with life, it's great to see. It's really awesome.

When you say that his only enemy was himself, in what way do you mean that?

I feel like he has always unjustifiably wracked himself with a certain amount of self-doubt. He has always beaten himself up about his work, and viewed himself as a no-good hack. I can't tell whether some of that is false modesty, but honestly, I really don't think it is. He really is somebody that I think has arrived at where he's at through years of holding himself up to a very high artistic standard. So his greatest enemy is his own self-doubt, his own anxieties holding him back.

That's interesting, because he has had great success as a teacher. What are some of your observances about that part of his career?

Marko took part in the very first workshop Massive Black did, so I got to watch him teach early on. He had had some experience of at least talking about art and showing art to people back in Germany. But Marko is self-taught – he obviously never went to art school or anything like that – so anything he's communicating to the kids in these workshops is all knowledge he's learned on his own. And I think that's been one of the best things about his approach – the fact that it is kind of an oblique approach, if you will, to representational drawing and painting. He's had to figure out a lot of stuff on his own, and when you do that you approach problem-solving differently. That gives his teaching advice a very unique quality. He'll start a character with one line down to the foot, and draw it up from there into a fully realized character, and kids are just awestruck.

But it's also his outspoken personality that helps for him. He's gregarious and that makes him a little more approachable to students because they know that he's not overly serious – but on the other hand, if you do something he doesn't like, he's going to tell you. That's another thing he brings to the table. For several of the workshops, he and I would do portfolio reviews together on the last day of the event. Because I'm art director at Massive Black and he's a Marvel superstar, everybody wants us to look at their portfolios. Listening to him comment on students' portfolios, he shares with them very constructive insight and I don't think he hides much of it in art speak. He's very plainspoken, which I think resonates with younger students.

Was his style of drawing shocking to you when you first saw it?

It wasn't necessarily the style that was shocking, but it was more the ease with which he was able to do it that was really surprising. Nobody in our entire group had ever really seen anything quite like that. He could just belt something out without even thinking about it.

Coming from a more traditional background, I had never seen anybody do it quite like that. It was shocking to all of us. On the day we first

met him in Amsterdam, at our first conceptart.org workshop, we went out to a bar, started drinking, and sat down and he started drawing in his books. It was funny – he would draw something and we'd just all scream "Ahhhhh!"

So he was a monster talent from the beginning?

Oh yeah.

What do you think of his career now? Do you think this was where he was always headed?

Oh yeah, definitely. From the first time I ever met him I told him, "You're born to draw comics, man." His style – the dynamic aspects of his artwork and his propensity towards figurative stuff. – is just an undeniably good fit for comic art. His destiny for comics was always kind of a clear path, as far as I was concerned. Now, that's not to say he's not a great concept artist. Far from it – he's amazing at that. But when he first got hit up by Marvel and started doing a couple of gigs for them, I kind of saw it as the baby bird spreading his wings a little bit, that this was really the moment where he gets to shine. Honestly, I couldn't be prouder of him at this point. I beam like a proud surrogate father.

Do you have any advice for him?

Yeah, I tell him all the time, "Just don't screw this up." He's gone this far. God only knows what he's gonna end up doing. He's one of those people that can do whatever the hell he wants. I think that even his closest friends, we all just kind of sit back and wait to see what happens next.

Do you think that whatever happens next will have something to do with his hair?

Ha! That amazing haircut, how that's endured for the past three or four years now! Actually, we call it monster hair because a kid of one of our old co-workers told him that he had "monster hair."

So that's one of his nicknames, then?

Yeah, Marko has monster hair. And it's still there. You know what's funny is that I actually hadn't seen him for about a year or so, and we met up with him in New Zealand last November, and I took one look at his hair and said, "Ahh! Same old Marko!" It's awesome; it's good to see.

And I think that's the thing, too: when you're a young, single guy, it's easier to keep up with the trends, and he was always really on the cutting edge of stuff, all dapper and new hair and all that. And now he's pulled a "me," where he's getting a little older, and he's growing roots, and he's got the wife and kid, so he's adapting. It's cool to see. Like I said, I'm so damned proud of the guy. I see the stability in him, and I just breathe a sigh of relief. He's made it. He's made it.

■ CLOSING THE BOOK PART II:

INTERVIEW WITH ANDREW JONES

*Along with Coro Kaufman and Jason Manley, multimedia artist **Andrew Jones** was also a part of the Massive Black family. Working with fellow founder Manley, Andrew built Massive Black into one of the premier concept art studios in the industry, a full-service production facility that provided concept art, modeling, animation work and more for video games, film, toys and other media. In discovering Marko Djurdjevic, he not only found an incredibly talented recruit for his company, but also a friend for life.*

How did you discover Marko Djurdjevic?

Jason had mentioned seeing his work online and realized that there was something pretty extraordinary happening with his talent. We had made some plans for a Massive Black workshop in Amsterdam, and the first time I met him we were just pulling into the train station late at night. It was all very cinematic: There he was, this bold silhouette with his magnificent hair and his jacket, and he came right up to us. There was definitely no mistaking that it was Marko. We hit it off instantly as two people and two friends.

I found out quickly that he's the kind of guy that is attracted to curious people. He likes people that are interesting and capture his imagination. And you know, the first time I ever saw him draw, I had never seen any person draw like that. I didn't know that it was possible. When he draws, it's like he's somehow tracing directly from his imagination, illustrating whatever his thoughts propel him to do. We really bonded in Amsterdam, so much so that it's almost intimidating how well we got along.

What specific qualities about his art inspires you and makes you realize that he's got a unique talent?

The output is always impressive. He's got all of his foundational skills down – composition, figure drawing, and anatomy. I admired a lot of the work that I had seen him post on the forums, and now the things that he gets published, especially all of his Marvel covers. But what really locks Marko down as one of my favorite artists is the process that he takes while creating an image.

After all the workshops that Jason and I do, the biggest deterrent to any one artist's personal success that we're constantly seeing is their own lack of self-confidence, submitting to their own fear. We can teach a lot about anatomy and structure and other details, but at the end of the day it's up to the individual to use their talents and it almost always involves them overcoming fear. Fear of failing—most people are so afraid of making a bad drawing that they don't even try.

It's almost like an archetypal fear among most people, but it's heavily prevalent within the artistic community. You've got all these guys with all their egos and insecurities, and Marko is one of the first artists I've ever seen that could draw without any fear whatsoever. He's just the Daredevil of artists – he's completely fearless. Nothing is too ambitious for him, no pose or angle is too intimidating, no composition or battle scene makes him flinch.

He can draw anything, a lot of times without even any reference. I've seen him draw exotic animals right from his imagination. He gets the

anatomy right, he gets the placement of the eyes and the nose and the teeth. I think he's got what I would call a photographic memory, and he can trace from it. You can't teach that. You can't give a demo on how to draw from your photographic memory. It's an instilled ability. It's kind of like a super-power.

His style is so unique – nobody would have ever taught him to draw the way that he does – and yet he's also a teacher, able to communicate certain standards to prospective artists. How can someone with such a unique style relate to students in an instructor's capacity?

That's a great question, and it's something I wondered about at first, too. For instance, I thought there was no point in doing his instructional DVD because you can't teach anybody that certain self-taught skill that he has. But where he makes up for that is he is a really amazing communicator. What I don't like about words like "talent" or "gift" is that it takes credit away from the hours and hours of discipline and dedication and effort and energy someone's invested in their craft, and Marko has done all that. He showed me some of his drawings from when he was 17 or 18, and some of them were amazing, but at the same time there was nothing super spectacular about them. Frankly, they would be overlooked. His raw talent and vision were just the start, but all the things he's been able to do for himself have been through constant training and self-evaluation.

One of the best examples of that is, years ago, he made a decision to not to use a pencil anymore. This was before Photoshop or any computer stuff for Marko. What this meant is that he would draw everything with a pen, and if he messed up, he had to toss it and start the drawing all over. He did this for two years. And I think that developed a level of confidence in his drawing – it's a bulletproof confidence.

I rarely ever see him change his mind. And it's because he's built up such a repertoire, he's trained his eye. He knows what good composition is, he's studied graphic design and he knows what good design is, he's got anatomy down, he studied Hogarth…So he did do a lot of work, and when you watch his DVD to see his presentations, all the advice that he gives is universally applicable. You can't train someone how to draw from the imagination, but you can teach them what to look out for, what things to avoid, how to practice, and how to refine their skill. And he can give a great critique on a sketchbook!

What about his abilities as a painter?

That was the one thought that lingered after we first saw his sketches on concept art, we thought he was a maestro with the pencil, but he can't paint. There's the chink in the guy's armor! He's got tone down, he's got form, and he can render. But he had no knowledge of color. And even coming into Massive Black, his coloring was very naïve. So we were always thinking that coloring was the one deficit for Marko, and it kind of made us all feel a little better in our own artistic insecurities – at least there was some area that he hadn't completely mastered!

But then, I don't know, it might have taken a couple months, and all of a sudden he's busting out color. It started to look naïve at first, but progressively he started to break things down. Marko is a guy who can figure out a way of unraveling the mystery in things. He's a very kind of brass tacks person – to Marko there's not some mystic, ethereal god out there looking down at him. He's not a huge believer in the supernatural.

For him, what he can see is what's real; all he has to do is break it down into a fundamental understanding of it. So he just studied color and how it works. He started getting into the relationship between warm and cool, and how that works compositionally, and within a couple of months, Marko could color and Marko could paint.

At that moment, we said, "Oh man, it's all over now. He's learned how to paint!" He is so unstoppable at this point.

What do you think of his artistic trajectory: where he's been, where he's at right now, and where he might be going?

He's the kind of guy that I would never put any limitations on what he's capable of. It's amazing to see the dedication he has for Marvel, and what he's able to trade for them. He's expanding the Marvel Universe, which is an important thing. I think comic books have a really important role as kind of a modern American mythology. But at the same time, I think he's going to be even bigger than comic books. I have high hopes for Marko, I would like to see him begin illustrating his own stories. He's the one-man shop for everything, he's got such an amazing mind. He can do composition, he can do dialogue, he can do story plots – there's not any weakness that he has.

To start off, I would love to see more complete stories that are done by Marko, because he can do the pencils, he can do the covers, he can do the inking, and the coloring. So I'd like to see more of that. You know, he's so great at satisfying the client's need, but I would love to see the work that he would do just for himself. If he didn't have to worry about making money or supporting his family, I would just like to see the pure expression of Marko. We've talked before about working on some side projects – for instance, an illustrated book of Marko's dreams. He's got a pretty vivid dream life, and I'd love to see some fully painted scenes of his own experiences in his dreams. Things like that.

Describe one such dream that you can remember.

He's got this one – I'm not gonna do it justice – but he's got this one where he's standing in the water and he's got this encounter with a crocodile or an alligator. It's the way he describes it that makes me know it would be a very potent theme for his art. He has an amazing dream recall. So yeah, I'd love to see the Marko Book of Dreams someday.

And if he were to ever want to go into the fine art realm – and I just mean fine art as in the ideal of creating solely for yourself – I would love to see what he would be capable of if he really took full throttle control of his own potential.

Is there anything else you wanted to add?

I just really want to enforce that I think Marko's probably one of the most important visionaries of contemporary culture in our time. In Concept Art, Jason and I started a community where we met thousands of different artists. And I've been exposed to artists all my life. And there's no one I've ever met that even approaches the atmosphere of what Marko is capable of – and I mean on an artistic and human level, too. I'm so excited about this book, and I'm excited about more people being able to share in the work that he's done. But whatever you see on the surface of the work is completely overshadowed by the quality of his character, and I think that's something people should know.

To my son Adrian,

I know you're too young to understand it yet, but once you hit school you'll figure out your dad is crazy and all the kids will love you for it.

You have the world laid out in front of you.

I love you.

To my wife Jelena,

I know I'm a burden to live with and I work way too much, but you've done such a great job straightening me out that I can't thank you enough for it.

We'll hit a vacation soon. Promise.

To my best friends Andrew, Coro & Jason,

I know you three invested the most in me: your time, your nerves, your money, and I promise – I won't f#%@ it up!

This book is a testament to my conviction.

All this was possible because you guys believed in me from the beginning. You've all made my life into what it is today.

And that's a truth that can never be forgotten.

Thanks for your faith,

M.

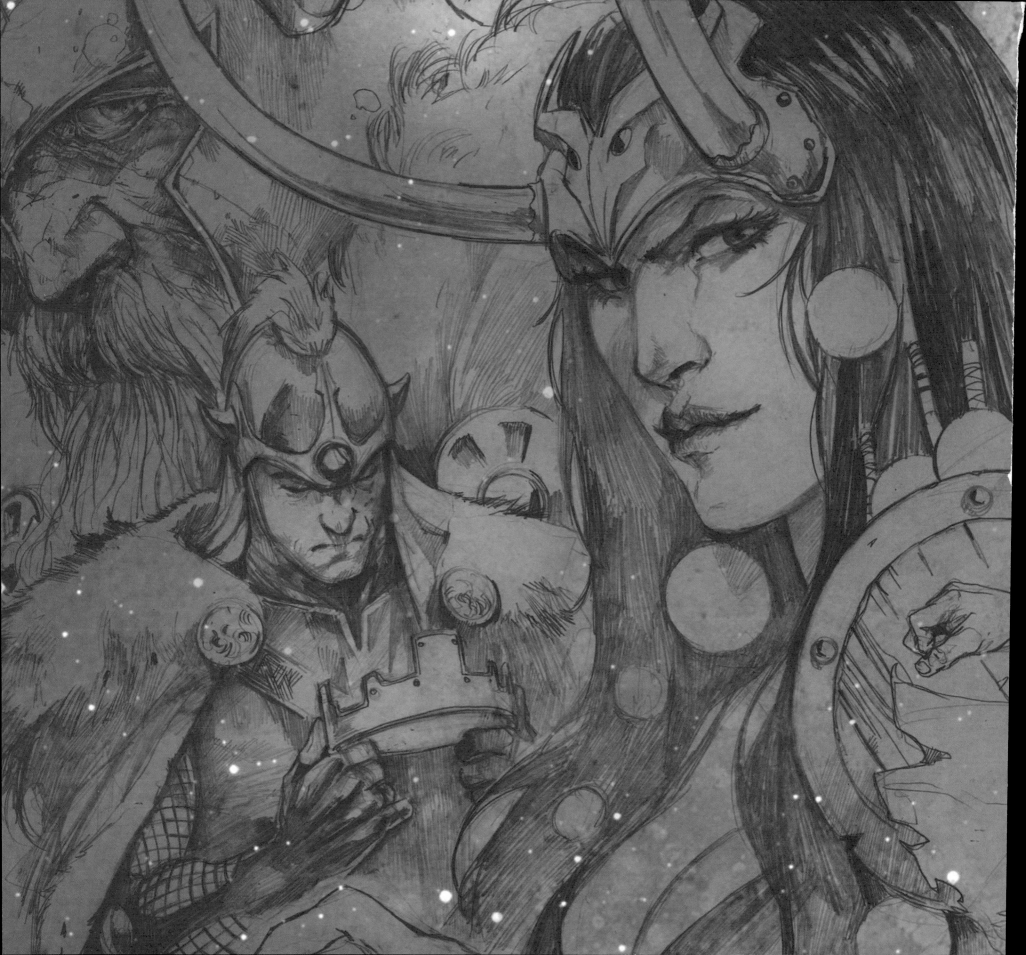